*For my comrades in the **Black Panther Party**,*
*for all those working for social justice and liberation,*
*for political prisoners around the world,*
*and for those who gave their lives to the struggle.*

**EMORY DOUGLAS**

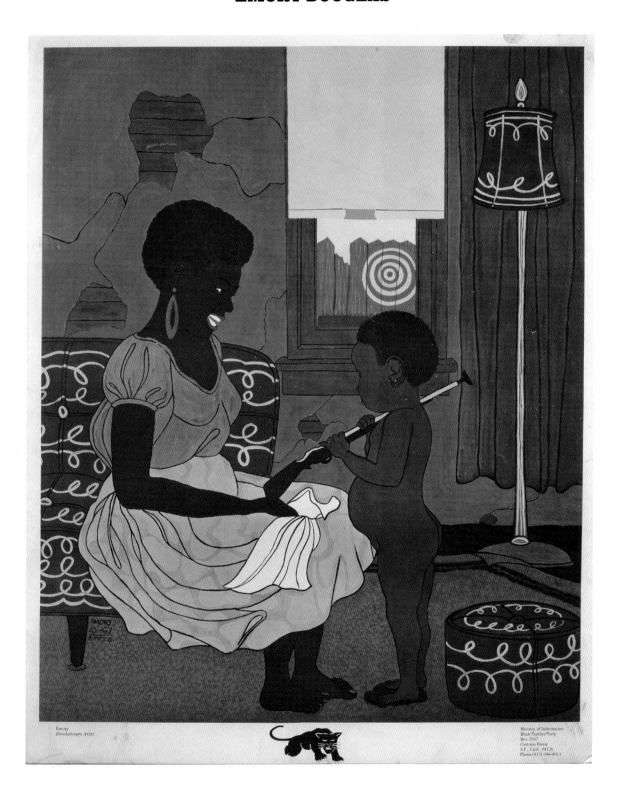

Emory
*Revolutionary Artist*

Ministry of Information
Black Panther Party
Box 2967
Customs House
S.F., Calif., 94126
Phone (415) 346-4013

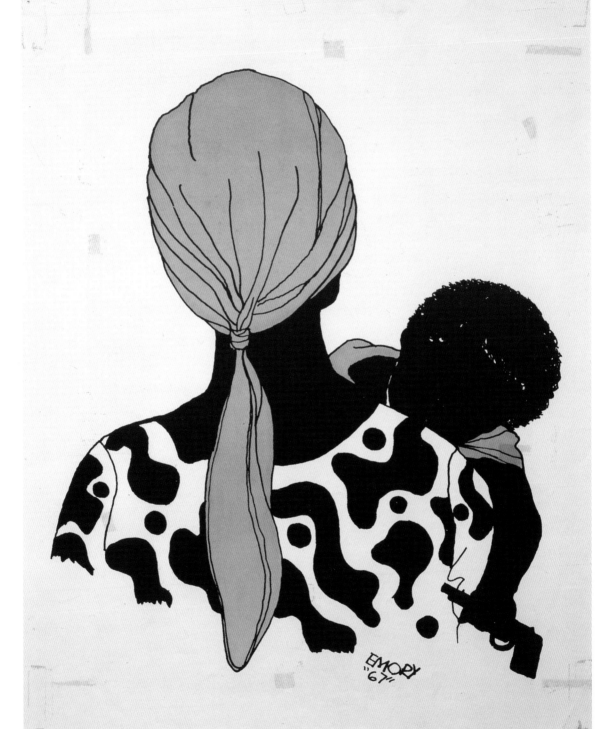

# BLACK PANTHER
## The Revolutionary Art of
# EMORY DOUGLAS

Preface by
DANNY GLOVER

Foreword by
BOBBY SEALE

Edited and with an introduction by
SAM DURANT

Contributions by
SONIA SANCHEZ, KATHLEEN CLEAVER, COLETTE GAITER,
GREG JUNG MOROZUMI, AMIRI BARAKA, and ST. CLAIR BOURNE

*RIZZOLI*
NEW YORK

# Praise for EMORY DOUGLAS

**T**he art of former Black Panther Party Minister of Culture Emory Douglas was a steady and shining presence in the *Black Panther* newspaper.

His artwork was militant, uncompromising, and clear as a bell. It showed armed black men and women, fighting to defend themselves and their communities from slovenly, unkempt pigs and boars. His work rarely needed captions, as the art spoke for itself.

This was revolutionary art, confrontational art, black art, and, more often than not, proletarian, and indeed, lumpen art. At a time when most black popular art was stylized and idealistic, Emory Douglas strived to portray people in the ghetto, sisters with their hair in braids, with frayed sleeves and worn shoes.

As someone who worked at the Ministry of Information, I remember that Emory didn't just do the front and back pages of the paper. He did layouts for almost the entire paper, every week. He isn't just an artist, but a gifted graphic artist who used his eye to place and block-in texts and graphics. I loved watching him do layouts because he seemed to be having fun as he slapped down pieces to ready the paper for the printers. I'm sure people will love his artwork!

MUMIA ABU-JAMAL
Author, *We Want Freedom: A Life in the Black Panther Party*

**E**mory Douglas's work was one of the first things that made clear to me what an artist's role in the Movement can be. To cut to the core of the problem is to represent the spirit and emotion that brings about resistance. And even more than that, while I was a newly developing artist, he made himself available and counseled many of us on our quest to become revolutionary artists.

BOOTS RILEY
Cofounder of the Coup

**I**n a letter from prison dated February 5, 1996, Geronimo Ji Jaga (Pratt) had this to say regarding Emory Douglas:

> *"Would recommend that you research the work of Emory and revive some of his earlier concepts if that is feasible from your end. Emory is really the silent warrior for he has survived all this with no ego ... as is so common among others. He was the first and only Minister of Culture and stands today as the best role model of us all from the original Central Committee. I'd like to shine the light on him as much as possible for he personifies the best image for the youth ..."*

Emory's drawings and photo collages exude the same kind of honesty and all-out love of the punk posters and squatter zines of my utopias. It's like his pages for the BPP newspaper come with their own soundtrack, smooth. Each a slice from a continuous narrative, blending the days of institutional slavery with contemporary policed reality. Mashing drawing with photography, storytelling, and proclamations. Like the sounds of the inner city, Emory's drawings are always charged. Full of life, tranquil and fierce.

RIGO 23
Artist

## THE GENIUS OF EMORY DOUGLAS

The conceptual brilliance and raw emotive power of Emory Douglas's masterful cartoons and illustrations for the *Black Panther* newspaper and the party's other propaganda media—posters, banners, buttons, record albums, bumper stickers, and broadsides—brought the Panthers' revolutionary analysis and daring grassroots political action program to vivid life for millions of oppressed African Americans and their white radical sympathizers. Emory's precision of statement and bold, defiant depiction of the common people and their struggle against the oppressor made the Panthers' message impossible to ignore and inspired untold thousands to join the movement for freedom, justice, education, and equal rights. Emory Douglas played a key role in building a mass following for the Black Panther Party and the black liberation struggle of the 1960s and '70s.

JOHN SINCLAIR
Writer

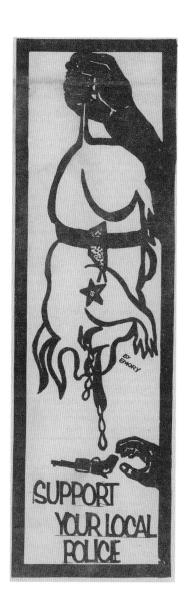

## I SMELL BACON

As a teenager, I discovered the work of Emory Douglas in the pages of the *Black Panther* newspaper, and it was love at first sight. Douglas's posters were the visual voice of the Panthers, and his unforgettable images of porcine cops and shabby slum apartments resonate with me to this day. I can still visualize his poster depicting a rat attacking a sleeping baby. What an incredible image! His work is alternately vicious and ennobling, grotesque and folksily beautiful. He's a great artist.

MIKE KELLEY
Artist

## ON DISCOVERING MY FATHER

All of my life people have told me, "Your father's a good man." Or, upon learning that Emory Douglas was my father, they'd say with a smile, "Emory's your father!" and stare at me as if determined to see his image in my eyes. I began to take it for granted that I could garner awe and praise from individuals simply by mentioning his name. But I wasn't sure why.

As a child I admired my father for being a steady presence in my life. He was (and continues to be) very generous, conscientious, and determined to raise me and my siblings with cultural understanding. If anyone asked I'd say, "He was a member of the Black Panther Party … a long time ago." That was all I knew of his contribution to society. Then, when I was twenty-two years old while in Paris completing a research project, I turned on the TV before going to bed. As yellow subtitles streamed across the screen I gasped, "Ahh, that's my father!"

In this interview I learned that my father was in fact the Minister of Culture of the Black Panther Party. Later I would learn that he was responsible for popularizing the term "pig" in reference to the police.

I was beginning to understand that he'd put a stamp on society. That he has done what I hope to do in this life—to leave a legacy for my children and all of humanity to inherit. Yet he himself has never bragged, boasted, or even mentioned these things to us in private conversation.

My father and I are still close and he remains humble in the face of his accomplishments. My brothers and I are proud of him as a human being, an artist, an activist, and a father.

CYNDI DEVESEY DOUGLAS

Emory Douglas is more than a cartoonist. Through his drawings, he encapsulated the rage that all of us had against the ignorant and mean foes whom African Americans were up against. With police death squads still in business, his work is contemporary.

ISHMAEL REED
Writer

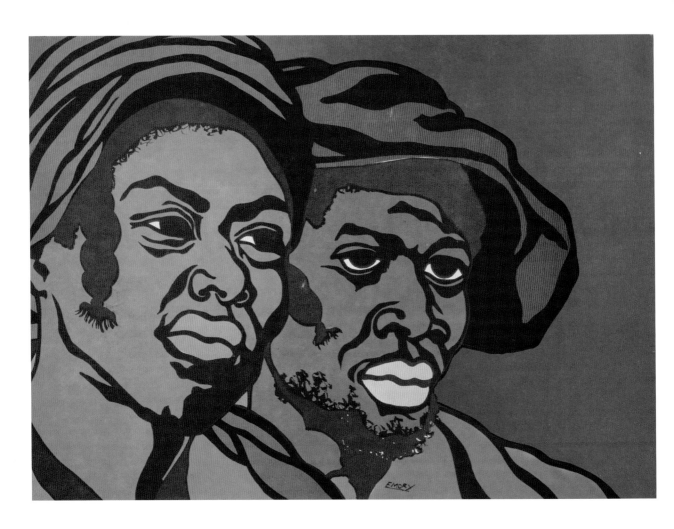

We are soldiers in the army
We have to fight although we have to die
We have to hold up the bloodstained banner
We have to hold it up until we die

My mother she was a soldier
She had in her hand the freedom plow
And when she got old and couldn't fight anymore
She said I'm gonna fight anyhow

My father he was a soldier
He had in his hand the freedom plow
And when he got old and couldn't fight anymore
He said I'm gonna fight anyhow

Now all of us are soldiers
We have in our hands the freedom plow
And when we get old and can't fight anymore
We gonna have to get up and fight anyhow.

# CONTENTS

Colette Gaiter

# *INTRODUCTION TO REVISED EDITION*

Since the first publication of this book, Emory Douglas continues his almost fifty years of revolutionary art making and activism. The body of work presented, from the active period of the original Black Panther Party, visualizes an unprecedented collision of events and ideas.

Those who knew Emory's work in its time expand their experience through these essays. New audiences observe that some of the Black Panther Party's most radical ideas evolved into cultural norms. Emory—as he prefers to be addressed and signs his work—currently travels all over the world to interact with young activists. New generations experience his signature aesthetics of revolution, which spread virally and inspire works that are now embedded in contemporary visual vocabulary.

Once considered by the government to be a dangerous radical, Emory and his work became iconic across genres and ideologies. The 2013 Smithsonian Folklife Festival in Washington, D.C. included Emory's images of Black Panther uniforms as cultural fashion icons. The contemporary art world acknowledges his work's formal qualities and content. Exhibitions at the Museum of Contemporary Art, Los Angeles, the New Museum in New York City, and in galleries and museums all over the world position his work in the global canon of twentieth-century art.

Published articles and retrospectives bring his provocative drawings and aggressive graphics to larger and more diverse audiences, but Emory's mission has not changed. As mainstream institutions celebrate Emory's revolutionary legacy, he brings young people

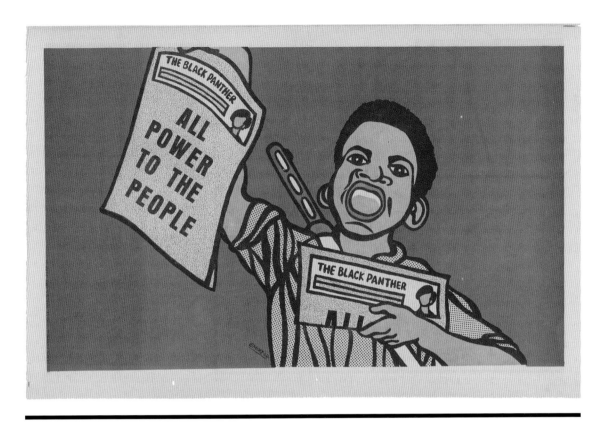

from various ethnic and socioeconomic backgrounds into those spaces to listen to his stories and collaborate on new work.

Emory's ongoing activist artwork takes on poverty, discrimination, imperialism, U.S. immigration policy, freedom for political prisoners, and the prison industrial complex, among other issues. His work and beliefs are not specifically about race—they are about justice, which would eliminate racism. Contrasting the fierce visual protests, Emory's personal humility is essential to his appeal. His visual and spoken activism on injustice peacefully coexists with respect and genuine concern for all people.

Currently, in addition to making new work, Emory uses computer software to repurpose his vintage drawings in a contemporary context, renewing the original calls to action. He also uses social media to communicate and collaborate worldwide with other artists and activists, extending the work he does on-site and in real time through his travels. His manifesto calls on artists to pay attention to craft, work hard and consistently, and stay focused.

He has an artistic second life as a freedom fighter without enduring much of the danger and scrutiny he survived as a leader of the Black Panther Party. If Emory Douglas did not create these provocative images decades ago, many artists who make work about immigration reform, Occupy Wall Street, marriage equality, and other important social issues would not have such a deep well of inspiration from the mid-twentieth century counterculture to draw from. Emory's purpose and work become more resonant and appreciated as time passes because they connect to an essential desire for humanity, justice, and visual truth. ●

**ABOVE**

March 9, 1969: "All Power to the People" was a slogan often used by
the Black Panther Party. The party brought many slogans into
popular use. Others included "Seize the Time," "Revolution in Our Lifetime,"
"Off the Pig!," and "Each One Teach One."

Danny Glover

# *PREFACE*

---

**W**hen you think of Emory Douglas, you think about his very warm and very gracious style. He's so unassuming, very quiet, almost borderline shy. The smile comes first before any words. It's hard to imagine that some of the images he was able to create became legendary and even iconic in some sense.

I remember those images. Sam Napier, the circulation manager of the *Black Panther* newspaper, and I used to eat breakfast all the time in a little restaurant on the corner of Ellis and Fillmore. Before the Panthers sold them, they would go and put them up on the walls of the community. They considered the community their gallery. In a sense it's an appropriate analogy. The images were images the community embraced. They were so right on and so appropriate for the struggle at hand at that time, and a sense of self-determination ensued from those images that Emory created.

When I think about it, there was a sense of immediacy in Emory's art. Of course, we're talking about using art in the most fundamental way of bringing people to a certain place, and in bringing them there, also defining and legitimizing the space that they're in. It's really fascinating from the standpoint of looking at art because it was not only his individual art, it was a collective art as well. That's what art should be—collective—and Emory's art represented a kind of collective energy.

I remember a rally at De Fremery Park and the civil rights leader Roy Wilkins had come out to speak. This was in 1968. The Panther Party had captured the imagination of black America and Roy Wilkins, a stalwart of integration at that particular point in time, realized

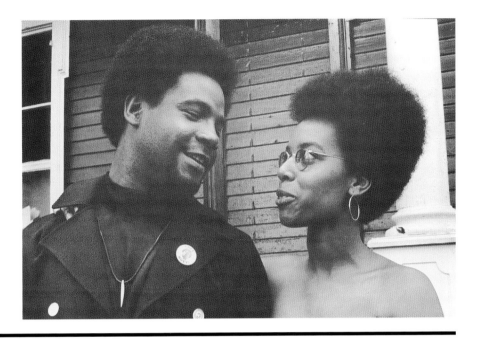

that his credibility was in question as well. At that rally, he and other people felt that they had a different expectation of themselves.

I believe that Emory's art in itself elicited a lot of different emotions among people. For example, his early artwork for the Black Panther Party in some sense defined policemen as pigs, and therefore the party newspaper had the graphic images of them as pigs. When you think about the very brutal response of the police to that expression, it substantiated the image itself.

So, when I think about those first images, I think on one hand, the characterization went along with the definition to a certain degree. But it was young people who were able to embrace those images in some sense, and once they embraced the images, then they had some level of credibility. And I think the credibility behind that was what I remember.

Of course, when you begin to use the words, "Off the Pig! Off the Pig!" they create another language. And the art itself supported the language that was created. So, the language became a part of the discourse. Now, if you're a policeman, what do you feel about that? There's the reaction of anger and hostility on one hand, but at the same time, how do you begin to question your role in the whole situation? Because the people you interact with have defined you through Emory's art.

Certainly the art and images that Emory Douglas created played a significant role in that whole process which in turn created a sense of empowerment and entitlement. We are all the better for it. ●

**ABOVE**
Emory Douglas, Minister of Culture and Revolutionary Artist for the Black
Panther Party, with Barbara Easley at Free Huey Rally,
Bobby Hutton Memorial Park (De Fremery Park), August 25, 1968.

Bobby Seale

# *FOREWORD*

Emory Douglas was there in our Black Panther Party's founding days in early 1967 at Eldridge Cleaver's Black House in San Francisco. Following a planning meeting in San Francisco about providing an armed escort for sister Betty Shabazz (Malcolm X's widow), Emory asked Huey Newton and me about joining our organization. But he didn't become involved in the party until a little later, when Huey and I agreed to make Eldridge Cleaver the Minister of Information. Cleaver immediately wanted Emory Douglas to work with him as the party's Revolutionary Artist. Emory said, right then, "OK, yeah, great! I'm joining the Black Panther Party for Self-Defense, right now, tonight." And I said, "Right on time!" Our conversation, at first, was about the layout I gave Emory for the *Black Panther* newspaper, Black Community News Service.

I founded our Black Panther Party newspaper, and, with "Big Man" Elbert Howard (who later became the Deputy Minster of Information) and L'il Bobby Hutton, we wrote, laid out, typed, and mimeographed one thousand copies of the *Black Panther* newspaper's very first issue. It was Emory who laid out the next issue to be printed on a roll press and on real newsprint. While I was interested in layout techniques and the need to get more photographs for future issues, Emory began to explain to me how we could use drawings and art, how we could insert lots of art that reflected our cause and the Ten-Point Platform and Program.

In the third issue, *before* we coined and popularized the term "pig" (in reference to "police who occupy our community like a foreign troop occupies territory"), Emory was the key in our urgent need to counter the "Support Your Local Police" campaign. Emory took a

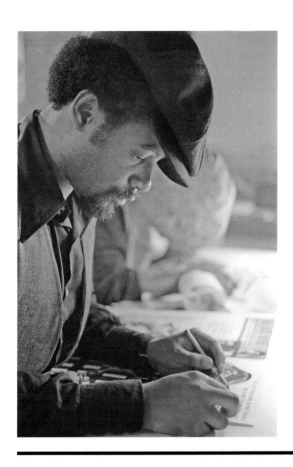

drawing of a four-legged, snout-nosed hog and drew on it a police cap, a star-shaped badge, and a police utility belt complete with a revolver. When he showed us the layout, we were all flabbergasted with Emory's artistic abilities. Huey, Eldridge, Bobby Hutton, Kathleen Cleaver, and I all praised Emory. Emory laid out the page with the drawing and captioned it, "Support Your Local Police." Eldridge wrote up the definition of a pig with Huey's, Emory's, and my contribution, which became synonymous with Emory's image of the police (or a politician giving orders) brutalizing people and violating peaceful protesters' constitutional rights. Explain to Emory your issue or problem, and before you know it, Emory has a caricature of it.

I later suggested that Emory be our Minister of Culture during my reorganization of the party following Huey Newton's arrest in October 1967 and my release from a six-month jail term for our protest at the California state capital. Right after I was arrested, it was Emory who became the party's spokesperson.

Emory understood clearly that at that time, the most important thing to hold on to in the midst of overt racist oppression was our revolutionary culture, which was about the need to give the people more economic, political, and social empowerment. With Emory Douglas as our political party's Minister of Culture, we thrived with realization that we could organize everybody. He was not only the dedicated Revolutionary Artist of our sixties' and seventies' protest movement era. Emory Douglas's artistic flavor was the revolutionary humanistic reflection of the sixties mood, our aspirations, and the demands for our

**ABOVE**
Emory Douglas at work.

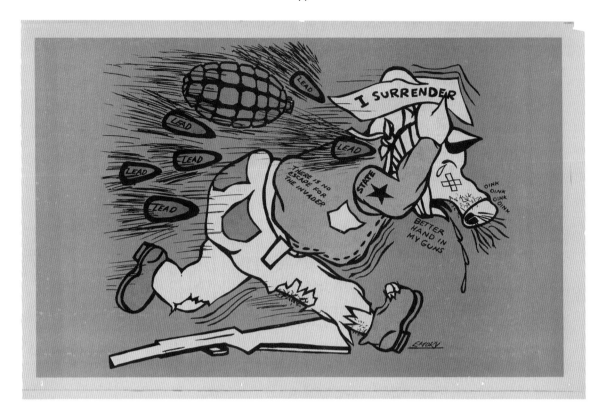

constitutional, democratic civil/human rights during the Black Panther Party's heyday, from spring 1967 to the late seventies.

With our Black Panther Party newspaper circulating more than four hundred thousand copies at its weekly peak, it was Emory's responsibility to get the weekly paper completed on time. It was largely Emory's images that communicated and helped the average protester and grassroots organizer define the phenomena of who and what our oppressors were. Emory's leadership and art further reminded us and called us to action to try and make that phenomena, those oppressors, act in a desired manner. There were weekly images of our daily struggle, our many court-room trials, the many community programs, my "Mayor of Oakland" campaign, and many representations of the social issues that plagued us. Art portraying the death of our party members. Images of Nixon and the avaricious politicians along with J. Edgar Hoover and the titans of corporate greed. Images of the people fighting back, defending themselves, and the deaths of some of those who wrongfully attacked our people. In many artistic images and with Emory's signature layout design, our newspaper showed me being chained, shackled, gagged, and brutalized in the court room of the great Chicago 8 conspiracy trial. All these images, together in this book, are the works that defined our Black Panther Party goals and objectives, as exemplified in our synergetic slogan, All power to all the people!

Power to the People, Right On!

Toward a Future World of Cooperational Humanism! ●

**ABOVE**

January 24, 1970: In this image, Douglas uses his trademark pig caricature to represent the atmosphere of social unrest and protest.

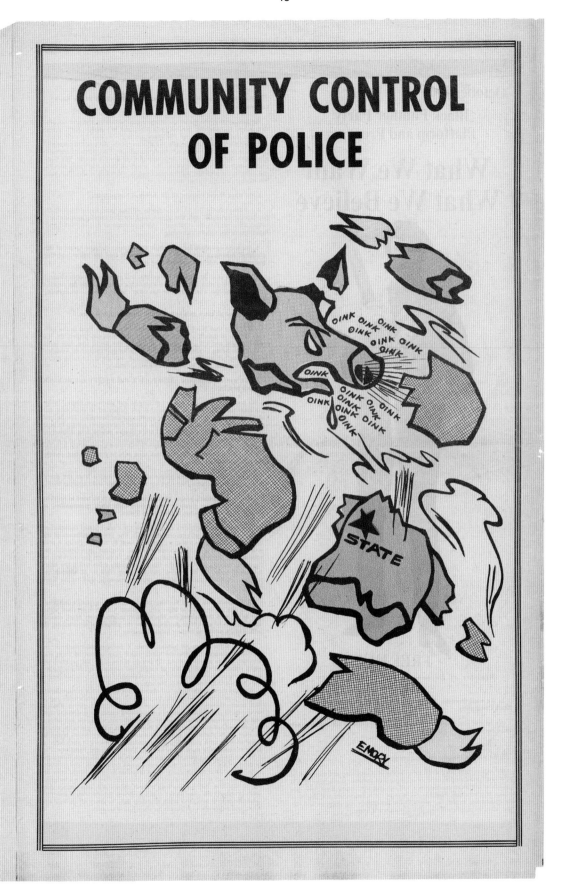

# COMMUNITY CONTROL OF POLICE

**February 7, 1970:** The pig caricature here is shown exploded into fragments, metaphorically illustrating people's frustration with police behavior in the black community.

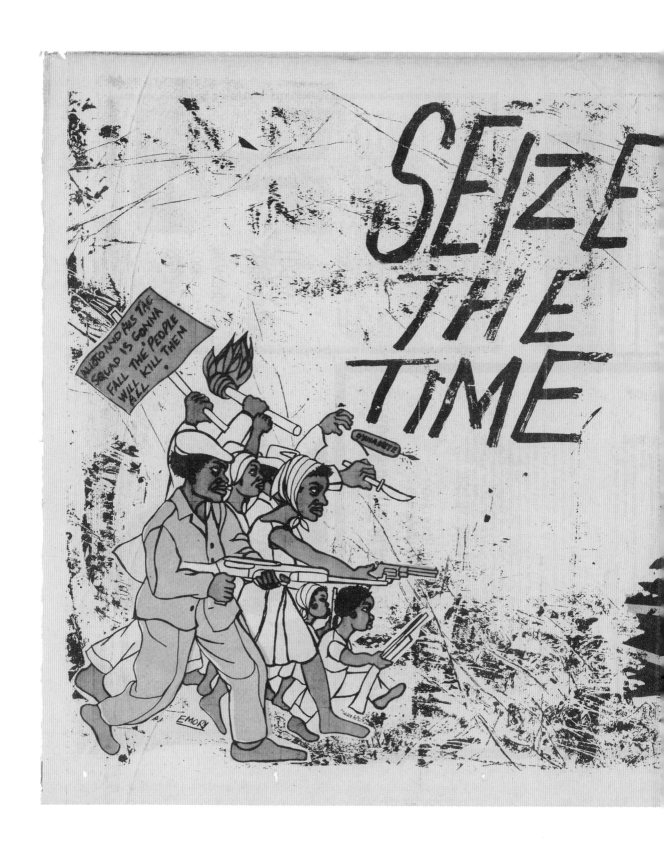

**September 27, 1969:** The protest sign in this image refers to San Francisco Mayor Joseph Alioto's newly formed military-style police unit now known as S.W.A.T.

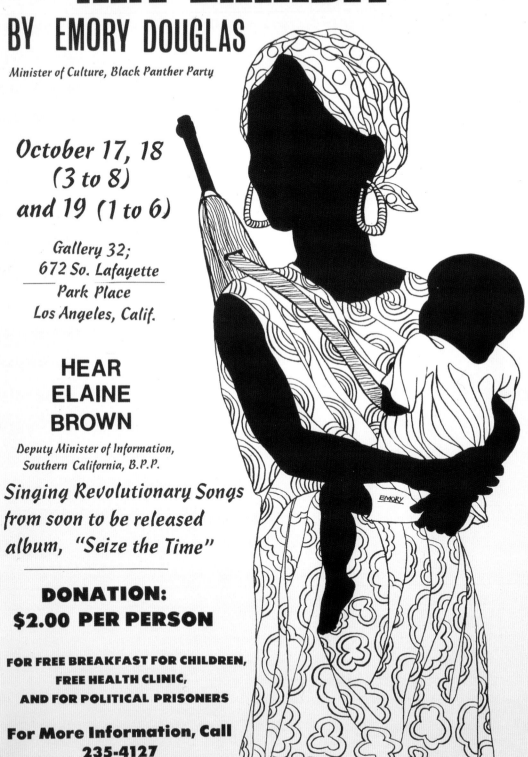

# SEE REVOLUTIONARY ART EXHIBIT

## BY EMORY DOUGLAS

*Minister of Culture, Black Panther Party*

October 17, 18
(3 to 8)
and 19 (1 to 6)

Gallery 32;
672 So. Lafayette
Park Place
Los Angeles, Calif.

**HEAR
ELAINE
BROWN**

*Deputy Minister of Information,
Southern California, B.P.P.*

Singing Revolutionary Songs
from soon to be released
album, "Seize the Time"

**DONATION:
$2.00 PER PERSON**

**FOR FREE BREAKFAST FOR CHILDREN,
FREE HEALTH CLINIC,
AND FOR POLITICAL PRISONERS**

**For More Information, Call
235-4127**

**1967:** The original drawing for this poster was made in 1966 before Douglas joined the Black Panther Party.
The Los Angeles chapter of the party organized this exhibition of Douglas's work. It was common for different
Panther chapters to put together events like this to fundraise for the party.

Sam Durant

# *INTRODUCTION*

---

**M**any of the images in this book may shock viewers coming to them for the first time. These images, some nearly forty years old, are still as powerful as when Emory Douglas first created them. They are dangerous pictures, and they were meant to change the world. Douglas was the Revolutionary Artist of the Black Panther Party and then became its Minister of Culture, part of the national leadership. Douglas created the overall design of the *Black Panther*, the party's weekly newspaper, and oversaw its layout and production until the party's demise in 1979–80. During this era Douglas made countless artworks, illustrations, and cartoons, which were reproduced in the paper and distributed as prints, posters, cards, and even sculptures. Following the party's credo of "each one teach one," he managed party cadre in the production of the paper, mentoring and inspiring dozens of artists to make revolutionary art that often appeared in the paper alongside his own. After the party dissolved in the early 1980s, Douglas continued working on various projects and producing new art. This book chronicles a wide selection of his work done while a member of the Black Panther Party.

As I was too young to have participated in the movements for social change in the 1960s, I know the history of the Black Panther Party primarily through historical documents: books, films, art, photography, and music. Like many younger readers coming to this book, my understanding has been formed by the accounts that are available: the writings, memoirs, and

autobiographies of the leaders like founder Bobby Seale, Minister of Defense Huey P. Newton, Chief of Staff David Hilliard, Minister of Information Eldridge Cleaver and Communications Secretary Kathleen Cleaver, along with the growing body of anthologies, collections, and compilations.[1] These texts, written by the participants in and witnesses to the movement, radically contradict the image of the Black Panthers as it was constructed by the mainstream media. If one were only to know the party through mainstream media accounts, one would think that they were violent terrorists bent on the armed overthrow of the government and the extermination of the white race. But as one learns the history of the party from those who made it, a very different reality takes shape.

Unlike the nonviolent methods advocated by many civil rights groups, the Black Panther Party was founded on the principle of self-defense "by any means necessary," including armed resistance.[2] In accordance with their constitutional right to bear arms, members carried guns and when attacked, were determined to return force with force. The early works Douglas made reflected this with depictions of armed revolutionaries and cari-

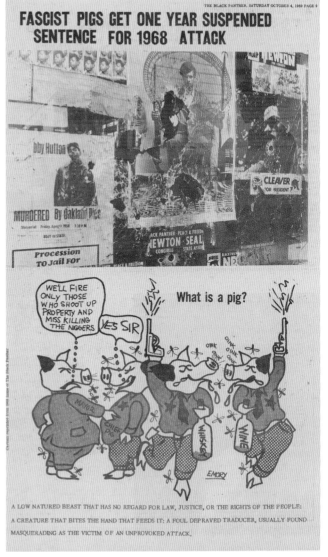

catures of the "oppressor": politicians, police, and the military. As an extension of the teachings and writings of Malcolm X and Frantz Fanon, these images were conceived to empower blacks to pursue their freedom by emphasizing that when violently oppressed, they had the right to defend themselves. The images inspired revolutionary consciousness and active resistance to racism and governmental abuse of power in the black community. Similar to the theories underpinning the revolutionary movement of Russian Constructivism, which included artists such as Aleksandr Rodchenko, Varvara Stepanova, and El Lissitsky, Douglas's work was direct and propagandistic in support of a specific agenda—it was not intended to incite violence or to urge people to literally go out and kill the police, but to provoke a new consciousness in the community. His work revealed the causes of oppression and most importantly, encouraged the self-empowerment necessary to bring about change.

**ABOVE**

October 4, 1969: The Oakland Black Panther Headquarters was shot up by police in 1968 after party leader Huey P. Newton was acquitted in the death of a police officer. The drawing below the photo also refers to the incident.

1 See the bibliography for a list of titles.
2 For sources on the history of the Black Panther Party, see the bibliography.

By 1968 the party's focus had shifted away from advocating armed resistance toward the development of social programs, electoral politics, and international coalition building. Free breakfasts for children, health clinics, food banks, ambulance service, transportation, and other social programs became a priority. (It's important to note that many of these programs, which were first initiated by the Panthers, have since been provided by the government.) Party members ran for local, state, and national offices and built alliances with a wide range of political groups. As the party changed, Douglas's artwork reflected the shift. By following the chronological progression of his work, it becomes clear that he produced a visual record of the party's development, reflecting the history of its struggle and its evolving mission.

The visual history of the Black Liberation Movements in America has often been confined to attributed and unattributed photographic documentation and anthologies of political graphics. This book constitutes a first: a monographic study of a single artist from this period of revolutionary political struggle in the United States. It is significant not for the purpose of elevating an individual artist's identity by separating and isolating it from a movement whose primary purpose was to create the *collective* empowerment of oppressed people. Rather this book recognizes Douglas's work precisely in its context and firmly *within* the history of the Black Power Movement and in relation to the field of contemporary art. With this in mind it becomes important to understand the political frameworks of these two "fields": that of revolutionary art in the context of the civil rights struggle and its historical exclusion from what Adrian Piper defines as the "Euroethnic" art world.[3] Douglas's work circulated outside of the art-world sanctioned venues of the gallery and museum in the pages of the *Black Panther* and on buildings, walls, windows, and telephone poles in communities around the world.

Douglas himself is quite ambivalent about receiving recognition for his work; his motivation is simply the desire to preserve a history that remains largely invisible and under constant threat of disappearance, erasure, and reversal. Douglas views his work as belonging not so much to him, but to the people for whom he has always worked. His interest today remains the same as when he first joined the Black Panther Party: the liberation and empowerment of oppressed people. He continues his dedication to the struggle for social justice, still working in support of jailed former party members and other political prisoners while continuing to work for African American newspapers.[4]

I met Emory Douglas in 2002 when he came to the Museum of Contemporary Art in Los Angeles to give a lecture. I was having an exhibition at the museum and asked them to invite him to do a presentation while my show was on view. I was surprised that he agreed and looked forward to meeting him, albeit with some trepidation. I was in the process of making artwork dealing with political and cultural subjects in African American history, including the Black Panther Party. I wasn't at all sure if I could or should do this kind of work, as it was taboo in the "Euroethnic" art world (among white liberals, anyway) for a white artist to do work about

3 "Through art education, criticism, exhibitions, and other practices and institutions devoted to preserving and disseminating what I shall refer to as *Euroethnic* art, the socioeconomic resources of this class of individuals enable its art practitioners to promulgate its fascinating but ethnocentric artifacts as High Culture on a universal scale. According to these shared criteria, then, those creative products that are dominated by a concern with political and social injustice or economic deprivation, or which use traditional or 'folk' media of expression, are often not only not 'good' art; but they are not art at all. They are rather 'craft,' 'folk art,' or 'popular culture'; and individuals for whom these concerns are dominant are correspondingly excluded from the art context." Adrian Piper, "Power Relations in the Existing Art Institutions," in *Out of Order, Out of Site: Vol. 2, Selected Writings in Art Criticism 1967–1992* (Cambridge, MA: The MIT Press, 1996), 65.

4 Douglas was instrumental in securing the release of Los Angeles Chapter leader Geronimo Ji Jaga (Pratt) in 1997 after serving twenty-seven years for a wrongful conviction.

black subjects. But this was at the time of the "post-black" debate, and I thought it might be a moment of possibility for a white artist to do work about American (black) history and the politics of race without it being another iteration of a white cultural producer appropriating and profiting from black culture.[5] Douglas's impending visit raised the stakes of my dilemma. I am still not entirely sure what he thought of my show. He seemed mildly amused, but at least he didn't appear to hate it.

After giving him a tour of my exhibition, he delivered an astonishing lecture on his work to a packed auditorium. Douglas was powerfully articulate in discussing his work and how it represented the ideology of the party and the struggle of the black community for political power. The response was overwhelming, and the audience was unusually diverse, one that I had never seen attending a museum lecture. There were artists and curators, of course, but there were also a large number of people not often found at a museum lecture: former Black Panthers, cultural and political activists, community members, and young people. It was clear that there was a wide and very interested audience for Douglas's work. After the lecture, during casual conversation I wondered aloud why there wasn't a book on his work, as there was obviously a huge interest in it. That was the beginning of the process that has resulted in this volume.

One of the most remarkable things about Douglas's artwork is how it reveals the rich and important history of the Black Panther Party in visual form. In order to examine his unique body of work, we have been fortunate to secure contributions to the book from first-hand sources, from Douglas's peers in the Movement along with significant offerings from younger, politically committed cultural producers. The remarkable essays in this book bring perspectives to the breadth of Douglas's work and career as well as to the movement in which he was a leader. I have been awed by their generosity and commitment to this project, as is amply reflected in the quality of their contributions.

During breaks in her incredibly busy schedule of prison visits, international lecturing, organizing, teaching, writing, and editing—all in the service of a lifelong campaign for social justice—Kathleen Cleaver has provided a riveting essay written in the style of a memoir about her life and time with Douglas. As the Communications Secretary of the Black Panther Party she came to know Douglas very well. Her elegant prose documents the breakneck pace of their lives and work on a multitude of party activities and travels and concludes by recounting the story of their involvement in the 1969 Pan-African Cultural Festival in Algiers.

Cultural activist and former member of I Wor Kuen, Greg Jung Morozumi has been working with Douglas for many years.[6] He has been a political organizer and cultural worker for decades, producing scores of exhibitions, events, and publications. In 1997 Morozumi helped curate a comprehensive exhibition of Douglas's work. He was also responsible for the Black Panther Party retrospective, *Power to the People*, in San Francisco in 2004 where Douglas's work was the central focus. In his essay here, Morozumi offers a skillful mapping of the connections between the Black Panthers and Third World liberation groups like the Brown Berets,

5 According to Thelma Golden, "post-black" is a shorthand phrase for "post-black art," a term she and Glenn Ligon seriously and ironically employed to identify work by an emerging generation of black artists who were "adamant about not being labeled as 'black' artists, though their work was steeped, in fact deeply interested, in redefining complex notions of blackness." "Introduction," in *Freestyle* (New York: The Studio Museum in Harlem, 2001), 14–15.

6 I Wor Kuen (translated from Cantonese as "Righteous Harmonious Fist," after the anti-imperialist peasant insurgents of the Boxer Rebellion) was a national Asian revolutionary organization that encompassed the Red Guard Party of San Francisco's Chinatown in the early 1970s and was closely allied with the Black Panthers.

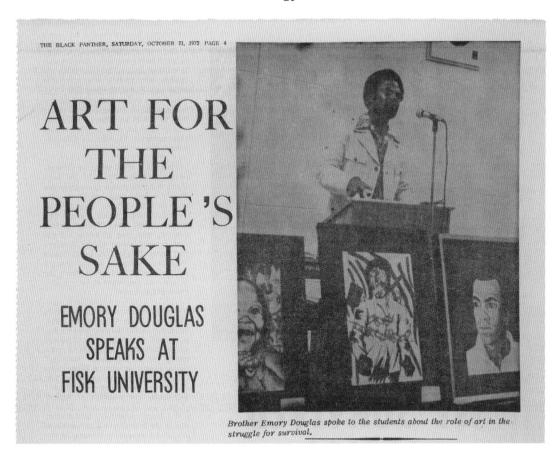

THE BLACK PANTHER, SATURDAY, OCTOBER 21, 1972 PAGE 4

# ART FOR THE PEOPLE'S SAKE

## EMORY DOUGLAS SPEAKS AT FISK UNIVERSITY

*Brother Emory Douglas spoke to the students about the role of art in the struggle for survival.*

the Young Lords, and I Wor Kuen. He positions Douglas's work in relation to Frantz Fanon's influence on the party's ideology. His essay frames the black liberation struggle as historically linked to global anticolonial struggles, as well as outlining the significance of Malcolm X and Robert Williams to the party's militant stance.

Multimedia artist and theorist Colette Gaiter's thorough explication of Douglas's work and its historical precedents also details its connection with global anticolonial struggles as well as linking it to young political artists working today. Gaiter has been researching and writing on African American graphic designers for nearly fifteen years and is working on a documentary on Douglas. In her essay, she shows how his work illustrates the changing ideology of the party as it moves from a focus on guns and armed resistance to a concentration on social programs and electoral politics. Gaiter deftly contextualizes Douglas's work both art historically and within the history of revolutionary graphics and design, while offering a thoughtful exegesis of the various elements that comprised Douglas's signature style.

Former Poet Laureate of the state of New Jersey, Amiri Baraka is one of America's greatest living writers. Baraka is also a committed activist, devoting his life to the struggle for social justice and freedom for oppressed people. Baraka's energetic essay chronicles his first meeting with Douglas through the Black Communications Project at San Francisco State University

**ABOVE**

October 21, 1972: Douglas lectured on revolutionary art during
his exhibition at Fisk University in Nashville, Tennessee.
He lectured and did interviews nationally and occasionally internationally
while in the party.

in 1967. Exploring the virtually unknown history of this groundbreaking program, he reveals that Douglas produced the stage sets used in the theatrical productions by the BCP playwrights. Baraka, a founder of the Black Arts Movement, explains the split among cultural producers along ideological lines in the mid-1960s, which unfortunately prevented Douglas from continuing his work with artists who had conflicts with the party.

The legendary poet Sonia Sanchez has graciously allowed us to reprint one of her seminal works from the period. Part of the Black Arts Movement, Sanchez met Douglas in San Francisco, and later he did the cover illustration for Sanchez's first book, *Home Coming*. While teaching at San Francisco State in the 1960s, she was instrumental in the development of the first Black Studies Program. Her poetry was some of the most militant of the time, revealing a deep commitment to black liberation. She has published over a dozen volumes of poetry as well as numerous plays and children's books. Sanchez's poignant and uncompromising work has made her one of the nation's most significant poets.

One of America's foremost documentary filmmakers, St. Clair Bourne conducted an interview with Douglas especially for this volume. He has produced over forty-five films in the last thirty years, among them profiles of Amiri Baraka, Langston Hughes, and Paul Robeson. Bourne's clear understanding of the period and his generous support has contributed immeasurably to the completion of this volume. The discussion here is centered on Douglas's artwork

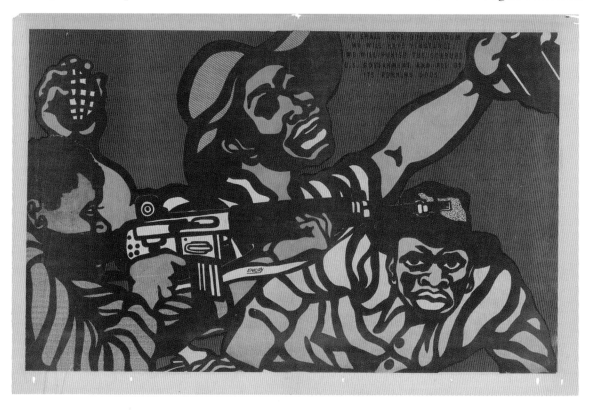

**ABOVE**
October 17, 1970: A collage of three earlier drawings (see pages 72 and 128), a technique that Douglas often employed.

and career as a cultural producer. Bourne elicits new biographical information, as well as fascinating details of Douglas's working methodology and inspiration.

As the writers in this volume consider Douglas's extraordinary legacy and his critical contribution to both the party and the field of revolutionary artistic production, his work should be understood in relation to several historical traditions. In his art, there are echoes of the antiestablishment satire of Honoré Daumier, William Hogarth's depictions of bourgeois corruption and working-class oppression, and the antifascist collages of Käthe Kollwitz and John Heartfield. Douglas's scathing depictions of corrupt politicians and greedy businessmen as pigs and rats resonate with George Grosz's grotesque caricatures. The dynamic exhortations for a proletarian utopia by Russian artists after the 1917 Revolution come to mind as well. American artists Charles White, Ruth Waddy, Sargent Johnson, and Elizabeth Catlett, artists whom Douglas admired, create yet another context in which his work can be placed. Third World artists, such as Mexican graphic artists José Guadalupe Posada and Manuel Manilla, and the many artists responsible for the political posters from China, Viet Nam, and Africa inspired and informed Douglas's work. The artists of the graphic arts collectives from post-revolution Cuba both influenced and were influenced by Douglas.[7]

Douglas's life and work exemplifies Walter Benjamin's call for artists' work not to simply serve the revolution, but to actively produce it. Benjamin argued that artists are not autonomous, that their artwork always serves a political interest, and that the artist must choose those interests:

> ... the present social situation compels [the writer] to decide in whose service he is to place his activity. The bourgeois writer of entertainment literature does not acknowledge this choice .... A more advanced type of writer does recognize this choice. His decision, made on the basis of a class struggle, is to side with the proletariat. That puts an end to his autonomy. His activity is now decided by what is useful to the proletariat in the class struggle.[8]

Benjamin continues on with descriptions of what the author as active participant in the revolution should do, work that almost verbatim describes the cultural activities of the Black Panther Party.[9]

Douglas shows us what it means to be a politically committed artist. His contribution to the party's work and the dedication of his life to the struggle for social justice is defiantly and joyously revealed in his extraordinary body of work. In the opinion of this artist, Emory Douglas is among the most significant American artists of our time who has yet to be adequately acknowledged, and this book will enable others to consider his remarkable contribution to our culture. ●

---

7 See Lincoln Cushing, *¡Revolución! Cuban Poster Art* (San Francisco: Chronicle Books, 2003).

8 Walter Benjamin, "The Author as Producer" in *Reflections* (New York: Schocken Books, 1986), 220.

9 Benjamin cites the Russian writer Sergei Tretiakov as a great example of the author as producer. Tretiakov went to rural peasant communities after the Russian Revolution and "... set about the following tasks: calling mass meetings; collecting funds to pay for tractors; persuading independent peasants to enter the *kolkhoz* (collective farm); inspecting the reading rooms; creating wall newspapers and editing the *kolkhoz* newspaper; reporting for Moscow newspapers; introducing radio and mobile movie houses, etc." Ibid., 223.

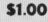

**1969:** Poet, writer, and Black Arts Movement activist Sonia Sanchez asked Douglas to illustrate the cover of her first collection of poems.

# definition for blk/children

a policeman
             is a pig
and he shd be in
             a zoo
with all the other piggy
                 animals.     and
until he stops
     killing blk/people
cracking  open  their  heads
remember.
          the policeman
     is a pig.
             (oink/
                 oink.)

—Sonia Sanchez

# What Is A Pig?

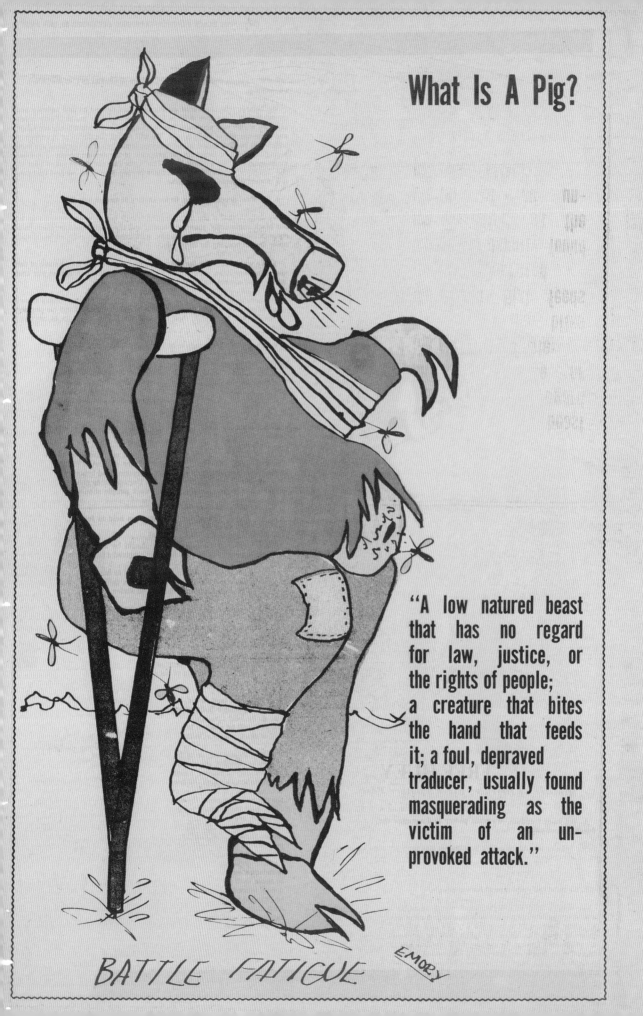

"A low natured beast that has no regard for law, justice, or the rights of people; a creature that bites the hand that feeds it; a foul, depraved traducer, usually found masquerading as the victim of an unprovoked attack."

BATTLE FATIGUE

EMORY

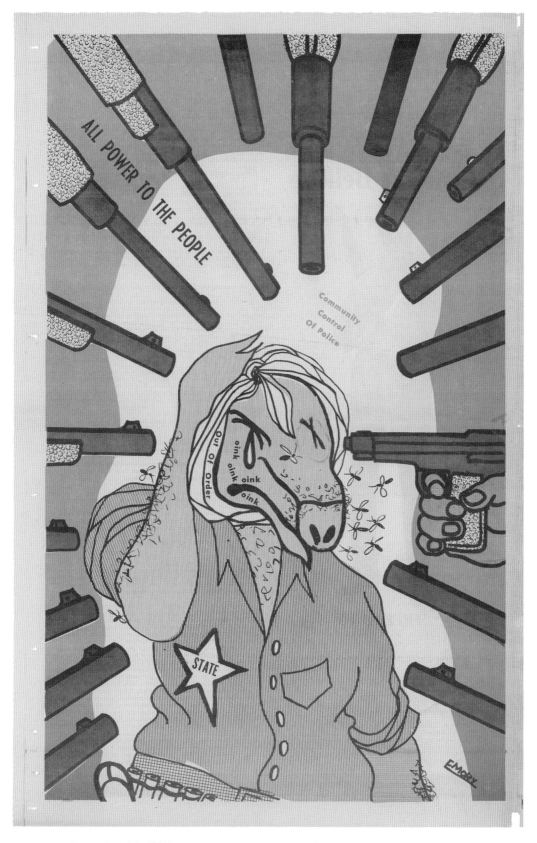

*Opposite page* **December 20, 1967:** Responding to the characterization of the police as pigs
by Black Panther Party leaders Huey P. Newton and Bobby Seale, Douglas developed a variety
of iconic caricatures to represent abusive police, the military, and other oppressors.

**October 18, 1969:** Community control of the police was a founding principle of the Black Panther Party,
as explained in point number seven of the Ten-Point Platform and Program (see page 104).

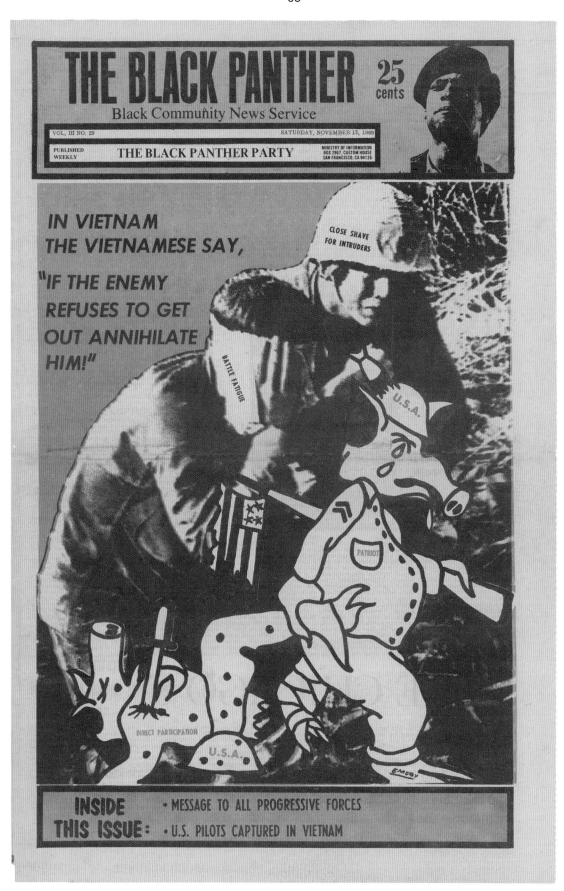

**November 15, 1969:** The *Black Panther* newspaper contained local and international news, and the Viet Nam War was frequently covered—and harshly criticized. Huey P. Newton, the party's chief theoretician, believed that domestic state violence was inseparable from American aggression abroad.

# THE BLACK PANTHER

25 cents

Black Community News Service

VOL. IV NO. 25 & 26      SATURDAY, MAY 31, 1970

PUBLISHED WEEKLY      **THE BLACK PANTHER PARTY**      MINISTRY OF INFORMATION BOX 2967, CUSTOM HOUSE SAN FRANCISCO, CA 94126

# BABYLON

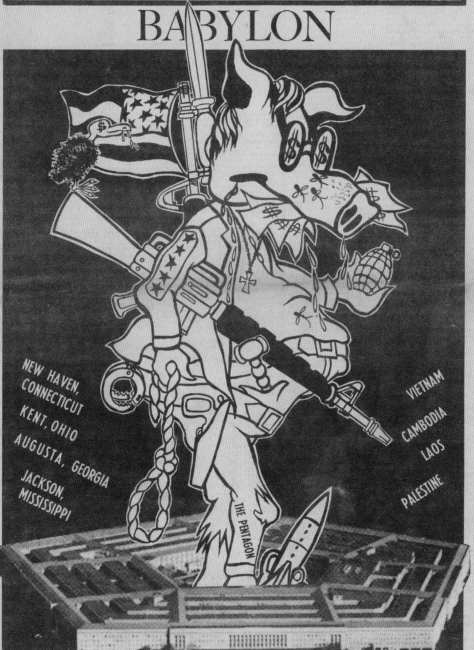

The Pentagon By Eldridge Cleaver Story Page 14

# THE BLACK PANTHER

### Black Community News Service

**25 cents**

VOL. IV NO. 16 — SATURDAY, MARCH 21, 1970

PUBLISHED WEEKLY

## THE BLACK PANTHER PARTY

MINISTRY OF INFORMATION
BOX 2967, CUSTOM HOUSE
SAN FRANCISCO, CA 94126

# IMPERIALISTS

*All this proves even more clearly that U.S. imperialism is the most barbarous and shameless aggressor of modern times, the main force of aggression and war, the chieftain of world reaction, the bulwark of modern colonialism, the strangler of the national liberation and independence, and the disturber of world peace.*

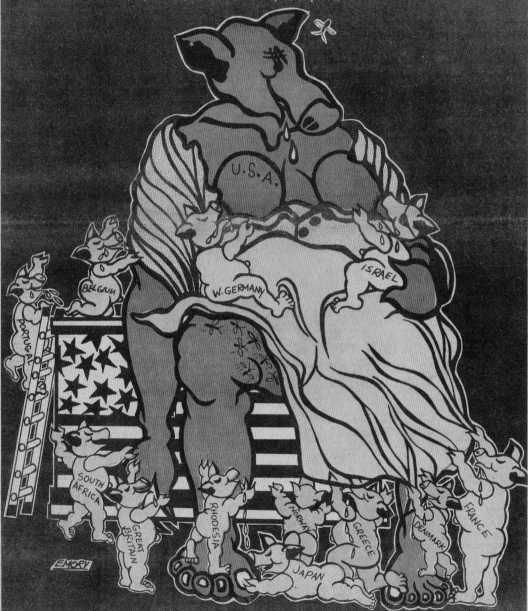

**INSIDE:** Interview With Chairman Bobby

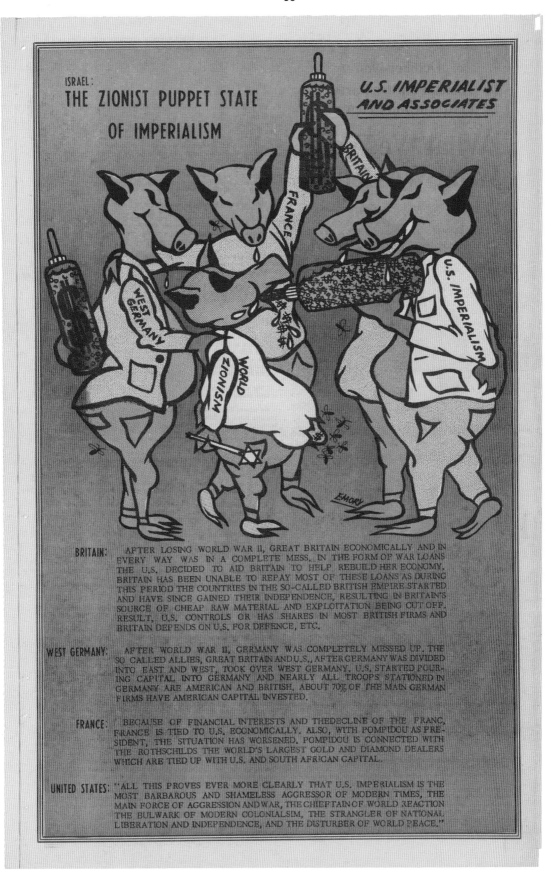

*Opposite page* **March 21, 1970:** This drawing was done while Douglas was in Algiers, Algeria.
Eldridge Cleaver presented it to the local paper where it was first published.

**April 11, 1970**

## IT'S ALL THE SAME

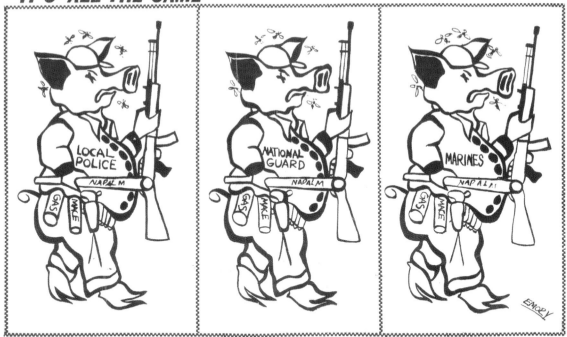

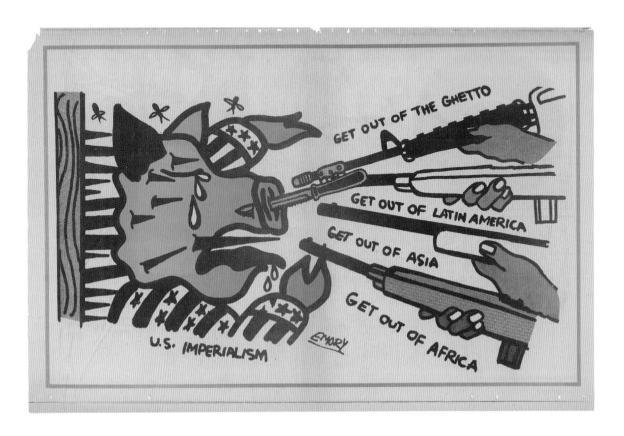

Top **September 28, 1968**                    Bottom **January 3, 1970**

# bootlickers

Her back faces to Harlem.

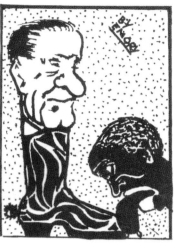

# gallery

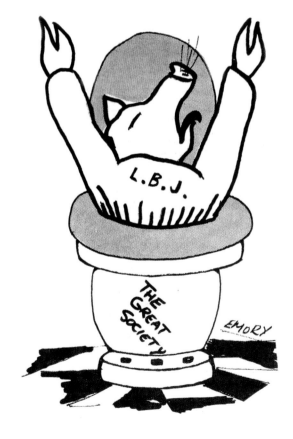

*Top* **Circa 1968:** Douglas's scathing depictions of government officials extended to black leaders who supported policies detrimental to their constituents. These leading figures were satirized not for their personalities but for their positions on specific issues.

*Bottom* **October 12, 1968:** This image satirizes President Lyndon B. Johnson's lip service to Great Society social programs.

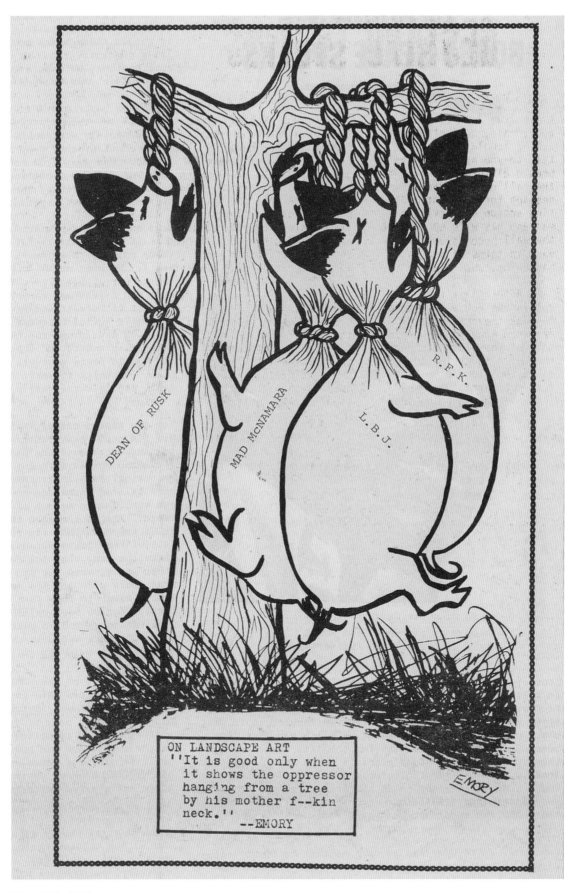

**March 16, 1968:** This image refers to President Johnson's cabinet members: Secretary of State
Dean Rusk, Secretary of Defense Robert McNamara, and Attorney General Robert F. Kennedy.
The caption reflects the Black Panther Party's ideological position on the role of art in the revolution.

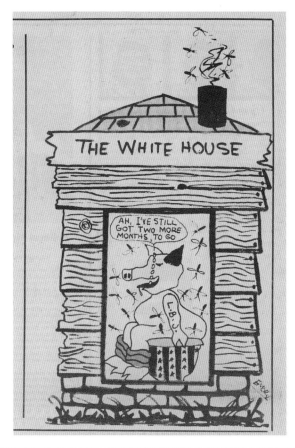

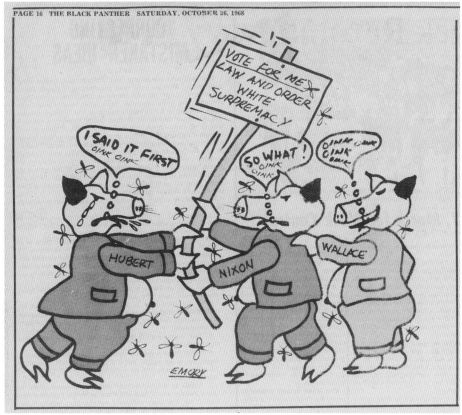

*Bottom* **October 26, 1968:** Lyndon B. Johnson declined to run for reelection in 1968. Less than a month after this image was printed, Richard Nixon defeated the Democratic nominee Hubert Humphrey in the presidential election.

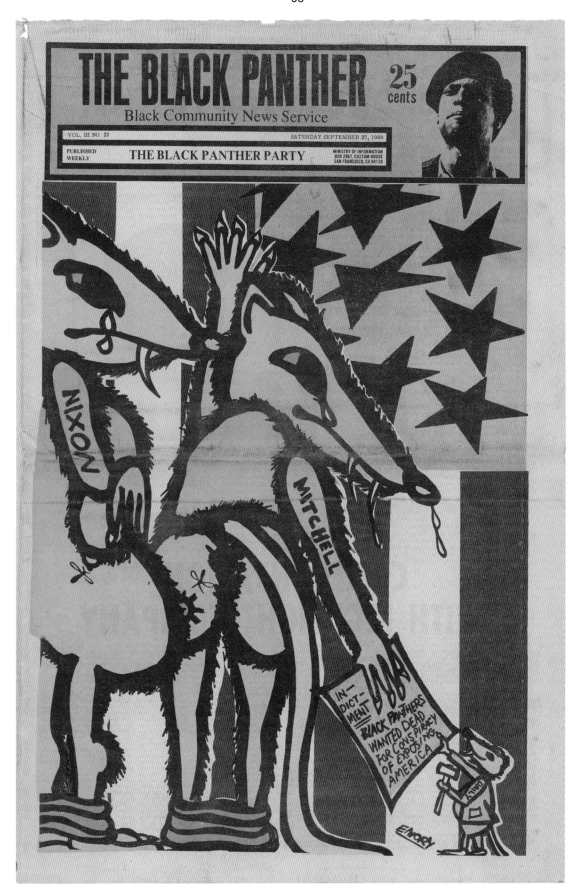

**September 27, 1969:** After the riots in Chicago during the 1968 Democratic National Convention, it became
clear that Mayor Richard Daley was involved in the suppression of progressive organizations. The Chicago 8 conspiracy
trial was an example in which progressive leaders were charged with inciting the riots that the police actually provoked.

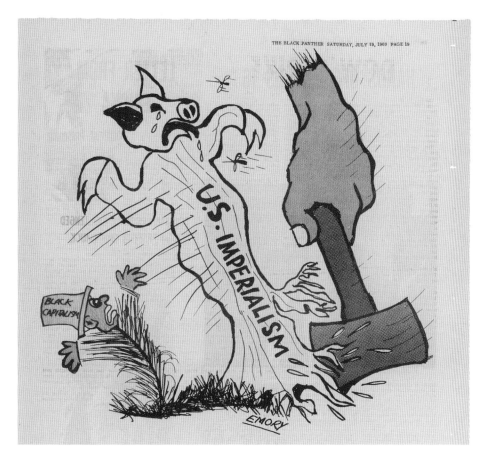

*Top* **July 19, 1969**

*Bottom* **July 19, 1969:** The recently coined term, black capitalism, is shown here in league with U.S. imperialism, revealing that both have the same exploitative practices and goals.

# 'WHATEVER IS GOOD FOR THE OPPRESSOR HAS GOT TO BE BAD FOR US'

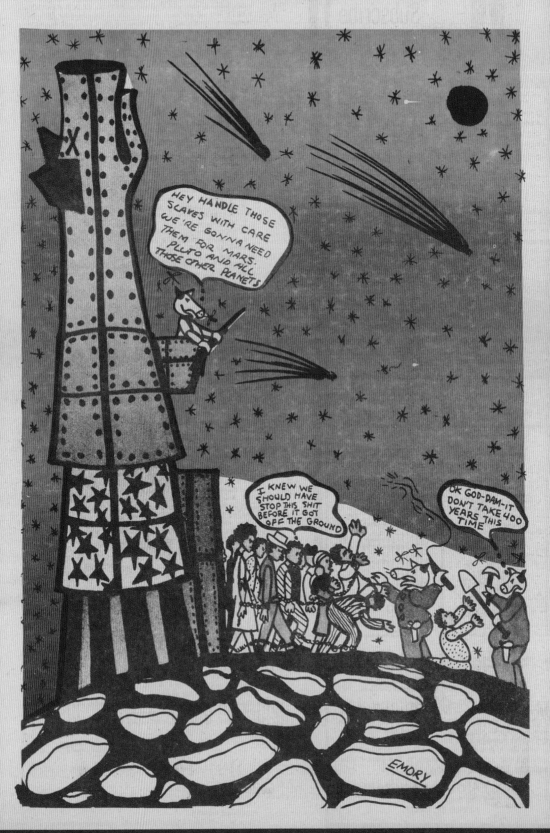

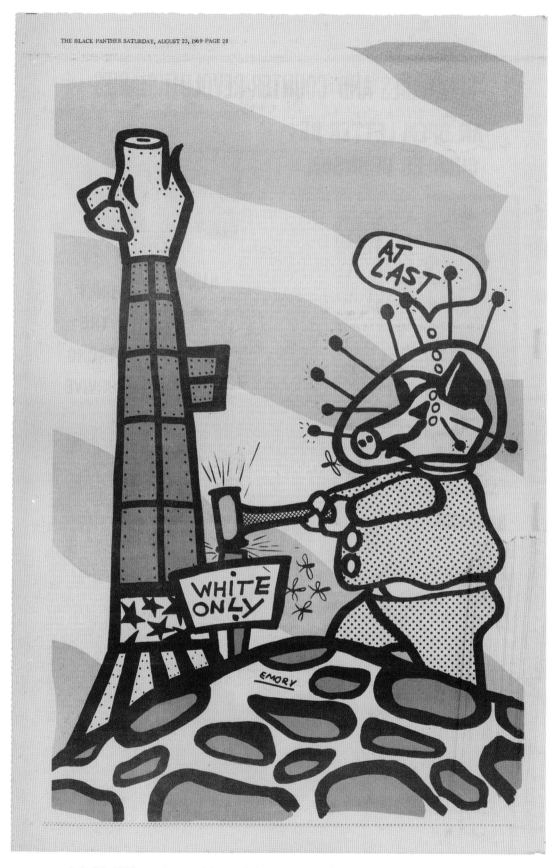

THE BLACK PANTHER SATURDAY, AUGUST 23, 1969 PAGE 28

*Opposite page* **July 26, 1969:** Douglas responded to the idealistic rhetoric around space exploration around the time of the *Apollo 11* moon landing. In this work, he predicts how racism and oppression could continue in America's new frontier, outer space.

**August 23, 1969**

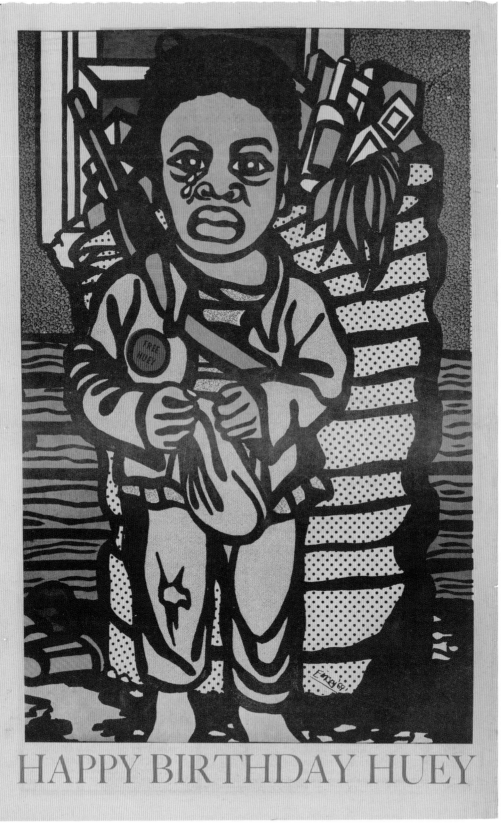

# HAPPY BIRTHDAY HUEY

**February 17, 1969:** Birthday wishes for Huey P. Newton while he was incarcerated served to keep the community focused on his legal case. Because of efforts by law enforcement to eliminate the party's leadership, Newton was often in jail.

*Opposite page* **June 7, 1969:** In April 1969, the New York Police Department conducted a predawn raid, arresting the "Panther 21" and charging them with conspiracy to bomb several buildings in New York City. More than three years later, all twenty-one Panthers were acquitted of all charges in only forty-five minutes of jury deliberation.

# THE BLACK PANTHER

## Black Community News Service

25 cents

VOL. III NO. 7      SATURDAY   JUNE 7, 1969

PUBLISHED WEEKLY     **THE BLACK PANTHER PARTY**     MINISTRY OF INFORMATION
BOX 2967, CUSTOM HOUSE
SAN FRANCISCO, CA 94126

# FREE THE NY 21

## AND ALL POLITICAL PRISONERS

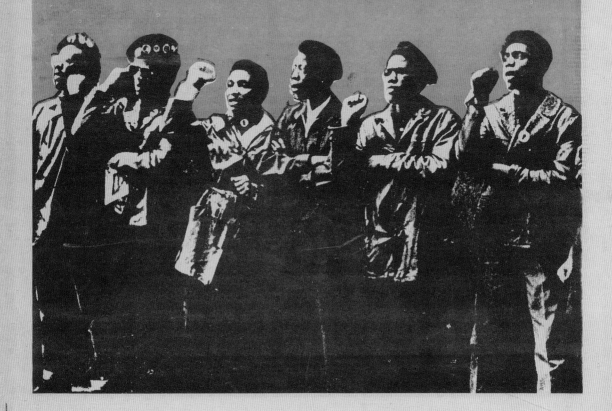

# THE BLACK PANTHER

### Black Community News Service

**25 cents**

SATURDAY AUGUST 30, 1969          VOL. III, NO. 19

PUBLISHED WEEKLY          THE BLACK PANTHER PARTY          MINISTRY OF INFORMATION
BOX 2967, CUSTOM HOUSE
SAN FRANCISCO, CA 94126

# KIDNAPPED

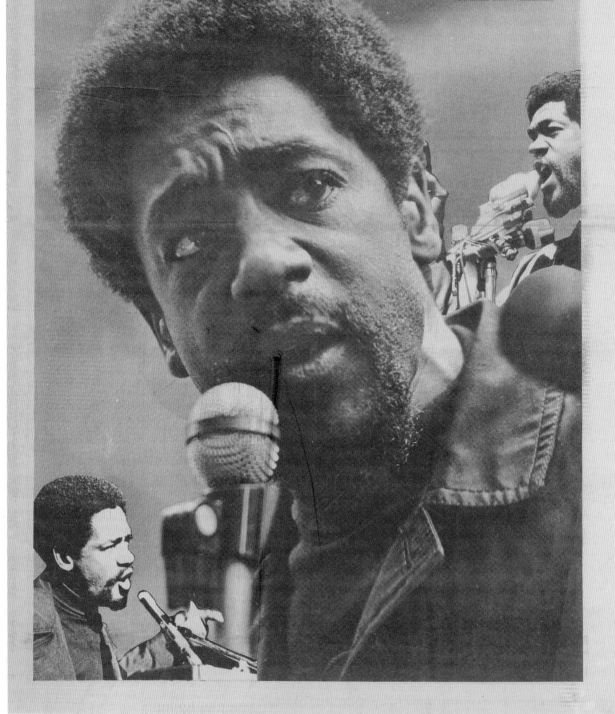

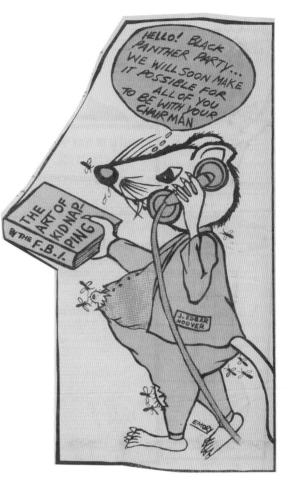

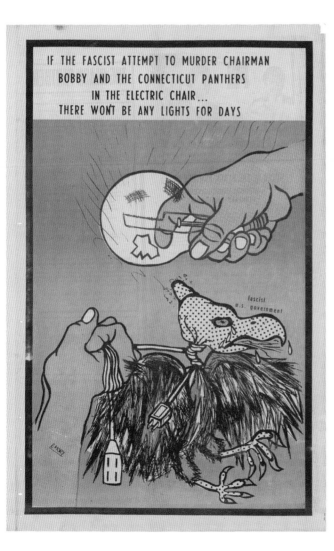

*Opposite page* **August 30, 1969:** In 1969, Bobby Seale was
taken into custody in Berkeley, California, by federal agents and
transported to Chicago to stand trial in what became known as the
Chicago 8 conspiracy trial.

*Left* **April 6, 1970:** In the government's repeated attempts to destroy
the Black Panther Party, Bobby Seale was again falsely charged, this time
with the murder of police informant Alex Rackley, in the New Haven
Black Panther trials.

*Right* **August 30, 1969:** J. Edgar Hoover instituted the
controversial COINTELPRO (Counter Intelligence Program)
which sought to destroy the Black Panther Party and other radical
groups. The speech bubble refers to party Chairman Bobby Seale.

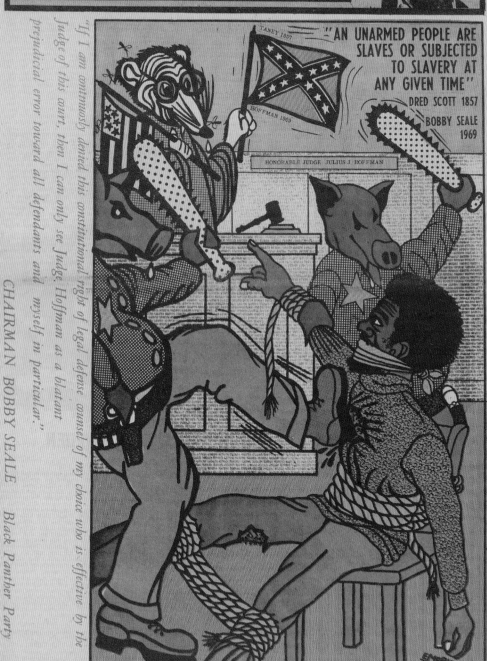

**November 8, 1969:** Bobby Seale became the first defendant in a U.S. courtroom
to be bound and gagged for demanding the right to self-representation.

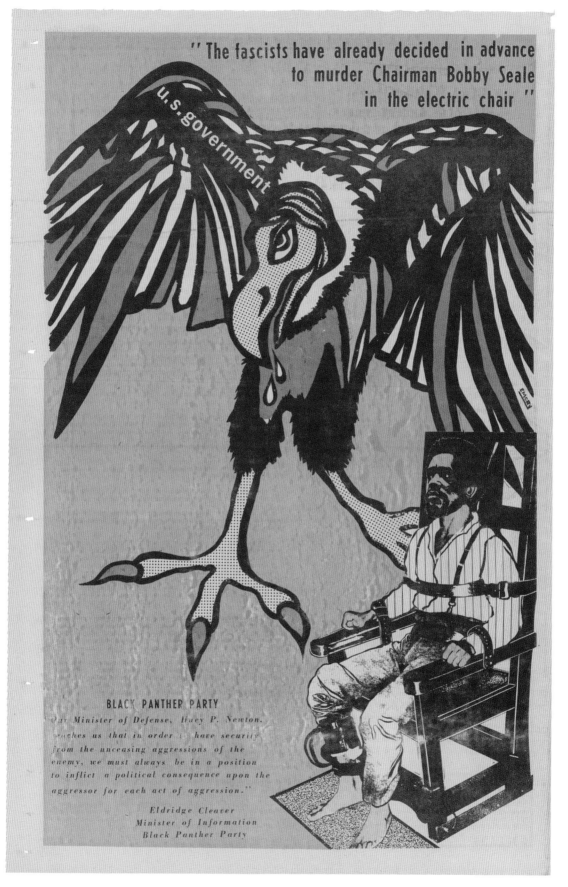

" The fascists have already decided in advance to murder Chairman Bobby Seale in the electric chair "

BLACK PANTHER PARTY

Our Minister of Defense, Huey P. Newton, teaches us that in order to have security from the unceasing aggressions of the enemy, we must always be in a position to inflict a political consequence upon the aggressor for each act of aggression."

Eldridge Cleaver
Minister of Information
Black Panther Party

**March 15, 1970:** Bobby Seale is shown here strapped to an electric chair, indicating that he was facing the death penalty in the New Haven Black Panther trials. Seale credits this image with helping save his life.

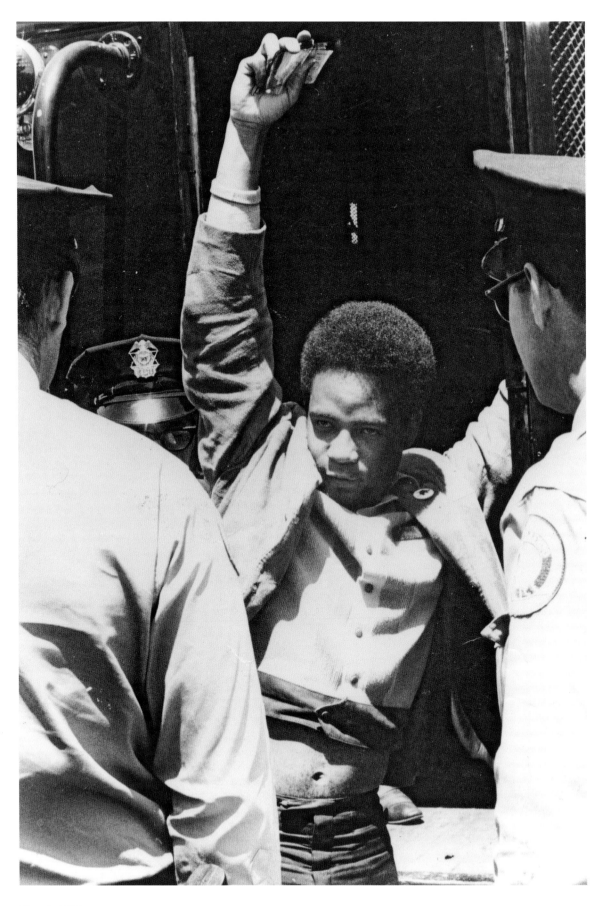

**May 2, 1967:** Douglas being arrested after protesting the Mulford Bill at the California State Capitol in Sacramento. This bill, also known as the Panther Bill, made it illegal to openly carry weapons.

# A PICTURE IS WORTH A THOUSAND WORDS

## MAY 1967

**ON THE NEWS FILM** the grey-and-black image of Emory Douglas shows a brown-skinned young man wearing a sports jacket, his Afro neatly trimmed, walking among the group of Black Panthers being arrested at the state capitol in Sacramento, California. The defiant way he turns on his heel, tilts his head back, and strides towards the van to be handcuffed conveys his pride in taking part in the confrontation. News cameras were rolling that May 2, 1967 when thirty Black Panthers led by Chairman Bobby Seale rode to Sacramento to contest the proposed Mulford Bill—called the "Panther Bill"—introduced at the urging of the Oakland police. They wanted to put an end to the open and legal carrying of weapons during the Black Panthers' patrols on the Oakland streets. At the capitol, Seale read to the press Defense Minister Huey Newton's Executive Mandate denouncing the legislation, which insisted that the second amendment to the Constitution guaranteed the right to bear arms. Then, he led a disciplined phalanx of armed "black militants" inside the floor of the California state legislature, where pandemonium erupted. Sensational coverage portraying the event as an "invasion" spread the news around the world. On that day, Emory Douglas stepped into history, and during the ensuing Black Power years, created bold artwork that consistently influenced and mirrored the deep transformations being experienced by his generation.

That May 2, 1967, the writer Eldridge Cleaver, wearing a black leather jacket and a black beret, was also arrested in Sacramento. His lawyer was able to demonstrate that he was covering the demonstration on assignment from *Ramparts* magazine and had merely held a camera. Cleaver's association with the Black Panthers was not yet public and, fortunately, the news film helped get the charges filed against him for carrying a weapon—a serious violation of his parole that could have landed him back in prison for the next four years—thrown out. After

famous writers had mounted a campaign to secure Cleaver's release from prison based on his literary talent, he'd settled in San Francisco, but the prison officials continued to view him as a threat due to his identification with Malcolm X and kept him under strict surveillance. In Sacramento, he had a close call.

I was in a state of shock when I first learned he was jailed, thinking I would never see him again. Only a month earlier, I'd met Eldridge when he came to speak at a black student conference organized in Nashville, Tennessee, by the Student Nonviolent Coordinating Committee (SNCC), the civil rights organization I'd dropped out of college to join the summer before. He had remained in town after the weekend conference ended to work on a magazine article and get to know SNCC better. By the time he'd returned to California in April, we had fallen madly in love.

## JULY 1967

We kept our love blossoming with frequent long distance telephone calls between Atlanta, where I worked at SNCC's headquarters, and San Francisco, where Eldridge lived. That July, when hippies from around the world flocked into the Haight-Ashbury District to experience San Francisco's "summer of love," I flew there to visit Eldridge. All of us involved in the Movement knew our activities were being tracked by the police and FBI, but that reality was not something I kept at the forefront of my mind—and that summer I was unaware of how closely my activities were being recorded. Later, it was revealed that the Black Panther who drove Eldridge to the airport to pick me up was in fact a covert informant. Lively discussions among members of the Black Panther Party and other activists Eldridge knew took place regularly in his studio apartment overlooking DuBoce Park, which was also the place where he edited the *Black Panther* newspaper after work. Although the letterhead stated that the Minister of Information was "underground," Eldridge held that position. At his place, conversations and strategy sessions cropped up spontaneously; folks would drop by to bring him articles, a *Ramparts* magazine secretary would show up to type columns, and Bobby Seale set up a layout table for the paper. Emory designed the paper's masthead, made drawings to accompany articles, and collaborated closely with Eldridge on getting the paper ready to take to the printer. That's how Emory and I first met.

He had a quick smile, a soft voice, and a light in his dark brown eyes that made you notice him. He dressed carefully, in a low-key style, and usually had a pocket full of hard candy, wrapped in cellophane paper. He would always ask, "You want some candy?" so I began thinking of him as the candy man. Most of the Panthers

who came to Eldridge's place smoked cigarettes—Kool was the favorite brand— but I don't recall seeing Emory smoke. During that intoxicating summer visit to the Bay Area, hardly any of the people I met at Eldridge's apartment had been born in California, and Emory was no exception. When he was very young, he'd moved to San Francisco with his mother from Michigan, and they lived in a flat at the corner of Divisadero and Haight Streets, a few blocks down the hill from Eldridge's place at 42 Castro Street. We saw him frequently. More of a listener than one of the talkative crowd that gathered in Eldridge's apartment, Emory's own intensity came out in his drawings. As people talked, he would quietly smile or chuckle to himself, then turn to his sketch pad where the anger or insight he'd heard would be captured in an image. His drawings gave visible form to the bold ideas of revolution we were kicking around those days.

The level of anger and resentment over police brutality, intimidation, and the repeated murders of young black men was rising to a volatile flash point in crowded urban neighborhoods across the country, including the liberal San Francisco Bay Area. Ghetto riots and mass uprisings were breaking out more and more frequently; National Guard troops were being regularly called up to restore law and order after the local police forces were overwhelmed. SNCC's charismatic chairman Stokely Carmichael had launched the call for Black Power! during the summer of 1966 from the heart of the southern protests against racist terrorism and segregation. Its impact was immediate. Young leaders like Bobby Seale and Huey Newton spoke to blacks in tones inflected with the fire of burning ghettos, which appealed directly to each of us infuriated by the racist mobs who beat peaceful black demonstrators, by the murders of civil rights leaders, and by seeing our friends and classmates shipped off to die in Viet Nam. Black Power! ignited a passionate impulse to act in the hearts of black youth everywhere; it hit a psychic fault line, shattering familiar boundaries of black submission and white authority and triggering an explosion of black pride, freedom, and love. In the San Francisco Bay Area, Emory joined the Black Panther Party for Self-Defense that Newton and Seale had started. His unique renderings of pigs dressed in police uniforms became a distinctive feature of their party newspaper—a visual counterpart to the printed denunciations of police violence and racist abuse. We all shared the poet Derek Walcott's feeling—"how could I face such slaughter and be cool?"[1]

On July 12, while we were working on the paper in Eldridge's apartment, Newark exploded in the wake of a police killing of a young boy. We saw the spontaneous uprising as the early sparks of the coming revolutionary conflagration. Crowds of black people ripped through the city's streets, breaking store windows and looting, setting fire to buildings, fighting police, shooting and dying. Twenty-six people were killed and over a thousand were arrested. We squeezed the story onto the front page of the *Black Panther*, which was ready to take to the printer. LeRoi Jones (now Amiri Baraka), the celebrated black playwright and poet who lived in Newark, had written about such violence; his arrest during the confrontation made the events even closer to us, since he had visited the Bay Area and met several of the Black Panthers. Emory made a bold drawing of him, showing his head and shoulders, a scowl on his face, with his chin resting on his hand, to capture that rage that had erupted in Newark.

1 Derek Walcott, "A Far Cry From Africa," in *Every Shut Eye Ain't Asleep*, eds. Michael S. Harper and Anthony Walton (Boston: Little, Brown and Co., 1994), 75.

## FALL 1967

As summer drew to a close, I reluctantly returned to Atlanta, but I was engaged to marry Eldridge, so I knew I'd be back soon. Before I made flight reservations to come back, Huey was wounded in a pre-dawn shooting incident on the streets of Oakland one October morning. Police officer John Frey was killed and another officer wounded. Newton was jailed on murder charges for which he could go to the gas chamber. By then the organization he led had lost its cohesion, particularly after the Chairman and other key Panthers started serving the six-month jail sentences they received for the Sacramento demonstration. The party had no funds to continue renting its storefront office in Oakland, and no meetings were being held. The situation pushed Eldridge to decide that "helping Huey stay out of the gas chamber was more important than remaining out of San Quentin" on parole, and he emerged publicly as a passionate Black Panther spokesman. He insisted that I return as soon as possible to help him mobilize the popular support he knew was crucial to keeping Newton alive. I flew back to San Francisco that November, and in the midst of launching a "Free Huey" campaign, we were married at the end of December. We settled in a one-bedroom apartment on Oak Street, not far from the freeway entrance to the Bay Bridge that led to Oakland, where Eldridge spent more and more of his time.

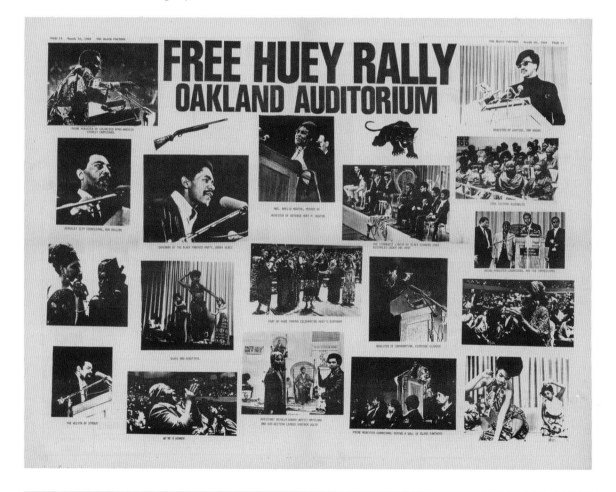

**ABOVE**

March 16, 1968: This spread from the *Black Panther* shows photographs
from the first Free Huey Rally. The event was held in California
and included SNCC leaders Stokely Carmichael, H. Rap Brown, James
Foreman, and local politicians, such as Ron Dellums.

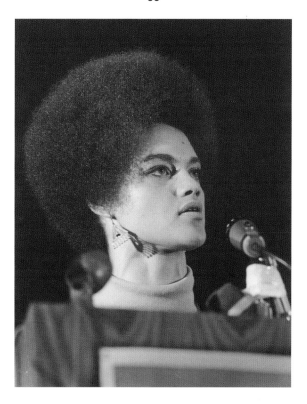

## JANUARY 1968

The new surge in black pride inspired by the call for Black Power! animated men and women alike. We all insisted upon respect for our right to defend our community, refused to tolerate racist abuse, and repudiated the subservient attitude of the past with bravado. We were changing our hair styles, our beliefs, and our attitudes towards our community to reflect the powerful affirmations generated by the new consciousness. It was the brutal retaliation visited against all of us articulating a collective demand for justice for black people that promoted such an emphasis on "manhood" and armed defense. During those intense days, I met many young black women who came to work on one project, like putting out the newspaper, demonstrating at the courthouse, or sitting in on a political education class, who would next show up at a rally, then come to a Panther meeting, and gradually became absorbed as full party members. As we learned to commit ourselves to a revolutionary movement and enjoy the challenges of fighting side by side with men for freedom, Emory's drawings reflected the presence and energy of the women revolutionaries as the party cadre expanded.

Our energetic "Free Huey" campaign unnerved the Oakland police, whose brutality and racism were notorious. We knew they were tracking every move the Black Panthers made. The Oakland Police Chief Charles Gain held a press conference denouncing the Peace and Freedom Party as anarchists for aligning with the Black Panthers. We had planned a major demonstration outside the Alameda County Courthouse where Newton was jailed for January 16, 1968, when he would appear for a hearing in court. The day before that demonstration, one of the Panthers was arrested for handing out leaflets about it at an Oakland

**ABOVE**
Kathleen Cleaver, Communications Secretary
of the Black Panther Party and wife of Eldridge Cleaver,
at the Free Huey Rally, Marin City, August 28, 1968.

KATHLEEN CLEAVER

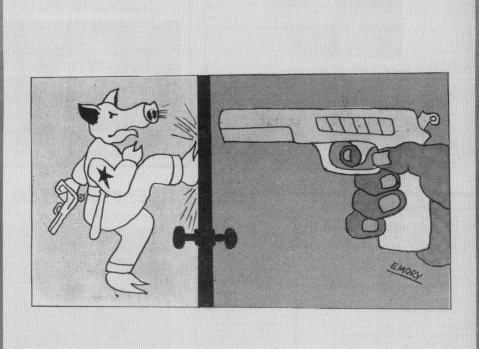

Knock, Knock
Who's There
"The Pig"
You Got A Warrant?
Don't Need One, I'm
Coming In
Bang! Bang!
Oink! Oink!
Off The Pig

Bobby Herron

**February 2, 1969:** The text on this page from the *Black Panther* newspaper
is by party member Bobby Herron.

high school. We sent out a flurry of phone calls to raise the bail money to free him. I spent much of my time sitting at the big green desk in our living room fielding calls, sending out press releases, and organizing meetings, press conferences, and protest demonstrations. I gave myself the title "Communications Secretary," since my home phone number was written on the press releases that I mailed out, and I wanted to sound official when I dealt with news media. The evening after we had gotten the bail together, I stayed up late to finish sorting Eldridge's papers, manuscripts, and correspondence piled up on the shelves of the walk-in closet in our foyer.

That night, Emory was with Eldridge riding around in a yellow panel truck that had "Peace and Freedom Party" in large letters painted along its side. They were visiting several meetings of Bay Area groups to win their support and ensure a high turnout at our demonstration at the courthouse the next morning. It was past 3:00 A.M. by the time Eldridge, with Emory trailing behind him, walked through the doorway. I felt relieved to see him at last. They both looked tired. Only a few moments afterwards—as if they had been followed up the stairs—we heard a loud banging on the door.

"Police, open up," a nasty voice shouted.

Eldridge turned to face the door, his body tense. I watched him from the bedroom. "Do you have a warrant?" he shouted.

"We don't need one!" the voice snarled.

"You can't come in here without one," Eldridge shot back.

"We'll kick the door down," the police shouted.

"You'll just have to do that," Eldridge said as he stepped back from the door. Emory stood motionless in the entry to our living room.

Suddenly, at least five tall white men wearing heavy navy blue uniforms and high black leather boots stormed into our apartment, with their long guns pointed at us. Two of them leaped past the front door they'd kicked down, and others climbed through the kitchen window in back. They blitzed through the bedroom, the living room, and the dining room yanking drawers open, looking under the bed, under the sofa, in the closets.

These men aren't ordinary policemen, I thought—they must belong to that elite unit San Francisco Mayor Alioto had just announced—the Tactical Squad. I walked into the living room where Eldridge stood, rigid with anger, talking constantly to his attorney, recounting every move the police raiders made. Emory and I stood frozen behind him, saying nothing. I felt as if I were watching a movie of a raid, not like I was physically in the same place where it was happening. My mind went blank.

The Tac Squad didn't find any guns—or whatever they thought they would find—and raced out of our apartment as quickly as they had busted in. A few moments later, a grey-haired cop wearing a light blue shirt and grey wool pants walked through the open doorway into our apartment. He stood facing Eldridge and said, almost sheepishly, "There was a report of a robbery tonight where two black men were seen driving a yellow van."

Eldridge scowled at him and mumbled something, then the man walked away.

Yeah, right, I thought to myself, as if anyone in their right mind would commit a robbery driving a yellow Peace and Freedom Party truck.

My numbness disappeared after the police withdrew. Then I clearly understood that the raid was supposed to disrupt our campaign for Huey's freedom. Eldridge would have been arrested as a parole violator if the Tac Squad had seized any guns, and instead of speaking at the courthouse rally, he would have been behind bars. My attention would have been diverted away from Huey's case to freeing Eldridge and that would have derailed our mobilization. It took longer for me to understand that someone—who worked with or lived close to us—had tried to set Eldridge up that night.

We held a press conference to announce our lawsuit against the San Francisco police department for their raid on our apartment. At every demonstration we passed out the leaflets we wrote denouncing the raid. The front page of the next issue of the *Black Panther* ran the story under Emory's cartoon of three chubby pigs dressed in police uniforms looking in a toilet, with a banner headline that read, "Pigs Run Amuck!" (below). Every successive incident of police harassment focused more attention on our movement. Radio programs, newspapers, and television covered our demonstrations outside the Alameda County Courthouse, broadcast interviews with our leaders, and followed the progress of Huey's case.

Speaking at our outdoor rallies, Bobby connected support for Huey with the goal of black unity, and asked people to demonstrate that unity at the Alameda County Courthouse. "Let people know we must unify on all levels," he proclaimed, "and deal with all areas of oppression. That right here in the confines of racist America, racism must be stopped." We were galvanizing students, community people, and Panthers into the "Free Huey" campaign. His case was turning into a centerpiece of our mass mobilization advocating the Black Panther Party program, and the party spread across California. At the same time, a handful of white Berkeley radicals, some socialists, some disaffected Democrats, and some antiwar activists were forming the Peace and Freedom Party to challenge the Democrats at the polls. Eldridge negotiated an alliance with them for support in our mobilization around Newton in exchange for our assistance in their effort to win a spot on the California ballot. We also forged coalitions with other Movement groups among Asians, Chicanos, Latinos, and American Indians.

The continuous rounds of demonstrations, rallies, and meetings with local organizations, and the television coverage our mobilization received were capturing people's imagination. High school kids, college students, ex-convicts, veterans, religious people, hard-working people, bikers, hippies, artists, writers, and middle-class folk all became supporters; many joined the party. As membership soared, we dropped the "Self-Defense" from the

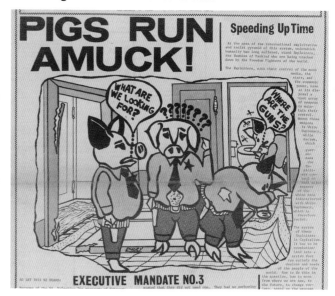

**ABOVE**

March 16, 1968: Douglas's cartoon illustrates the raid police
conducted on Eldridge and Kathleen Cleaver's apartment,
which he witnessed in 1968.

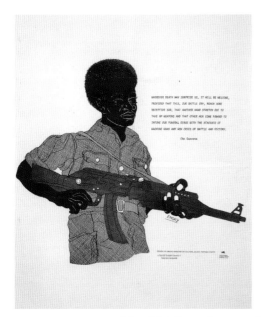

name and became simply the Black Panther Party. The momentum accelerated; new chapters opened in Los Angeles, Sacramento, and San Diego. Eldridge predicted that 1968 would become "the year of the Black Panther Party."

## APRIL 1968

The rapidly mounting denunciations of the Viet Nam War had gained a greater political magnitude after Dr. Martin Luther King Jr. joined the antiwar protest in 1967. When he asked from the pulpit of Riverside Church in New York how could he counsel young men to remain nonviolent when the United States government was the greatest purveyor of violence in the world, it elevated the stakes of the surging antiwar movement. For those who believed revolutionary change was essential, the guerrilla battles convulsing Viet Nam, the armed struggle percolating in parts of South America and Africa, and the victory of Cuba's revolution all fueled our confidence that the worldwide conflagration was catching fire at home. The Vietnamese men and women tackling America's military behemoth inspired our profound admiration. Continually pinpointing the United States as the monstrous enemy of all people fighting imperialism, Che Guevara had called for the creation of "two, three... many Vietnams."

Emory drew a simple poster of a black guerrilla cradling an AK-47 rifle (above), and in italics above the weapon was written the last sentence from Guevara's message to the Tri-Continental Conference:

> Wherever death may surprise us, it will be welcome, provided that this, our battle cry, reach some receptive ear, that another hand stretch out to take up weapons, and that other men come forward to intone our funeral dirge with the staccato of machine guns and new cries of battle and victory.

Eldridge and I framed that poster and hung it above our living-room sofa in the center of the wall. We believed Che's words were sealed in his blood once he was killed in Bolivia and took them as a continual inspiration for our own revolutionary commitment.

Newton's murder trial had been set to start during the second week in April 1968, but unforeseen events forced its delay. On April 6, two days after the assassination of Martin Luther King Jr. in the midst of a groundswell of riots and rebellions in over one hundred cities, a gun battle in Oakland erupted between Black Panthers and the police. That night seventeen-year-old Bobby Hutton, the first person to join the Black Panthers, was shot and killed as he was surrendering to the police. Afterwards, Eldridge, who had been shot in the leg, and eight other Panthers were arrested for their participation in the fight. Three policemen were wounded

**ABOVE**
1967: Douglas's poster with a black guerrilla and a quote
from Che Guevara that Eldridge and
Kathleen Cleaver hung in their living room.

during the ninety minutes of shooting that came to a halt after an exploding tear-gas canister set the basement where L'il Bobby and Eldridge were hiding on fire, and forced them to surrender. For days afterwards, hundreds upon hundreds of people made a pilgrimage through the charred building where the gunfight had happened—an incident that bore a chilling resemblance to the search and destroy missions we heard about in the war in Viet Nam. Although the sudden arrests and L'il Bobby's death threw our party into chaos, community empathy for our movement swelled, and King's murder inspired thousands to join the Black Panthers. Those of us living in the Bay Area were under siege—pulled into a deadly vortex of anger, violence, and love. Lines in a poem by Walcott captured how it felt to me: "this has moved past love to mania... This has the strong clench of the madman, this is gripping the ledge of the unseen, before plunging into the abyss."[2]

We rallied to support our arrested comrades, hastily organizing mass demonstrations, printing leaflets and posters, rushing out an issue of the newspaper and struggled to raise bail money at the same time we mourned the death of L'il Bobby. The national mourning and fury that King's blatant assassination unleashed surrounded and overshadowed our efforts. I went into overdrive to handle the crisis—political and personal all at once—that Eldridge's arrest, and pending parole revocation, created. That May the Peace and Freedom Party nominated their candidates for the November elections. Eldridge was nominated as their presidential candidate, Huey was selected for Congress, Bobby was picked to run for state assembly from Oakland, and in San Francisco I was chosen as a state assembly candidate for the district in which we lived. The incumbent was a powerful, well-known black politician named Willy Brown. We opened a storefront office on Divisadero, which doubled as headquarters for my campaign and the San Francisco chapter of the Black Panther Party. We printed up campaign posters and leaflets, and I appeared on television and radio and spoke to churches, schools, and community groups. Our call for freeing Black Panther political prisoners, ending the Viet Nam War, and empowering the black community was the platform I advocated. Our newspaper featured Emory's classic caricature of Willy Brown that showed his face atop a body completely bound by rope with his lips sewn tight to show his position on the issues I raised—such as the Viet Nam War and support for political prisoners. Spinning from meeting to meeting to speaking engagement to visits to Eldridge in prison to more meetings was exhausting, but I saw no choice but to do everything conceivable to organize attention on his case in hopes of saving his life.

---

2 Walcott, "The First," in *Every Shut Eye Ain't Asleep*, 75.

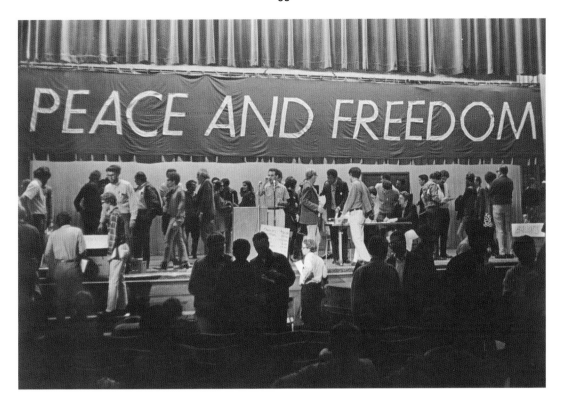

## MAY 1969

Richard Nixon's election as president seemed like the shot from the starting pistol for a systematic assault against the Black Panther Party that rolled ferociously across the country. By the time of Nixon's inauguration in January 1969, Eldridge had gone into hiding in Cuba, Huey was serving a sentence for manslaughter in a California prison, Bobby Seale was locked up and awaiting a criminal trial in Chicago, while Jon Huggins and Bunchy Carter, two Black Panther leaders in Los Angeles, were murdered in broad daylight on the UCLA campus during a shoot-out provoked by undercover agents. Every week we learned that another Panther office was getting raided, bombed, or shot up by local police acting in concert with the FBI. Even though hundreds of Panthers faced trials or jail time, and the expense of legal fees and bail was draining our resources, the Black Panther Party continued to expand. New offices opened, new delegates arrived at the national headquarters for training, and our newspaper was being distributed all over—Boston, New York, Philadelphia, Chicago, Dallas, New Orleans, Los Angeles, San Diego, and all the thirty or so other places where we had chapters. Emory's posters decorated every Panther office, and the newspaper made his cartoons nationally recognized. Our campaigns to defend imprisoned Panthers and combat the blatant attacks against us had won national and international support.

I'd asked Emory to accompany me when I left the United States to join Eldridge, believing we would go to Cuba. He was a gentle, quiet person whose presence would be comforting, as well as one of the men Eldridge was closest to in the party. Emory had a room in our house on Pine Street, where Eldridge and I had

**ABOVE**

Balloting at the Peace and Freedom Party State Convention,
when Eldridge Cleaver was nominated for President of the United States,
San Francisco, California, August 3, 1968.

KATHLEEN CLEAVER

moved right after his release on bail in June—it was more like a San Francisco Panther center than a private residence. Since our travel to Cuba was illegal, I'd devised a long, roundabout route that Eldridge's royalties from *Soul on Ice* were paying for. First, we'd fly over the Atlantic to Paris, from there across the Mediterranean to Algiers, where we would finally catch the Aeroflot flight to Havana. That was the Soviet airline which stopped there once a week on its route originating in Moscow. May 21, 1969—the day Emory and I arrived at New York's Kennedy airport to leave for Paris—was sunny and calm. He was excited about our international travel, and I was glad we would be together. When I reached the ticket counter, the airline representative told me she couldn't locate any reservations under my name, and further, the flight I claimed we were booked on was completely sold out. I immediately grew suspicious. I'd asked Ed Bullins, the playwright who was a friend of my husband, to drive us to the airport because I was certain he wouldn't betray us. He suggested we fly instead to London. When he slipped into the phone booth to call a friend in London, I turned back to the ticket counter, convinced some FBI interference had disrupted my travel plans.

Glaring at the woman behind the counter, I asked, "Is the flight to London sold out too?" It wasn't. I bought two one-way tickets to London, where Bullins's friend would meet us. We had gotten past the first hurdle, but I knew more would cross our paths. According to FBI records I saw many years later, Emory and I were identified as "national BPP officials" who were listed in "the Security Index and the Agitator Index."[3] An FBI memo that reported our movements to the London and Paris legations, instructing them to "alert sources" about our travel, also noted that "the CIA had been advised by liaison for its information."[4] Once our jet plane sped above the clouds, I leaned back on the seat, letting the tension drop from my shoulders—I felt like I'd escaped a dragnet. Since January, each previous plan I'd relied on to leave, which had depended on contacts Eldridge knew, was stymied. Finally, I decided I would have to make all the arrangements myself if I wanted to see my husband in time for the birth of our child—I was already seven months pregnant. When we reached Paris, that's when we discovered that everyone in the New Haven Black Panther chapter, which Jon Huggins's widow Ericka had just started a few months earlier, had been arrested on charges of conspiracy to commit murder.

By the spring of 1969, the surging momentum of the Black Power Movement for freedom and dignity connected its political and cultural expressions at the deepest level. The mounting Black Panther resistance to the increasingly violent attacks not only showered us with notoriety but also far-flung admiration, even from distant places like France and Algeria, where intense opposition to the U.S. war in Viet Nam enhanced the solidarity expressed towards us. There was no way that Emory and I could have known it when we boarded that flight, but Algiers had been selected by the Organization of African Unity to host its First Pan-African Cultural Festival, and the preparations for the international gathering were nearly complete.

African struggles to end colonialism—the Mau Mau rebellion in Kenya, Kwame Nkrumah's rise to power in Ghana, and Algeria's victory over French imperialism—had been powerful catalysts to our movements for civil rights in the United States. As the Black Power Movement accelerated, it pushed us to study care-

3 FBI Teletype to SAC (Special Agent in Charge), San Francisco, from Director, FBI, May 22, 1969 (released pursuant to a Freedom of Information Act request to Emory Douglas Jr.).
4 Ibid.

fully African independence movements and draw inspiration from them. During 1968, when the film *The Battle of Algiers* was shown in the United States, black revolutionaries felt an intense identification with the cadre of urban guerrillas who play the central roles. But nothing had a more transformative impact on the revolutionary posture of the Black Panther Party than the book *The Wretched of the Earth*. This seminal work by the French-trained Caribbean psychiatrist Frantz Fanon, whose analysis of the colonial domination of Algeria and the war to end it revealed so many parallels to the racial oppression blacks had suffered for centuries in America, became the bible of the Black Liberation Movement. In 1969 traveling to Algiers became almost like a pilgrimage for black revolutionaries.

### JUNE 1969

The night sky was black when Emory and I stepped off the cargo plane we'd traveled on after a traffic jam made us miss the passenger flight from Paris to Algiers. We landed at the Dar El-Beida airport on June 1, 1969 about 1:00 A.M. The air was moistened by a Mediterranean breeze, but there were no lights other than those at the terminal we were walking towards. Customs officials, a few uniformed soldiers, and tired cab drivers waiting for a fare were the only other people we saw in the airport. I'd never managed to contact any Cuban representative, but—barely an hour before leaving for the airport in Paris—an American journalist brought me a message from Eldridge whom he'd seen in Havana two days earlier. He told me that my husband was on his way to Algiers, and I should wait to meet him there. I felt relieved. Eventually, my calls to the Cuban embassy put me in touch with the only person who seemed to know about my situation. The official quickly arranged for me and Emory to stay in an inconspicuous place in a run-down waterfront area, identified by a plaque beside its door as the Hotel Victoria. Its elevator was a rickety, iron cage-like contraption barely wide enough for two people with luggage to fit inside.

During my second night at the hotel, the sound of tapping on my door woke me up. I opened it—and there stood Eldridge, wearing a khaki shirt and pants, with a suitcase on the floor beside him. We had not been able to see or talk to each other for six months—Eldridge looked thinner, and less confident than I'd remembered. I squealed with joy, threw my arms around him, and then he relaxed a bit and tried to smile. We knocked on the door to Emory's room that was beside mine—he came out, a huge grin on his face. "Hey, man," he told Eldridge, "good to see you." That night, the three of us stayed up for hours—reconnecting, exchanging news, and finding out what Eldridge's circumstances were. As a fugitive from the United States, his situation was precarious. He'd been assured before leaving Havana by Cuban authorities that he could come back with me, but after the disappointments and conflicts he'd experienced there, he was convinced it would be better for us to remain in Algeria.

Within a few days I needed medical attention. A handsome Angolan doctor who came to see me, exiled because of his work in the war to liberate his land from Portugal, put us in touch with other African political exiles, which led to our meeting Elaine Klein. She was a friendly American woman who'd become involved with the Algerian revolution while studying in Paris and had lived in Algiers ever since the country became independent. Her job in the Algerian Ministry of Information

involved drawing up a portion of the guest list for the upcoming Pan-African Cultural Festival, and she was delighted to meet us in Algiers. The Black Panther Party, she told us, was going to be invited to send a delegation to the festival.

## JULY 1969

Banners and lights were strung across the main boulevards to celebrate the arrival of festival guests, large posters celebrated heads of state that were attending, and people were pouring in from all over Africa, Europe, and even the United States. Afro American guests included the jazz musicians Archie Shepp and Nina Simone, Ed Bullins, the poet Don Lee (later Haki Madhubuti), and Stokely Carmichael, whose wife, the celebrated South African singer Miriam Makeba, was a featured performer. Once Eldridge and I were officially invited to the festival, Elaine Klein took us to check in at the Hotel Aletti, a palatial white edifice that towered over the center of Algiers. Eldridge held a press conference at the university auditorium on July 17, 1969, announcing his arrival in Algiers, his first public appearance since he'd clandestinely left California back in November. He was inundated by journalists, filmmakers, supporters, comrades, and old friends for the duration of the festival. Many representatives of African liberation movements and African political delegates were at the Aletti, where the Black Panther delegation which Emory brought back with him from California was also housed, which made it easy for us all to meet.

The storefront our delegation was assigned to house an exhibit in had large plate-glass windows that opened onto a wide city street. From the moment Emory taped the first poster in the empty window—the one of Huey Newton sitting on the wicker chair that fans behind his head like a throne, wearing his beret at an angle, and holding a rifle in one hand and an African spear in the other—crowds of young Algerians flocked outside and stared. Mounted on the bare walls inside, large prints of Emory's posters he'd framed in black for this exhibit graphically portrayed our people's struggle. There were drawings of armed Afro Americans, colorful portraits of martyred Black Panthers like Jon Huggins and Bunchy Carter, black-and-white ink drawings of H. Rap Brown and others, and several images of black women freedom fighters. His art transcended the language barriers and captivated the onlookers out in the streets.

Eldridge worked hard to make certain the center was painted, furnished, and functional in time for the opening ceremony. Stacks of our newspaper, the *Black Panther*, were arranged on tables inside the office area along with our literature. The final touch was the wooden sign he had made that was hung above the entrance, which read, "Afro-American Center." Emory and I met Julia Wright Hervé, the daughter of the exiled writer Richard Wright, when we passed through in Paris. She became an indispensable friend and interpreter who navigated our way to Algiers. She and her husband Henri came to Algiers and joined our delegation at the festival, bringing with them several French-speaking Afro Americans to work at our center.

Despite the scorching heat, when our exhibit opened on July 22, 1969, the crowd of guests from Algiers, other parts of Africa, Europe, and the Americas, was so large it spilled onto the sidewalk. Speaking in French, Julia Wright introduced the Black Panther delegation to the audience, which was surrounded by

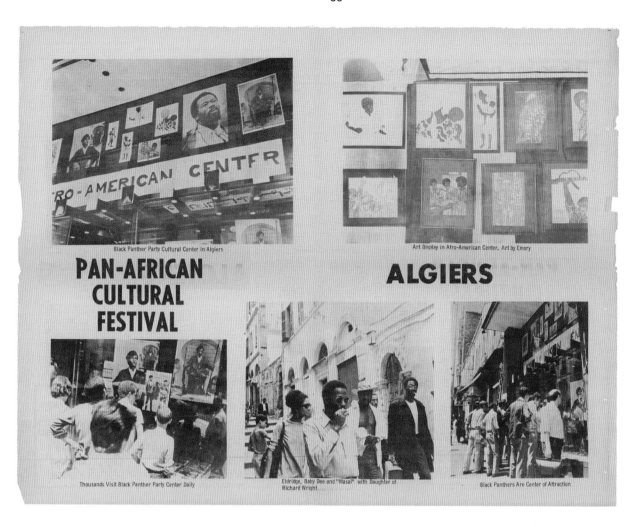

PAN-AFRICAN
CULTURAL
FESTIVAL

ALGIERS

Black Panther Party Cultural Center in Algiers

Art Display in Afro-American Center. Art by Emory

Thousands Visit Black Panther Party Center Daily

Eldridge, Baby Dee and "Masai" with Daughter of
Richard Wright

Black Panthers Are Center of Attraction

Emory's dramatic art depicting our movement. We received sustained applause
and an enthusiastic welcome. Placing our presence there in a historical context,
Julia remarked that when Malcolm X came to Africa five years earlier, he was
only one man, but the Black Panthers had come to Africa as a fully developed
organization representing the liberation struggle of our oppressed Afro American
people. Left unsaid was that our Revolutionary Artist, Emory Douglas, was essen-
tial to our historic communication with our African brothers and sisters. Emory's
practice in the Black Panther Party confirmed the truth in the remark Algeria's
President Boumedienne made during the formal opening ceremony of the festival
that "culture is a weapon in our struggle for liberation."[5] ●

**ABOVE**
August 9, 1969: Photographs of the Black Panther
delegation headquarters at the Pan-African Cultural Festival in Algiers,
1969, published in the *Black Panther*.

5 Eric Pace, "African Nations Open 12-Day Cultural Festival with Parade Through
Algiers," *The New York Times*, July 22, 1969, 9.

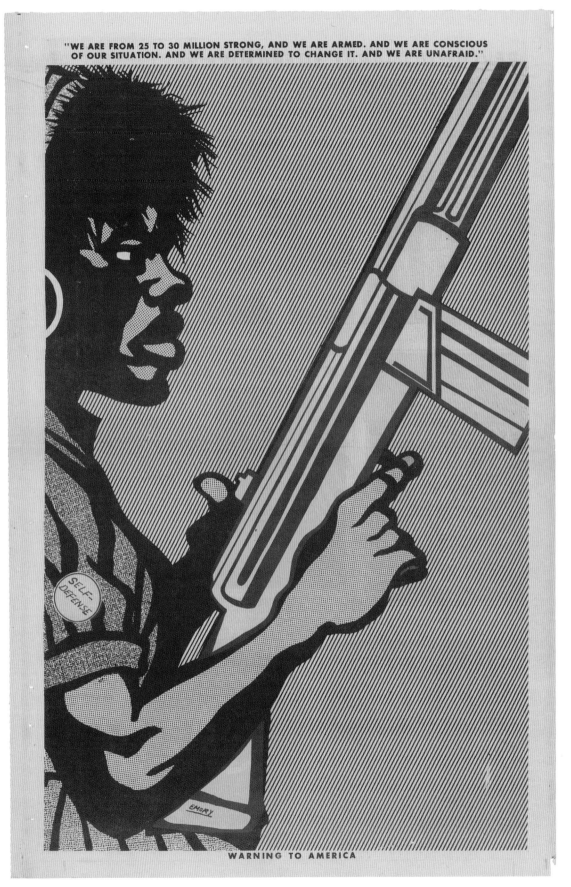

"WE ARE FROM 25 TO 30 MILLION STRONG, AND WE ARE ARMED. AND WE ARE CONSCIOUS OF OUR SITUATION. AND WE ARE DETERMINED TO CHANGE IT. AND WE ARE UNAFRAID."

WARNING TO AMERICA

**June 27, 1970:** The Black Panther Party included many women, from the rank and file to its leadership, as is illustrated in many of Douglas's works. Pages 64–91 show men, women, and children defending themselves against injustice and resisting the symbols of oppression.

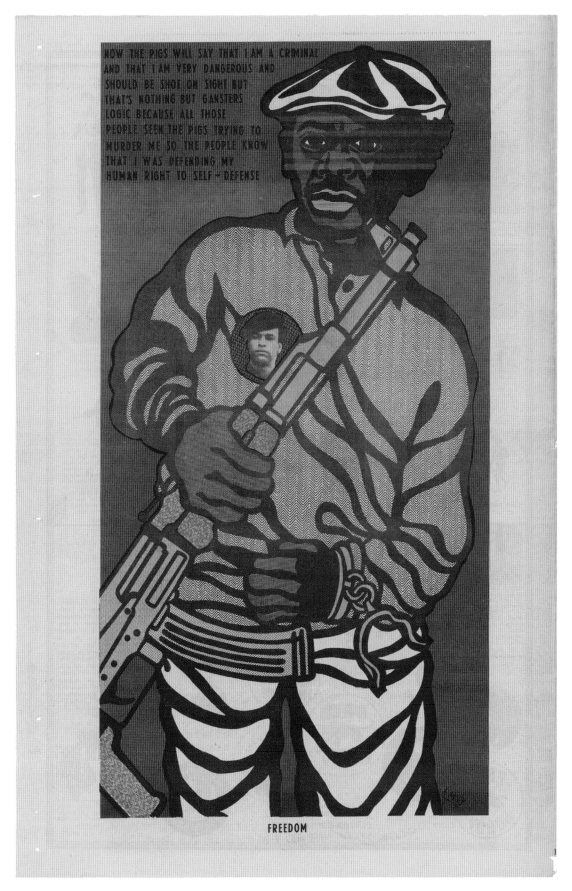

NOW THE PIGS WILL SAY THAT I AM A CRIMINAL AND THAT I AM VERY DANGEROUS AND SHOULD BE SHOT ON SIGHT BUT THAT'S NOTHING BUT GANSTERS LOGIC BECAUSE ALL THOSE PEOPLE SEEN THE PIGS TRYING TO MURDER ME SO THE PEOPLE KNOW THAT I WAS DEFENDING MY HUMAN RIGHT TO SELF-DEFENSE

**FREEDOM**

**August 8, 1970:** Huey P. Newton's metaphor of the panther as an animal that never attacks but defends itself to the death inspired people in the community to do the same, a credo exemplified in the quote above.

66

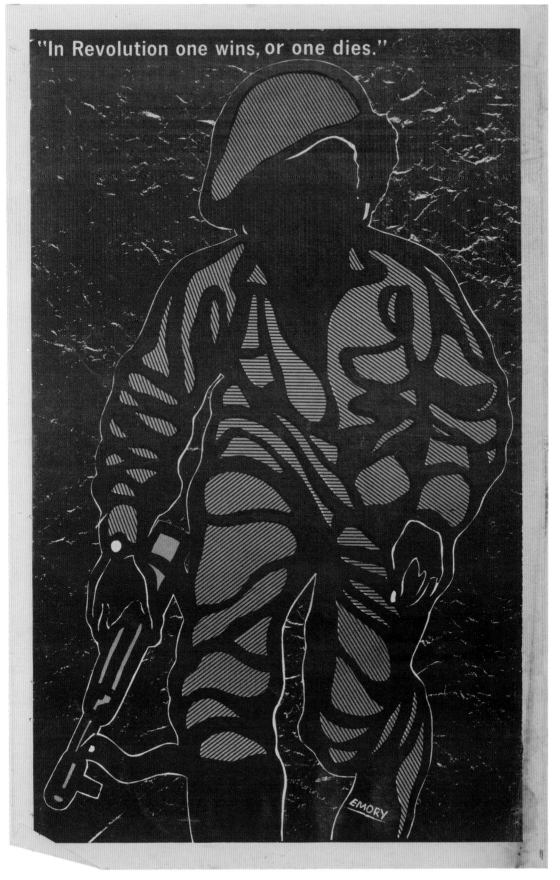

"In Revolution one wins, or one dies."

April 20, 1969

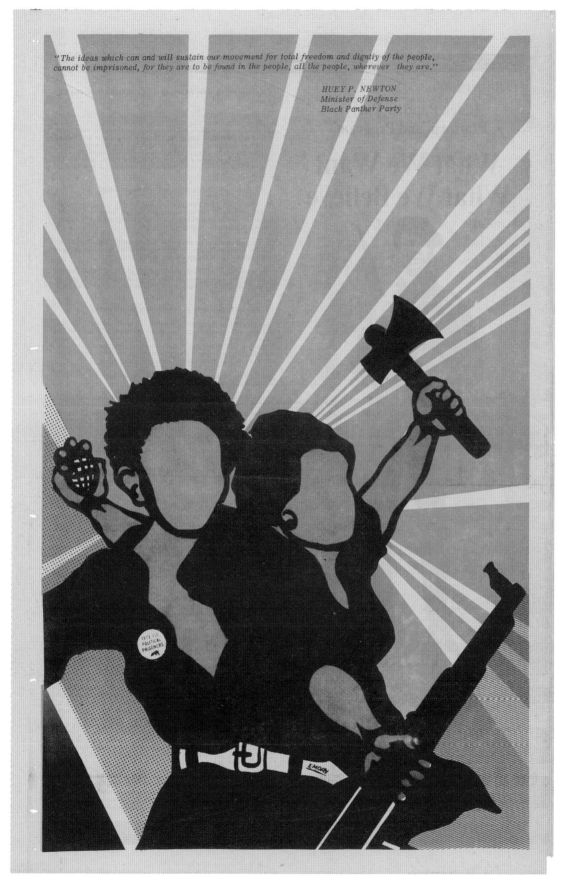

"*The ideas which can and will sustain our movement for total freedom and dignity of the people, cannot be imprisoned, for they are to be found in the people, all the people, wherever they are.*"

HUEY P. NEWTON
Minister of Defense
Black Panther Party

**February 17, 1970**

# WE WILL NOT HESITATE TO EITHER KILL OR DIE FOR OUR FREEDOM

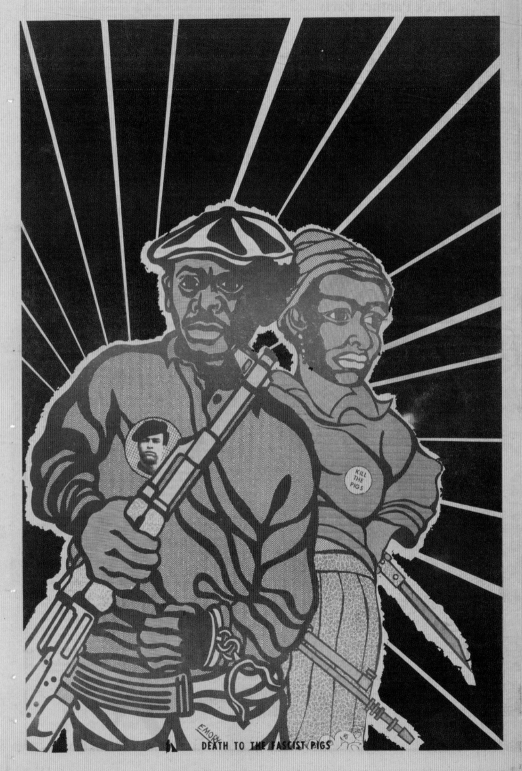

September 26, 1970

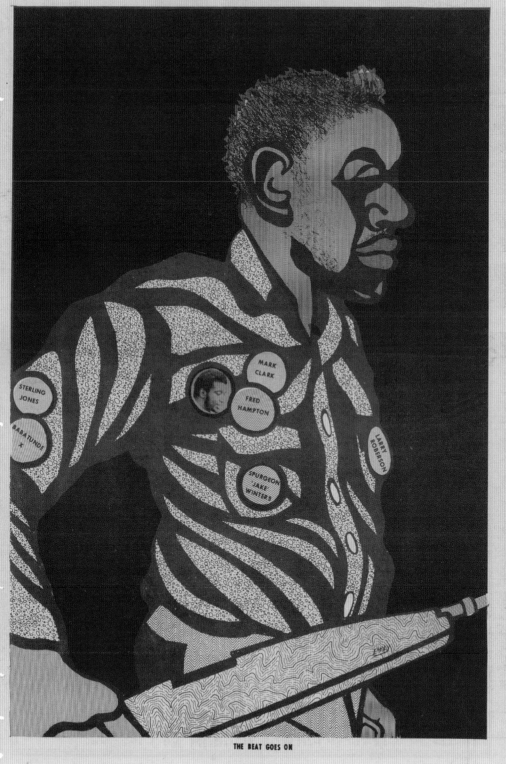

**December 5, 1970:** The buttons on the figure bear the names of murdered members of the Chicago chapter of the Black Panther Party. The quote is by chapter leader Fred Hampton.

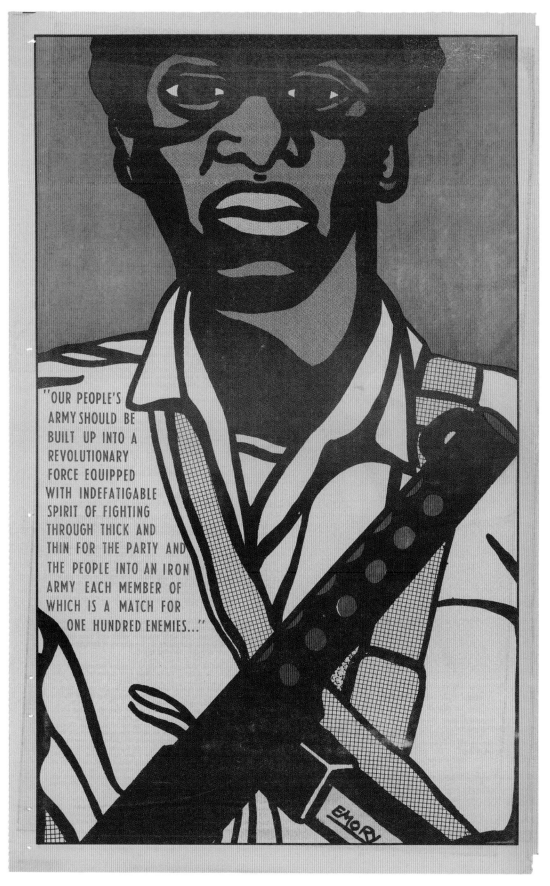

"OUR PEOPLE'S ARMY SHOULD BE BUILT UP INTO A REVOLUTIONARY FORCE EQUIPPED WITH INDEFATIGABLE SPIRIT OF FIGHTING THROUGH THICK AND THIN FOR THE PARTY AND THE PEOPLE INTO AN IRON ARMY EACH MEMBER OF WHICH IS A MATCH FOR ONE HUNDRED ENEMIES..."

**April 18, 1970:** The quote is by Douglas, paraphrasing the spirit and ideas of the Black Panther Party.

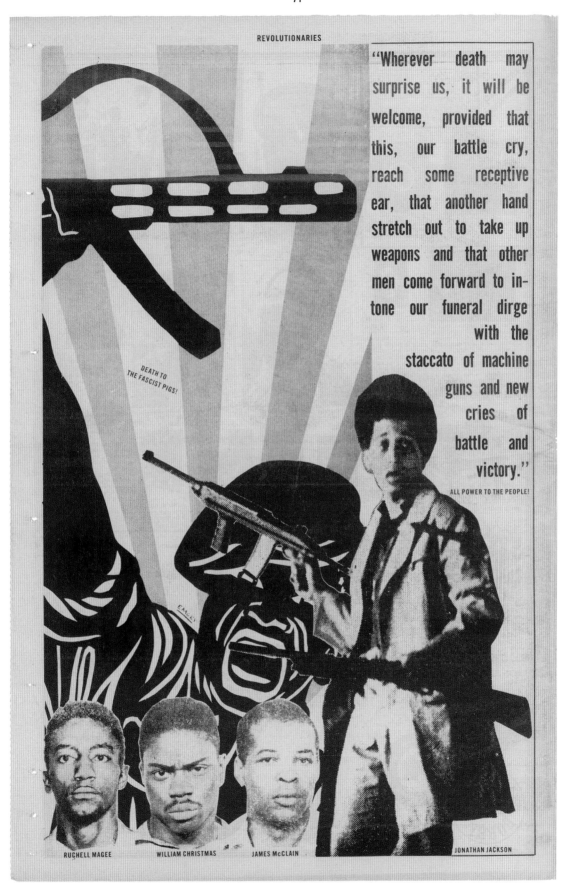

REVOLUTIONARIES

"Wherever death may surprise us, it will be welcome, provided that this, our battle cry, reach some receptive ear, that another hand stretch out to take up weapons and that other men come forward to intone our funeral dirge with the staccato of machine guns and new cries of battle and victory."

ALL POWER TO THE PEOPLE!

DEATH TO THE FASCIST PIGS!

RUCHELL MAGEE　　WILLIAM CHRISTMAS　　JAMES McCLAIN　　JONATHAN JACKSON

**August 15, 1970:** On August 7, Jonathan Jackson raided the Marin County Courthouse in an ill-fated attempt to free his brother, writer and prisoner George Jackson. Jonathan, along with two prisoners and the judge, was killed by police at the scene. Inmate Ruchell Magee survived and is still in prison.

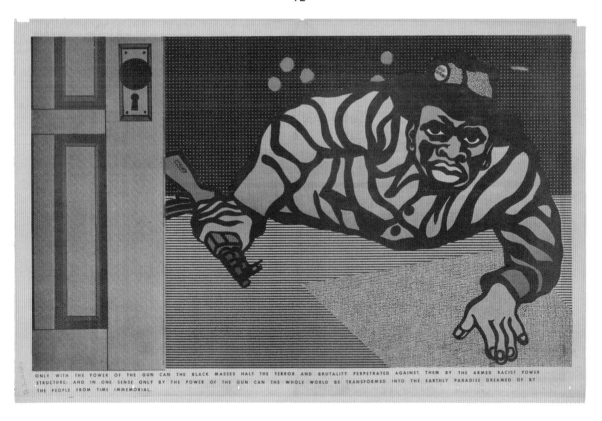

ONLY WITH THE POWER OF THE GUN CAN THE BLACK MASSES HALT THE TERROR AND BRUTALITY PERPETRATED AGAINST THEM BY THE ARMED RACIST POWER STRUCTURE; AND IN ONE SENSE ONLY BY THE POWER OF THE GUN CAN THE WHOLE WORLD BE TRANSFORMED INTO THE EARTHLY PARADISE DREAMED OF BY THE PEOPLE FROM TIME IMMEMORIAL.

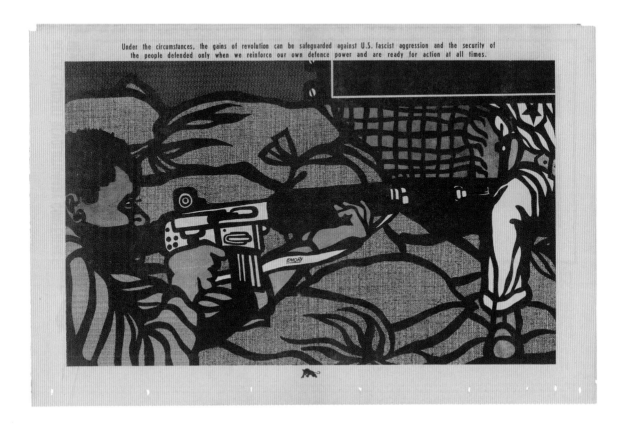

Under the circumstances, the gains of revolution can be safeguarded against U.S. fascist aggression and the security of the people defended only when we reinforce our own defence power and are ready for action at all times.

*Top* **June 13, 1970:** The images on pages 72 and 73 show people exercising their constitutional right to bear arms while defending themselves.

*Bottom* **May 9, 1970**

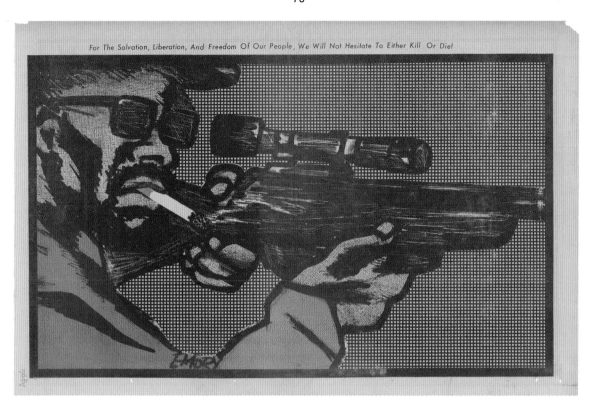

For The Salvation, Liberation, And Freedom Of Our People, We Will Not Hesitate To Either Kill Or Die!

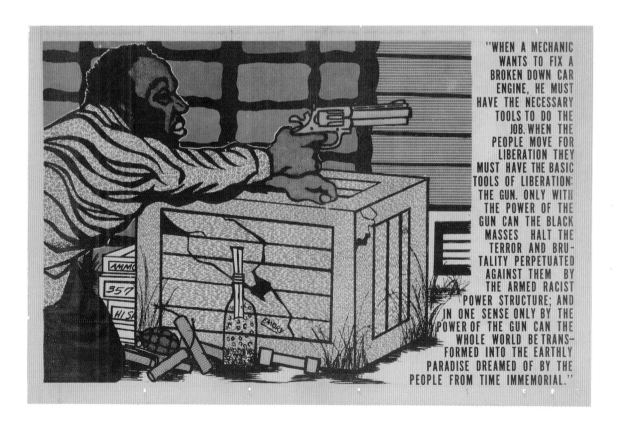

"WHEN A MECHANIC WANTS TO FIX A BROKEN DOWN CAR ENGINE, HE MUST HAVE THE NECESSARY TOOLS TO DO THE JOB. WHEN THE PEOPLE MOVE FOR LIBERATION THEY MUST HAVE THE BASIC TOOLS OF LIBERATION: THE GUN. ONLY WITH THE POWER OF THE GUN CAN THE BLACK MASSES HALT THE TERROR AND BRUTALITY PERPETUATED AGAINST THEM BY THE ARMED RACIST POWER STRUCTURE; AND IN ONE SENSE ONLY BY THE POWER OF THE GUN CAN THE WHOLE WORLD BE TRANSFORMED INTO THE EARTHLY PARADISE DREAMED OF BY THE PEOPLE FROM TIME IMMEMORIAL."

*Top* **June 20, 1970**          *Bottom* **September 5, 1970**

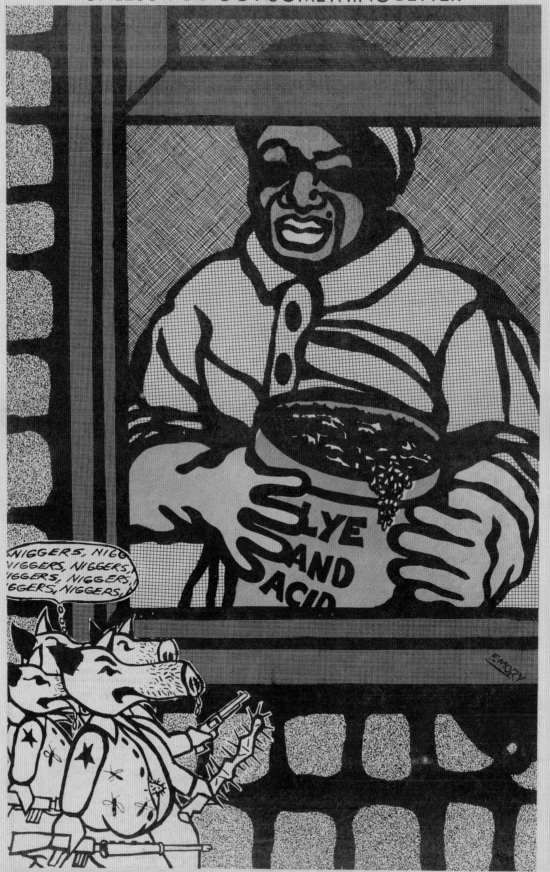

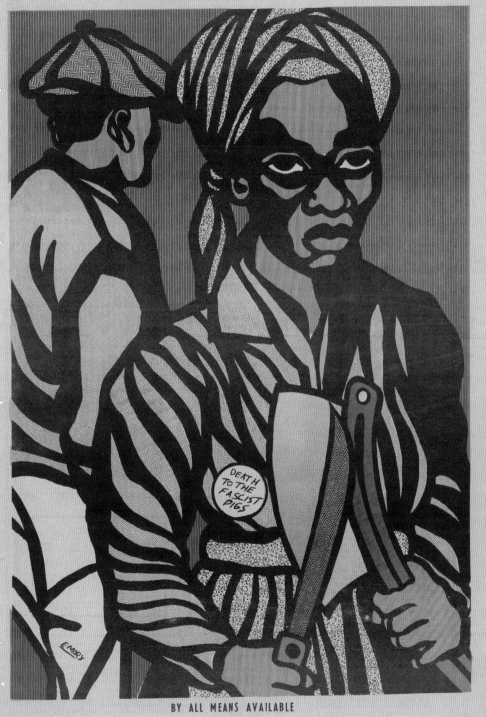

ALL THE WEAPONS WE USED TO USE AGAINST
EACH OTHER WE NOW USE AGAINST THE OPPRESSOR

DEATH
TO THE
FASCIST
PIGS

E. MORY

BY ALL MEANS AVAILABLE

*Opposite page* **June 6, 1970:** This image reinterprets Malcolm X's famous quote that when attacked,
black people had the right to defend themselves "by any means necessary."

**July 4, 1970:** Prefiguring the street gang wars of the 1980s and '90s, Douglas recognized the problem
of black-on-black violence and urged people to join together in fighting the common oppressor.

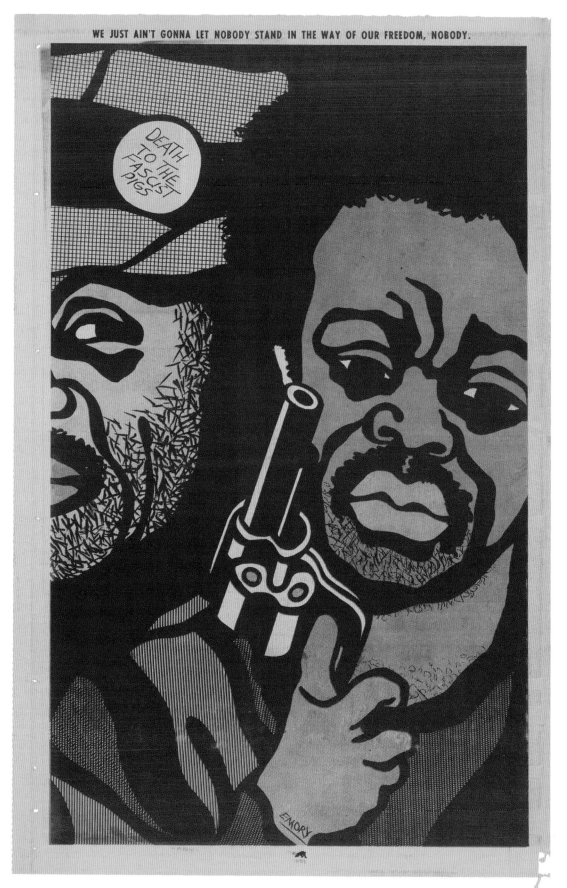

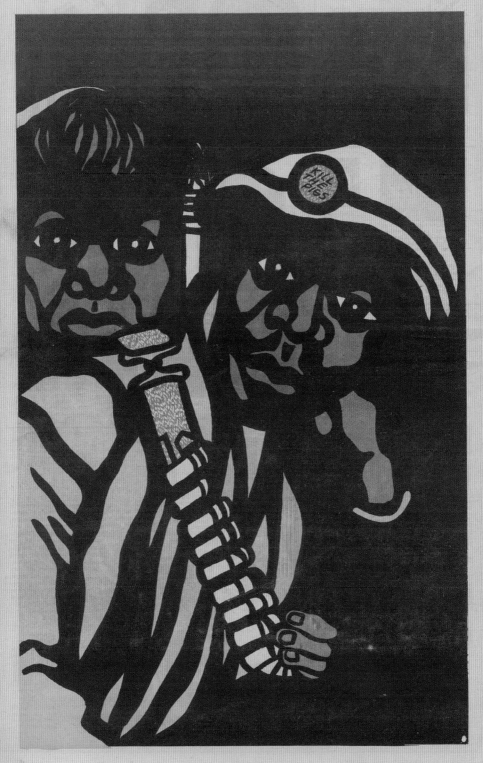

IN THE NAME OF LAND, BREAD, HOUSING, EDUCATION, CLOTHING, JUSTICE AND PEACE,
DO UNTO THE PIGS AS THEY ARE DOING UNTO US

July 18, 1970

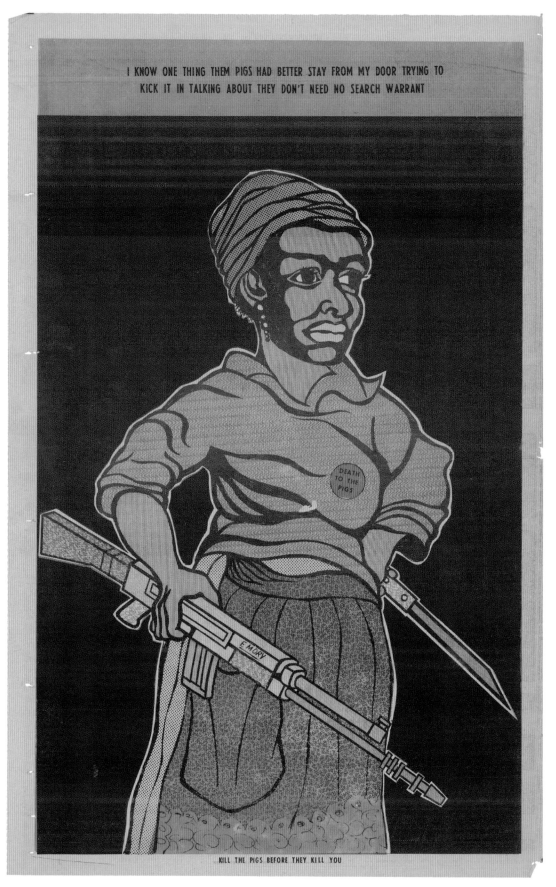

**August 21, 1970**

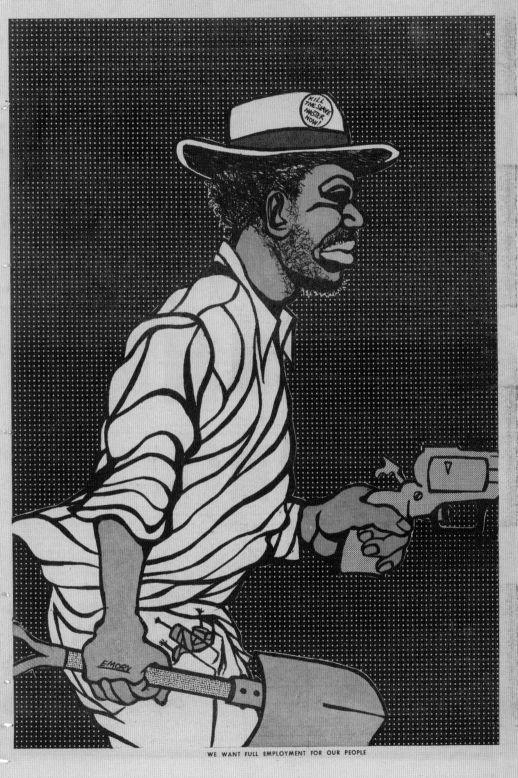

I'VE BEEN FORCED TO WORK ALL MY LIFE PICKING COTTON, DIGGING DITCHES, WASHING DISHES, SCRUBBING OTHER PEOPLE'S FLOORS. ALL THIS AND MORE I WAS FORCED TO DO FOR SLAVE WAGES... BUT THOSE DAYS ARE LONG GONE AND NOW I DEMAND EQUALITY, JUSTICE AND PEACE

WE WANT FULL EMPLOYMENT FOR OUR PEOPLE

**October 3, 1970:** Building on the self-defense imagery, the text in the image invokes point number two of the Ten-Point Platform and Program, referencing the need for employment and revealing the connections between the many facets of the party's ideology (see page 104).

JUST WAIT TILL THAT LANDLORD COMES AROUND
WITH HIS HANDS ALL STUCK OUT - SMILING TALKIN BOUT,
"WHY MRS. MAE WHAT A LOVELY DAY."

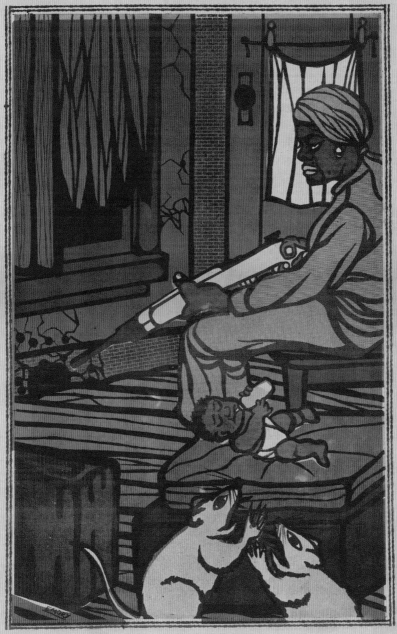

KILL THE GREEDY SLUMLORDS!

**September 12, 1970**

*Opposite page* **July 25, 1970:** The absence of weapons in this image illustrates the party's shift
from militant self-defense to an emphasis on their Survival Programs.

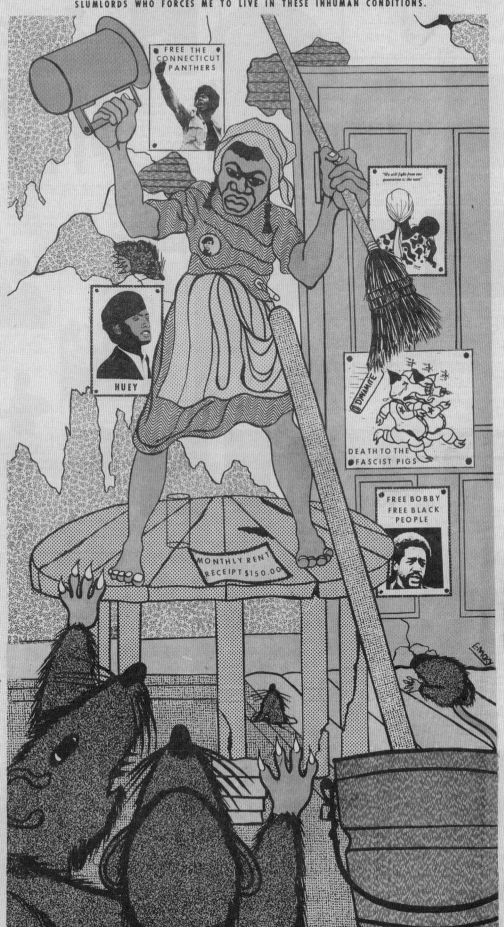

WE WANT DECENT HOUSING FIT FOR SHELTER OF HUMAN BEINGS

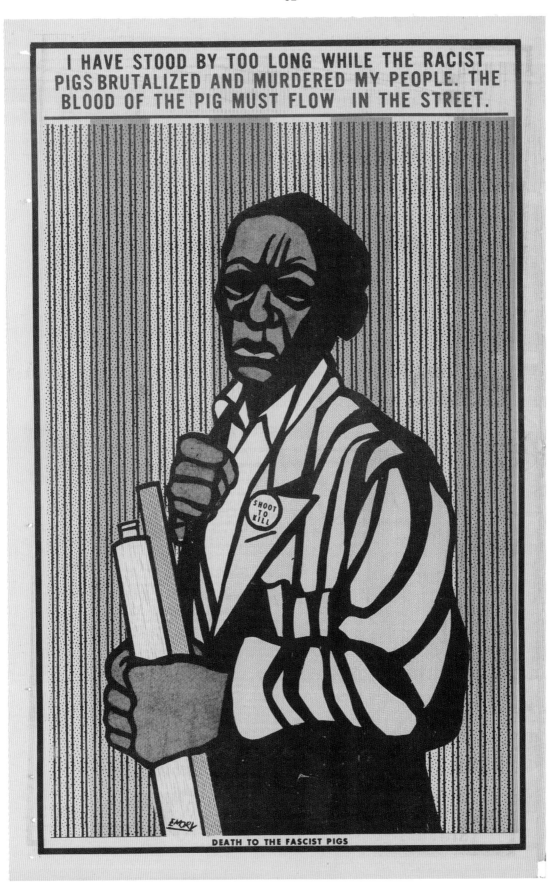

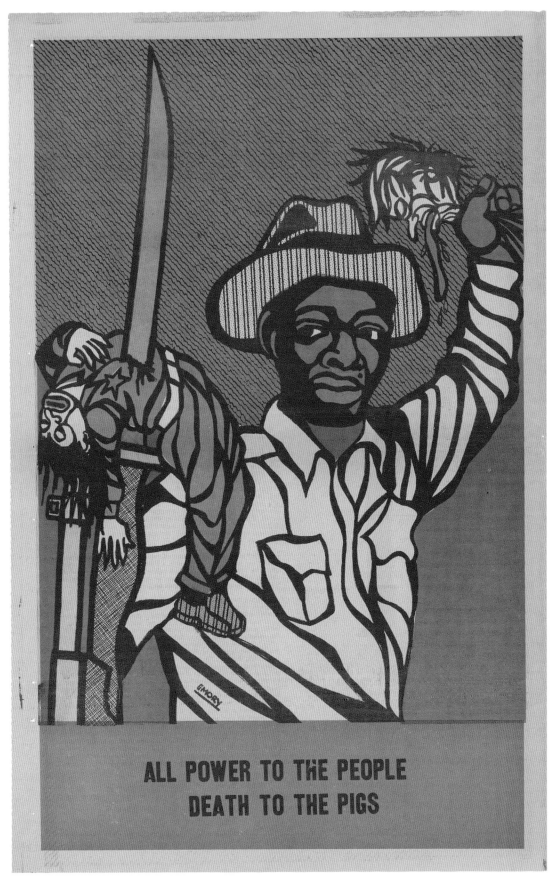

ALL POWER TO THE PEOPLE
DEATH TO THE PIGS

November 7, 1970

WHEN A PIG IS CAUGHT DIRTY SNOOPIN'
AND SHOWS YOU HIS BADGE AND BEGS FOR MERCY
- MERCY HIM TO DEATH WITH THE BUTT OF THE GUN --

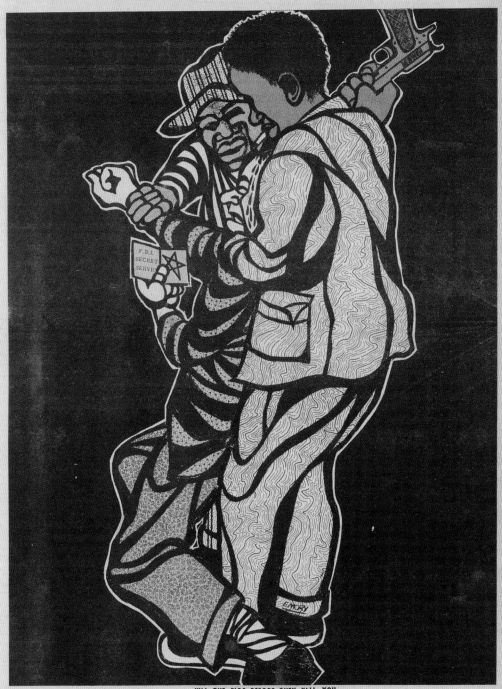

KILL THE PIGS BEFORE THEY KILL YOU

THE TERROR, BRUTALITY AND MURDER OF MY BROTHERS AND SISTERS IS THE SUFFERING OF BLACK PEOPLE. THEREFORE, NOT TO LET SUCH EVENTS CONTINUE I MUST MERCILESSLY DO AWAY WITH THE LOW - NATURED BEAST THAT BITES THE HAND THAT FEEDS IT.

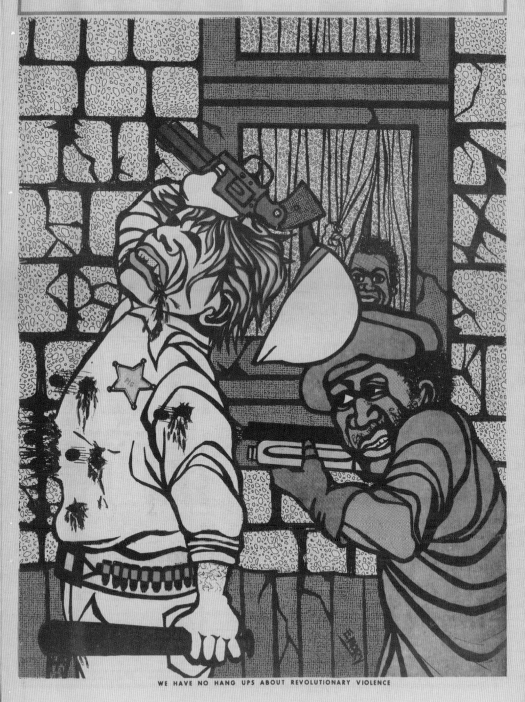

WE HAVE NO HANG UPS ABOUT REVOLUTIONARY VIOLENCE

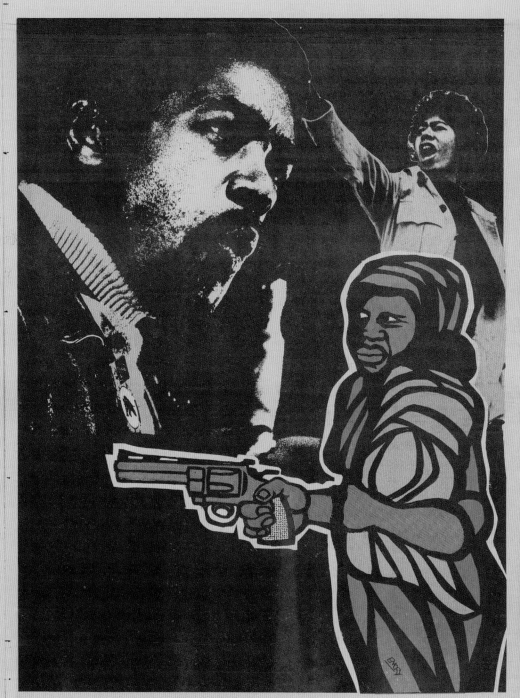

THE PIGS THINK THEY CAN INTIMIDATE
ME WHEN I SAY FREE BOBBY AND ERICKA,
BUT INTIMIDATION BREEDS RESISTANCE..."FREE
BOBBY, FREE ERICKA!" DEATH TO THE FASCIST PIGS!

**February 6, 1971:** Douglas's work repeatedly voiced the Black Panther Party's demand to free all political prisoners, including their own jailed party members. In this image, Douglas refers to the trial of Bobby Seale and Ericka Huggins in New Haven.

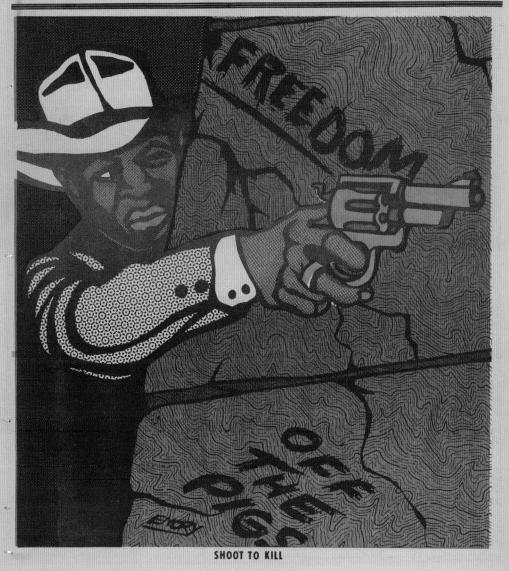

**March 6, 1971:** Douglas began this drawing in jail in New Haven, where he had come to help
with the legal defense effort for Bobby Seale and Ericka Huggins.

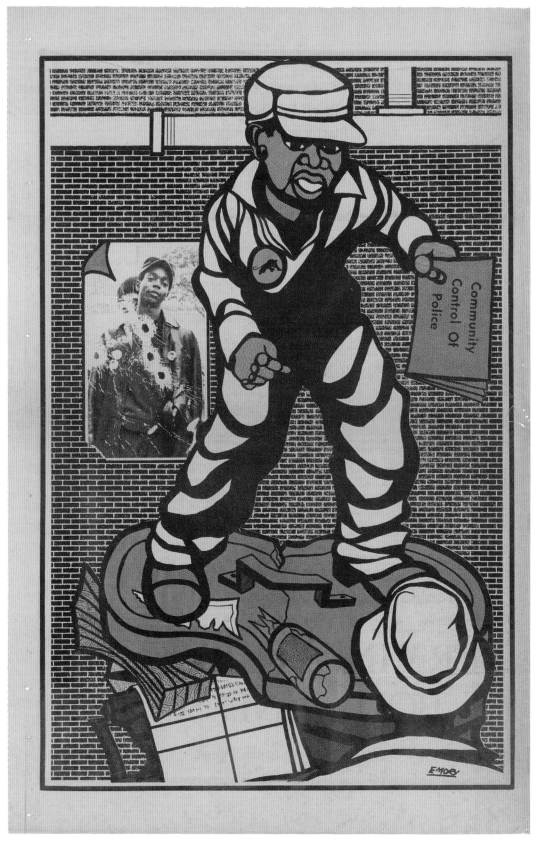

**April 3, 1971:** In this image, Douglas incorporates a photograph of seventeen-year-old L'il Bobby Hutton, the first member of the Black Panther Party, who was killed by Oakland police in 1968.

*Opposite page* **August 23, 1969:** The button on this figure reflects the jargon of the Black Panther Party, again using the words "pigs" and "pork" to refer to the police.

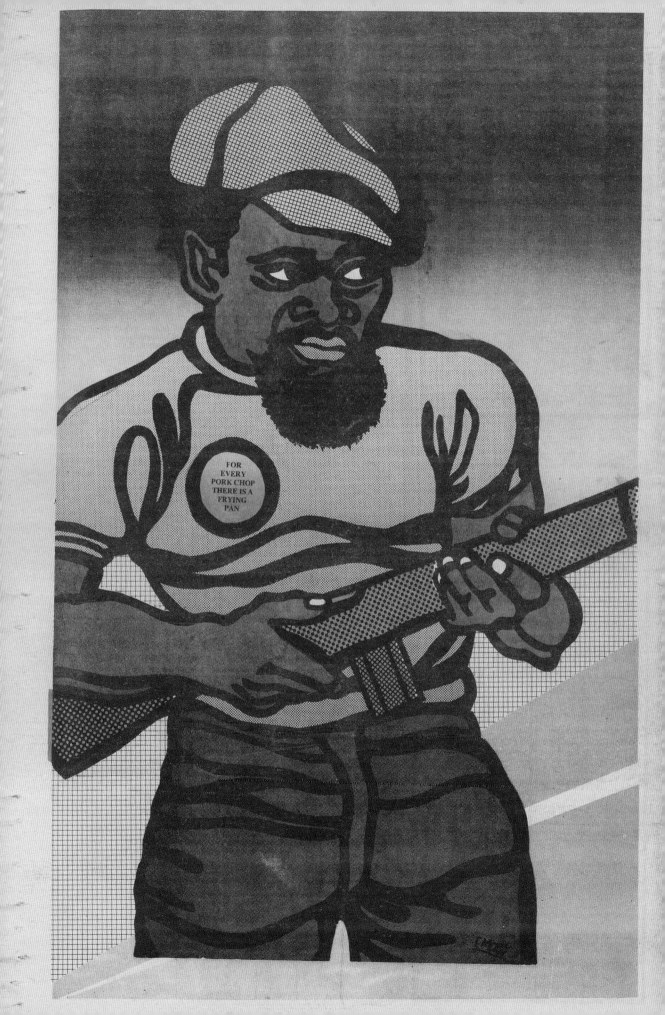

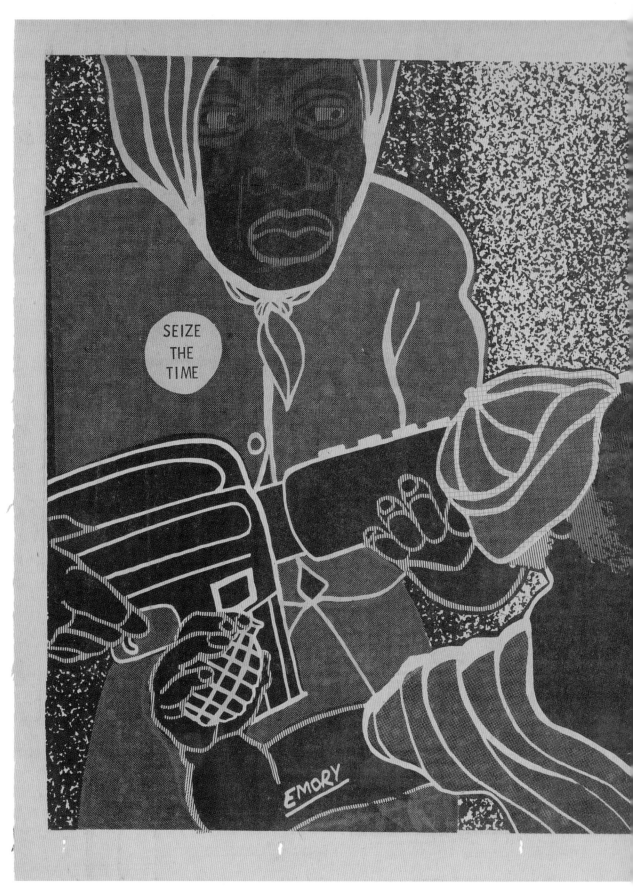

**September 13, 1969:** "Seize the Time" was a slogan used by the party
to motivate people to take control of their lives.

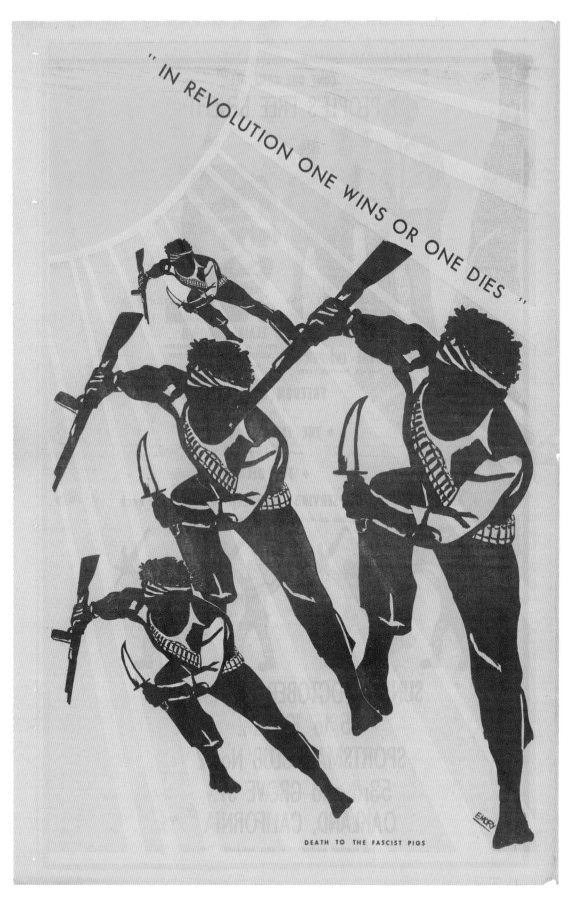

**October 24, 1970:** Douglas's drawing of revolutionaries running while holding guns and knives (above) inspired Colette Gaiter to make a similar work in mosaic (opposite) while in college.

*COLETTE GAITER*

# What Revolution Looks Like:
## The Work of Black Panther Artist Emory Douglas

Artists are here to disturb the peace.
—James Baldwin

It was in 1971, when I was still in high school, that I saw my first *Black Panther* newspaper—one my sister brought home from Howard University. I had never seen anything like it. The drawings were bright and bold, and the text was outrageous compared to everything else I had ever read about politics and world events. I loved it so much I copied one of Emory Douglas's images from the paper for a mosaic in my ceramics class. The image is of a black revolutionary running with a gun (right).

At the time I did not recognize the generic icon of a guerrilla warrior—a barefoot figure wearing tattered pants and a headband tied around his Afro, with a bullet magazine draped across his body and a rifle held prominently in one hand. The image was like the protest and propaganda posters from Viet Nam, Africa, Cuba, and South America—places in the world where colonialism, imperialism, and by extension, capitalism were being overthrown.

The *Black Panther* newspapers, with their huge typographic headlines, use of color, and strikingly rendered drawings of black people were irresistible to me. Aside from their pure visual seductiveness,

**ABOVE**
Colette Gaiter, ceramic mosaic with handmade mounted tiles on wood, 1971.
12 × 9 inches (30.4 × 22.8 cm)

I was attracted to Douglas's images because they showed both anger and hope.

By 1970 most of the marches, riots, and turbulent expressions of anger and frustration about discrimination that characterized the mainstream Civil Rights Movement were over. Laws had changed, but conditions had not improved nearly enough. What came into my house with the *Black Panther* was a glimpse of a reality I suspected was out there somewhere, although I had never experienced it myself.

As a black teenager in an overwhelmingly white suburban high school in the suburbs of Washington, D.C., the *Black Panther* visualized ideas that I did not know how to express. I was coming into my political consciousness and awareness of the world. My high school was liberal, even progressive, and I was regularly exposed to thinking that challenged the status quo. But nothing I had ever seen or read so clearly and succinctly laid out the underlying problems in late twentieth-century American society that disproportionately affected the black and poor. Radical change starts with pointing out plainly and clearly what no one else will dare talk about or represent, and Douglas's work shouted the Panthers' mission through images. While Douglas is not as well known as other Panther leaders, his work was essential to the Black Panther organization and its message.

Douglas's work on the *Black Panther* newspaper and for the party was fearless in content and style. He was the party's Revolutionary Artist, graphic designer, illustrator, political cartoonist, and the master craftsman of its visual identity. His distinctive illustration styles, cartooning skills, and resourceful collage and image recycling made the paper as explosive visually as it was verbally. He showed as much versatility with different styles and techniques as a musician who can play several instruments as well as write music. Douglas also served as a mentor of sorts to the other artists and designers he supervised while working for the party.

Art directing the newspaper was only part of his job as the party's Minister of Culture. He created posters that illustrated the party's general goals and publicized concerts and events. In addition to organizing community-based cultural activities involving musical performances, theater, and dance, he helped produce fundraisers in the Bay Area that showcased national talent like the Grateful Dead.

One of Douglas's most significant contributions to the party was his "branding" of the Black Panthers' revolutionary vision before the concept of branding was widely used for marketing ideas and products. The Panthers were adept at creating recognizable signifiers and icons that identified their members and eventually represented their ideology. Some ubiquitous elements of the "brand," which constantly appeared in the paper, were black berets, leather jackets, military-style machine guns, and the Panther logo. "This is what revolution looks like" was the message. The revolution would not be televised, so Douglas visualized it with his art and work for the paper, communicating specific instructions through his images.[1] After the perceived failures of the peaceful, mainstream Civil Rights Movement, Douglas, along with Huey P. Newton

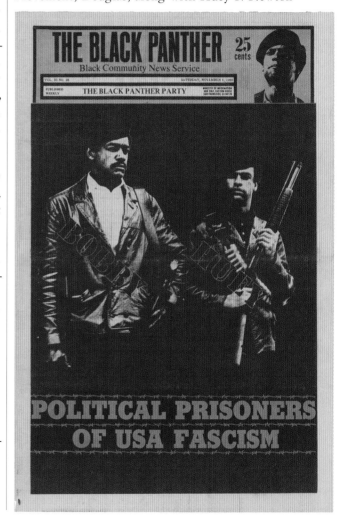

---

1 This expression "the revolution will not be televised" comes from the 1972 Gil Scott-Heron song of the same name.

and Bobby Seale, wanted to represent an ideal revolution against racism and oppression in the United States, hoping to bring about the equality that civil rights legislation had not.

The Black Panther Party leaders conceived the job of "Revolutionary Artist" as a critical part of the liberation struggle. In his manifesto "Revolutionary Art/Black Liberation," published in the *Black Panther* in 1968, Douglas wrote, "The Black Panther Party calls it revolutionary art—this kind of art enlightens the party to ... educate the masses of black people— we do this by showing them through pictures—'The Correct Handling of the Revolution.'"[2] The party's message was always translated into a visual medium because, as Douglas explained, "the masses of black people aren't readers but activists."[3]

Compared to the new millennium/post-9/11 climate of forced consensus in media messages and images, protest graphics of the 1960s and '70s are shocking in their directness. In revisiting them it is important to remember the conditions that made protest necessary. Institutionalized discrimination and injustice motivated political activism in a range of marginalized constituencies. Blacks and other minorities, as well as students, women, the disabled, and gays and lesbians organized successful legal challenges and protests. These groups were responsible for massive shifts in how Americans thought about race, sexuality, and gender difference.

The fact that we now take these changes for granted is a paradox. Activists and revolutionaries like the Black Panthers worked to make ideas that were once believed to be extreme—like equal opportunity for all Americans —seem like the natural order of things. Representing those changes in images was a fundamental part of the strategy to make previously radical ideas seem normal and universal.

The lesson to be relearned from twentieth-century protest movements is that individuals working collectively do have the power to effect change. In the late 1960s, the Black Panthers understood that people were ready for change, and they tried to galvanize the anger and frustration of alienated communities into an international revolutionary movement.

At the same time that the Panthers founded their party, the American involvement in the Viet Nam War—which started with sending military advisers to South Viet Nam—was evolving into a seriously divisive national crisis and eventually cost the lives of 55,000 troops. Over time, the war was less and less popular. Activists made people aware of deceptions that kept American troops in an untenable war. Americans who previously would have never dreamed of protesting their own government's policies, found themselves attending large-scale demonstrations. After the American military lost the war of public opinion and will, combat defeat soon followed.

As the U.S. persists in another controversial war in Iraq, it seems an appropriate time to take another look at Douglas's provocative work.

Douglas came to work on the paper in 1967, in an incredible moment of coincidence and synchronicity, when he met Black Panther leaders Huey Newton and Bobby Seale at a party meeting. Another party member introduced Douglas to them as an artist; he had studied commercial art at the City College of San Francisco and worked at a print shop. Newton and Seale were putting together the first issue of the *Black Panther* using a typewriter and copy machine. Together they discussed ways to improve the paper's image. Douglas volunteered on the spot to go home, get some supplies, and help make the paper look more professional.[4]

Newton and Seale understood the changing and increasingly important media culture. They tried to visually represent the party's community work while simultaneously preparing oppressed people for revolution, if necessary, in pursuit of psychological and economic liberation. They found the man to do this in the twenty-two-year-old Douglas. The night of that fortuitous meeting, Douglas committed himself to creating and maintaining the organization's visual identity, and he assumed the position of Art Director of the *Black Panther* until it ceased publication in 1979.

The confluence of Newton and Seale's carefully constructed ideology and Douglas's vision and artistic talent made the *Black Panther* a visual tour de force in the lively world of '60s and early '70s leftist political activism. Continuing a long tradition of revolutionary art, which was being used at that time in the service of conflicts all over the world, Douglas was the most prolific and persistent graphic agitator in the American Black Power Movements.

2 Philip S. Foner, *The Black Panthers Speak* (Cambridge, MA: Da Capo Press, 2002), 16.
3 Ibid.
4 Interview with the author, July 2004.

He profoundly understood the power of images in communicating ideas. Douglas took advantage of the tabloid-size paper by creating a back-page poster every week, which was often reprinted separately, sometimes in color. These extraordinary works of art were not displayed on pristine gallery walls, but wheat pasted on abandoned buildings in ghettos, and the newspapers were sold on street corners and college campuses all across the United States. As evidence of the paper's popularity, it had an impressive weekly circulation. Estimates of the *Black Panther*'s peak circulation range from 139,000 to 400,000; it had its highest circulation in 1970 and 1971.[5]

Inexpensive printing technologies like photostats (black-and-white photographic copies) and materials like press-down type and adhesive textures and patterns, made publishing a two-color, heavily illustrated weekly tabloid newspaper possible. Douglas's distinctive illustrations featured inventive combinations of textural effects and thick black outlines (which were used not only for the aesthetic effect but also to cover up any areas where two separately printed colors might not exactly line up). Douglas's facility with graphics and his printing expertise made the paper look like a more expensive publication.

Part of Douglas's genius was that he used the visually seductive methods of advertising and subverted them into weapons of the revolution. His images served two purposes: to illustrate conditions that made revolution a reasonable response and to construct a visual mythology of power for people who felt powerless and victimized.

The *Black Panther*'s back-page posters, created by Douglas and other artists working on the paper, tell the party's story over twelve years. In the early years of the party, the paper concentrated on empowerment by visualizing oppressed people, often armed, taking control of their own lives. In the party's final years, the illustrations on the back-page posters turned to more specific and attainable concerns like supporting candidates for elected office and economic development.

Douglas's imagery was dramatically different from earlier Civil Rights Movement graphics, which included text-based protest signs with demands like "JOBS FOR ALL NOW!" Douglas's work was persuasive and directed to a different audience—not to the oppressors, but to the oppressed. His work contained empowering messages—it was storytelling with an agenda.

The Civil Rights Movement was an essential and long overdue legal battle. The "first wave" of civil rights activity (the Black Power Movement was the second) was practical and legal in its focus, relying on photographic imagery as evidence to build its case in the public mind. Newspaper images of police dogs attacking black protesters and fire hoses turned on crowds of peaceful protesters built international support for the Civil Rights Movement by exposing institutionalized brutality through the trusted medium of photography. Reflecting the inherent difference between illustration and photographic documentation, the *Black Panther*'s images and bold graphics showed an imagined reality—what the revolution would make possible.

Douglas, whose work was concurrent and ideologically aligned with the Black Arts Movement, understood the critical need for self-representation in the liberation process. The 1960s and '70s Black Arts Movement, which was part of the larger Black Power Movement, helped to define an independent, unassimilated identity for African Americans through the vehicle of culture. Fighting oppression's psychological effects, black artists of every type created a world that replaced negative media representations with images of black pride and solidarity. Instead of telling stories and showing images in mainstream (white) media, Black Power advocates set out to establish true creative freedom for African Americans. By forming black presses, artist collectives, theater groups, and other organizations, black people were controlling the content of cultural material and its distribution within their communities.[6]

As Laura Mulvey argues in her essay "Myth, Narrative, and Historical Experience," "moving from oppression and its mythologies to a stance of self-definition is a difficult process and requires people with social grievances to construct a long chain of countermyths and symbols."[7] Visually connecting African Americans to the rest of the African diaspora was part of this process. Continuing the goals of the early twentieth-century Harlem Renaissance, the new political black power relied on creating an African American aesthetic that would serve black liberation's cause. Using the Black Power Movement's philosophy, Douglas's style of heavy black lines and patterns

5 The 139,000 estimate comes from a FBI headquarters memo to Chicago and seven other field offices, May 15, 1970, as cited by Ward Churchill, "To Disrupt, Discredit and Destroy: The FBI's Secret War against the Black Panther Party," in *Liberation, Imagination, and the Black Panther Party*, eds. Kathleen Cleaver and George Katsiaficas (New York: Routledge, 2001), 86. Douglas estimates the high circulation to be 400,000, and there are others who give estimates somewhere in between this and the FBI estimate.

6 Two of the biggest black presses were Broadside Press in Detroit, founded by Dudley Randall, and Third World Press in Chicago, founded by Haki Madhubuti (formerly Don Lee).
7 Laura Mulvey, "Myth, Narrative, and Historical Experience," *History Workshop* (Spring 1984): 3.

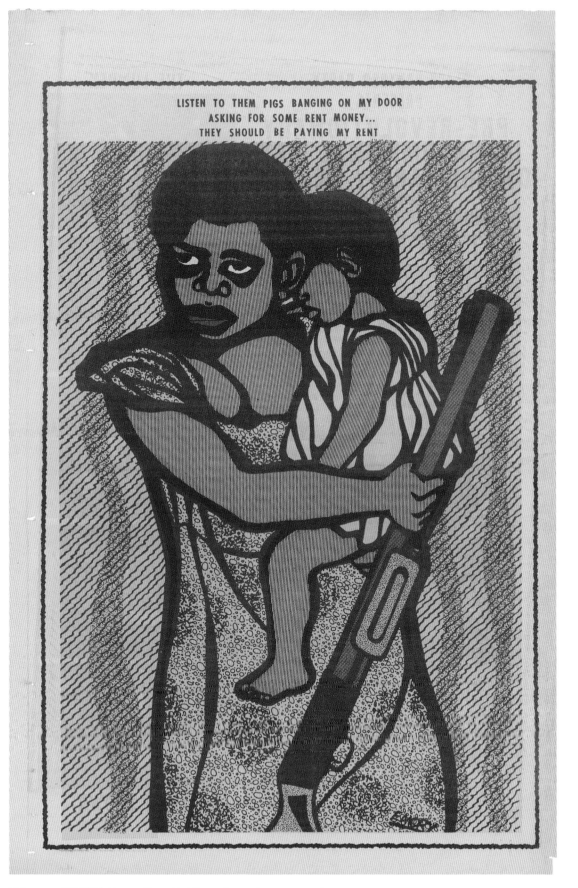

**February 27, 1971:** The use of heavy black lines and textural patterns was a signature of Douglas's. This image addresses the high cost of living and its toll on black families.

alluded to traditional African art, which relied on abstract symbolism and stylized representation instead of photographic realism valued in traditional white European art.

In the "second wave" of civil rights activity, the Black Power Movement activists shifted their focus from changing laws to changing minds. African American cultural creators tried to control production and distribution of mediated news (newspapers, magazines, television, radio, and nonfiction) and art (visual art, theater, dance, music, poetry, and fiction) as much as possible. Artists and writers like Amiri Baraka (LeRoi Jones), Sonia Sanchez (for whom Douglas illustrated the cover of *Home Coming*; see page 26), Elizabeth Catlett, Ed Bullins, Marvin X, and a multitude of others across the country worked in their own theaters, exhibited in black galleries, published their own magazines and pamphlets, and cultivated other young black artists. According to Larry Neal, one of the movement's most important poets, "The Black Arts Movement is radically opposed to any concept of the artist that alienates him from his community."[8] Art, politics, and life were inseparable from each other.

Literature and fine art contributions of the Black Arts Movement are well documented and celebrated. Print media, in the form of newspapers, poetry broadsides, and magazines, is probably the least documented and studied part of black creative production during this period. The Nation of Islam's newspaper, *Muhammad Speaks*, was published weekly and featured illustrations and images that were formally different from the *Black Panther*'s, but similarly served the organization's political agenda. Established black newspapers and magazines like *Ebony*, *Jet*, the *Amsterdam News*, *Pittsburgh Courier*, and *Chicago Defender*, had economic and political pressures that kept their content more conservative and mainstream and separated them from the more radical aspects of the Black Arts Movement.

Contrary to prevailing mythology, the Black Panthers were not black nationalists, which caused some conflict with others in the Black Arts Movement. The Panthers' goal was an end to global capitalism and imperialism. They believed that the worldwide problems of oppression could only be solved in alliance with countries outside of the Western world, coalitions not determined by race, but by ideology. The idea of armed revolution seemed possible,

at least as a galvanizing idea, considering what was happening in other parts of the world.

Douglas sought to take on capitalism and global media imperialism by visually and politically aligning the Panthers with the worldwide liberation movement. Images from Central America, Cuba, Asia, and Africa served as models for representing revolution. Comparing one Black Panther cover to a Cuban poster about the Viet Nam War shows their similarities in style and content (opposite).

The use of armed female warriors/revolutionaries also reflects the influence of international political imagery on Douglas. The smiling armed woman in one Vietnamese propaganda poster (below) exemplified the typical international war image of the 1960s and '70s. Douglas published similar images created by international artists often enough that readers learned to view images of armed men and women as commonplace.

OSPAAAL, the Organization of Solidarity of the People of Asia, Africa, and Latin America, which is

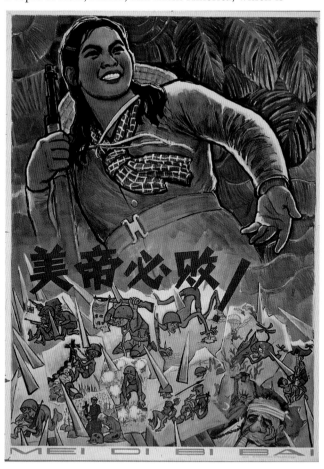

**ABOVE**
This Vietnamese propaganda poster showing a female warrior reiterated
the Black Panther Party's position that women's participation
was essential in international Third World revolutionary movements.

8  Larry Neal, "The Black Arts Movement," in *The Black Aesthetic*, ed. Addison Gayle, Jr. (New York: Doubleday, 1971), 257.

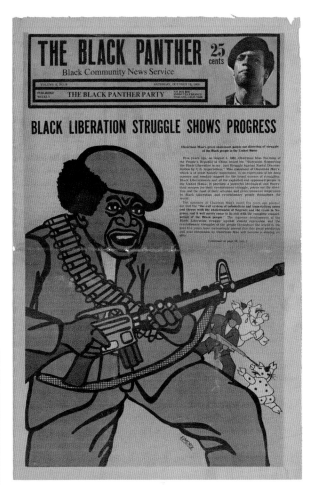

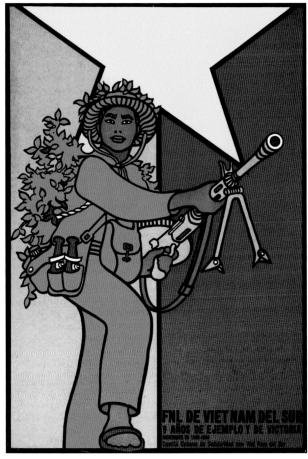

**ABOVE LEFT**

*National Liberation Front of South Viet Nam—9 Years*, by René Mederos.
Produced for Commission of Revolutionary Orientation
(now Editora Politica), Cuba, 1969. 27 x 19 inches (70 x 48 cm),
exists in both screenprint and offset versions.

**ABOVE RIGHT**

October 19, 1968: The two images on this page use a similar drawing
style to represent ordinary people as revolutionaries.

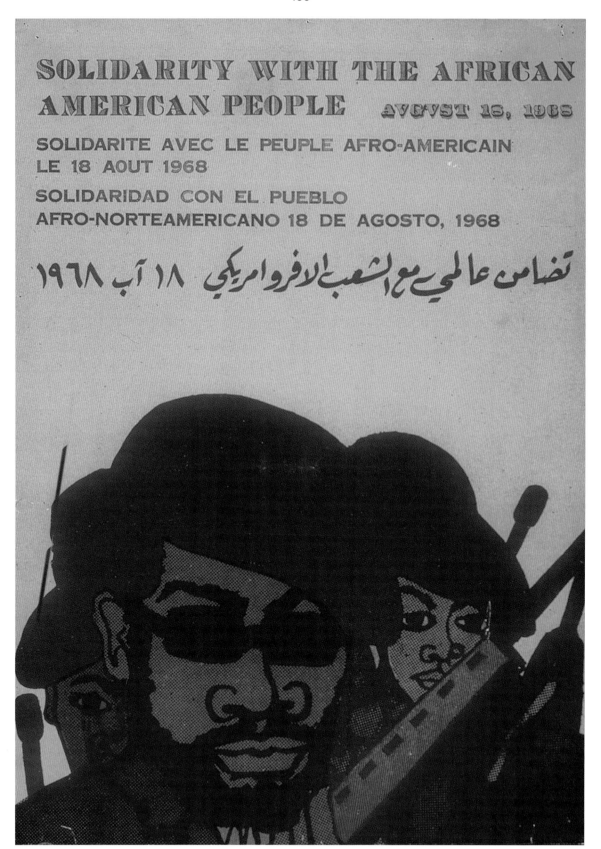

**1968:** *Solidarity with the African American People*, original illustration by Emory Douglas, poster
design by Lazaro Abreu. Produced for OSPAAAL, Cuba. 21 × 14 inches (54 × 36 cm), offset litho print.
This poster is an example of the collaborations among the international OSPAAAL artists.

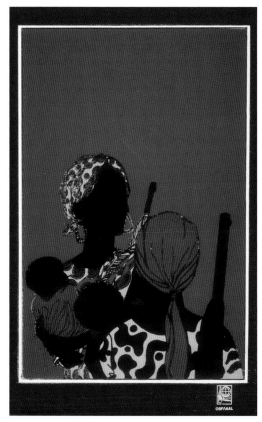

apron indicating the type of work she does, this triumphant woman sports a button with the faces of political prisoners Bobby Seale and Ericka Huggins.

In the *Black Panther*, poor people represented a new political consciousness. While most popular media represents the middle to upper class as the norm, Douglas portrayed poor and oppressed black people as the norm, the same way Norman Rockwell concentrated on illustrating ordinary (although idealized) white people in small-town America. Departing from the WPA/Social Realist style of portraying poor people, which some have argued is voyeuristic and patronizing, Douglas's energetic drawings showed respect and affection. His work maintained his subject's dignity while illustrating the harsh reality of life for the disenfranchised in the ghetto.

The empathetic representation of the poor in the *Black Panther* is one of Douglas's greatest accomplishments. One poster reads: "Black Misery! Ain't we got a right to the tree of life?" (see page 103). The woman in this drawing, hand on her hip in defiance, shares her home with a large rat, its size exaggerated by Douglas for emphasis. Although the posters often illustrated substandard living conditions, there was no self-pity. Another densely illustrated image tells the story of a young child trapped in poverty, but she holds a picture of a boy in the Panther Free Breakfast Program and stands in front of a photograph hanging on the wall of 1968 presidential candidate Shirley Chisholm. The top of the poster reads, "A vote for Chisholm is a vote for survival" (see page 159).

Douglas represented every segment of the poor and working-class population—including children, the elderly, and women. Douglas said the women in his drawings represented his "mother, sisters, aunts—all the women in the community."[11] In the pages of the *Black Panther*, his renderings of women engaged in everyday tasks like cooking, cleaning, and grocery shopping coexisted with images of women carrying weapons and defending themselves and subverted the sexism of traditional roles. Carrying on in the face of overwhelming oppression was as heroic and essential to the revolution as armed combat. Women were not only subjects of the paper's revolutionary art, some of the paper's artists were women, like Tarika (known as Matilaba) Lewis and Asali, reflecting the fact that women worked throughout the Panther organization.

still in existence, was Douglas's main source of international liberation art. The U.N.-recognized, Cuban-based nongovernmental organization "was once the primary source of solidarity posters produced in Cuba and aimed at activists around the world."[9] Douglas's own work was politically and formally allied to the OSPAAAL revolutionary artists. A 1968 poster from the organization, designed by Lazaro Abreu, featured one of Douglas's illustrations (opposite).

The twelve years the *Black Panther* was in print coincided with the period during which protest posters from the U.S. and around the world were at their most creative and dynamic. In the U.S., posters used in the Chicano struggle for self-determination in California were both visually powerful and politically effective, and it's clear that this work informed Douglas's.[10] Influenced as well by the international protest style, Douglas's art fused everyday black life with revolutionary spirit. Each person was a representative character, telling a story in a single image. A good example of this is a poster that reads, "Hallelujah! The might and the power of the people is beginning to show" (see page 102). Wearing an

---

**ABOVE**

Untitled poster, original illustration by Emory Douglas, poster design by Lazaro Abreu. Produced for OSPAAAL, Cuba, 1968. 20.5 × 13 inches (52 × 33 cm), screenprint.

9 Lincoln Cushing, *¡Revolución!: Cuban Poster Art* (San Francisco: Chronicle Books, 2003), 10.
10 Chon A. Noriega, *Just Another Poster? Chicano Graphic Arts in California* (Seattle: University of Washington Press, 2001), 8.
11 Interview with the author, July 2004.

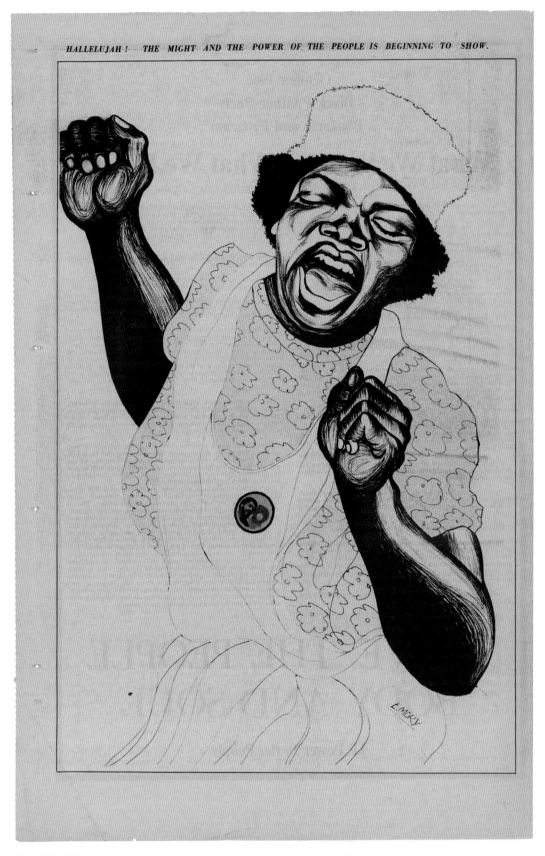

HALLELUJAH! THE MIGHT AND THE POWER OF THE PEOPLE IS BEGINNING TO SHOW.

**May 29, 1971:** Douglas's work is important because of its empathetic representation of the poor, showing their resilience and hope in the face of extraordinary obstacles.

*Opposite page* **June 12, 1971**

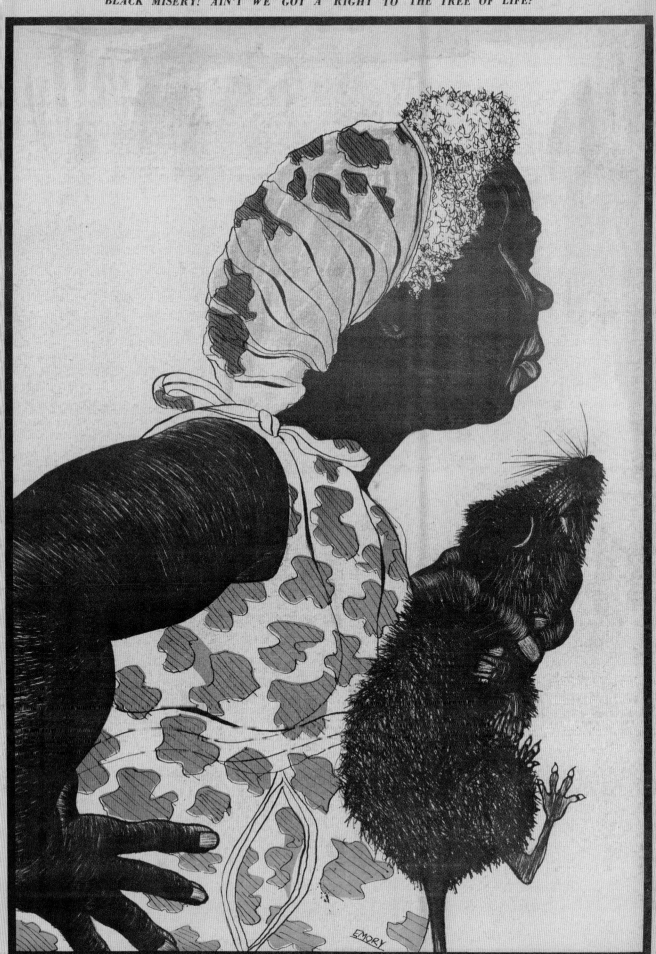

Paradoxically, even though his work portrayed the horrendous injustices and indignities suffered by the black population, Douglas's messages were essentially hopeful. There was no patronizing. As often as he exposed people suffering in deplorable conditions, he also drew dark-skinned African-featured people beaming with pride. These posters were not meant for the larger public or for those inflicting the misery, but for the people enduring life in the ghettos, giving them assurance that the Panthers were working to help them improve their lives permanently.

Douglas illustrated the direct impact of Panther initiatives and programs, like the Free Breakfast Program for Children, free health clinics, schools,

and art events, as well as being involved in administering the programs himself. (It's interesting to note that of all the important work he did for the party, Douglas is most proud of his community work.[12]) All Black Panther Party activities were based on their Ten-Point Platform and Program for self-determination. As the Ministers of Information and Culture, Cleaver and Douglas made sure all their messages reinforced the ten points, communicating tight coordination between the paper, the party, and the mission. Douglas believed that "Without the party, the paper wouldn't have had the same impact," emphasizing the symbiotic relationship between the party's and the paper's mission.[13] The ten points were:

### I.
We want freedom. We want power to determine the destiny of our Black and oppressed communities.

### 2.
We want full employment for our people.

### 3.
We want an end to the robbery by the capitalist of our Black and oppressed communities.

### 4.
We want decent housing, fit for the shelter of human beings.

### 5.
We want education for our people that exposes the true nature of this decadent American society. We want education that teaches us our true history and our role in the present-day society.

### 6.
We want completely free health care for all Black and oppressed people.

### 7.
We want an immediate end to police brutality and murder of Black people, other people of color, all oppressed people inside the United States.

### 8.
We want an immediate end to all wars of aggression.

### 9.
We want freedom for all Black and oppressed people now held in U.S. federal, state, county, city, and military prisons and jails. We want trials by a jury of peers for all persons charged with so-called crimes under the laws of this country.

### 10.
We want land, bread, housing, education, and people's community control of modern technology.[14]

12 Interview with the author, July 2004.
13 Marcy Rein, "The More Times Change...The Bay Area Alternative Press '68–'98," Media Alliance 17, no. 5 (1998), http://www.media-alliance.org/mediafile/17-15/altpress.html.
14 This is the second version of the Ten-Point Platform and Program, written in March 1972. The first was published in the Black Panther in October 1966 (see page 133).

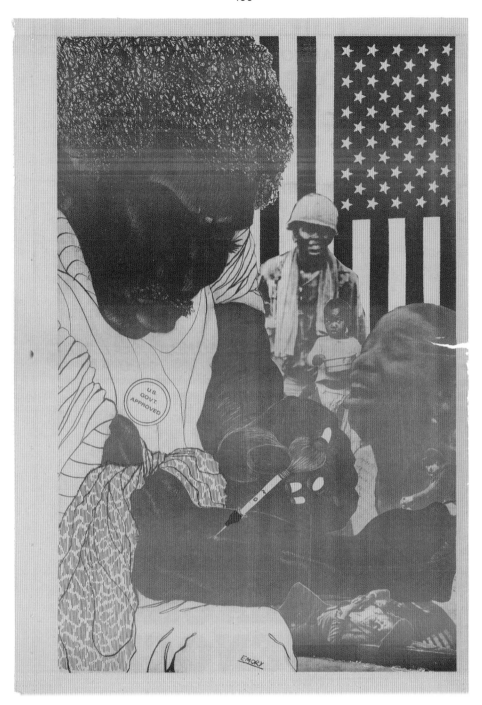

To further the party's platform and goals, Douglas's work employed a variety of styles and techniques. Photographic collages were an efficient way to recycle images and through his bold juxtapositions, he created striking works that had an impact that photographs alone could not produce. Some of Douglas's collages were purely photographic while others combined illustrations and photographs, resulting in some of his most compelling images. For example, in one back-page poster (above), combining an American flag, a black combat soldier, a young person screaming, and a drawing of a man injecting

drugs, Douglas spanned a range of issues—among them the controversial war and the devastating toll of drug abuse—and condensed the anguish being experienced by American black communities into a single image.

Douglas often used contrasts of scale for dramatic effect. This technique was most evident in oversize portraits of party leaders, martyrs, and everyday people who dominated the front and back covers of the *Black Panther*. The figure who loomed largest, both in the party and the public imagination, was Minister of Defense Huey P. Newton. Attractive and photogenic, he was the natural choice to visually represent the party and its programs. In addition to Newton, images of Cleaver, Seale, and other leaders were featured prominently on the cover and in the editorial pages but their faces were not as ubiquitous and widely disseminated as images of Mao Zedong, Che Guevara, and Sandino in their respective countries. What the Black Panther images shared with similar pictures from around the world, was the nearly god-like way Douglas presented them. He alluded to familiar images from art history and popular culture, including religious iconography, and sanctification was a recurring visual device. Douglas used radiating lines emerging from the heads and bodies of people the party thought should be admired and exalted.

Another persistent graphic theme, jail bars, metaphorically reinforced the message that poor and oppressed people were imprisoned by their plight. The bars also literally referred to the disproportionate and often illegal incarceration of black men. Douglas even used the bars frequently as design elements in editorial layouts (see pages 121–25).

Moving between different drawing techniques and materials, Douglas's illustration style ranged from using simple flattened shapes with hard outlines to more complex contoured fine lines to figurative soft-charcoal-and-pencil renderings. Usually, but not always, the boldness of the lines reflected the boldness of the image's message, and this was certainly true of the pig cartoons, his most politically biting representations.

Cartoons of policemen and politicians as pigs were among Douglas's signature images. He was not the first to use pigs to represent the police, but he certainly helped make "pig" the preferred epithet for law enforcement officers in 1960s and '70s counterculture.[15] His cartoons extended the pig icon to represent the entire capitalist military/industrial complex.

Other images addressing police and official misconduct often used a similar thick black line illustration style. One seminal back-page poster refers to the illegal raids and searches conducted by police on Panther members' houses and offices (below). The tag line at the top of the page reads, "Every door that the fascists attempt to kick down will put them deeper into the pit of death. Shoot to kill." A uniformed officer's body is rendered in the heaviest black lines and is at the feet of a woman standing in the doorway. Only her legs are visible, which draws the viewer's attention directly to the fallen person. Douglas often filled every inch of available newsprint with details, elaborating further on the story. In this image, Douglas sets the scene against the background of a run-down apartment,

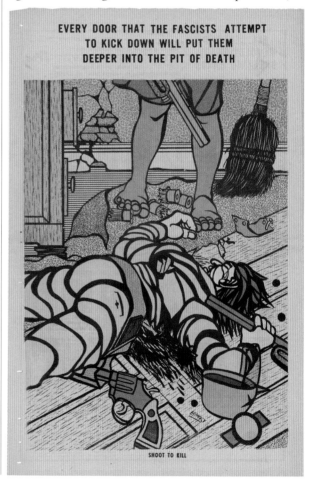

ABOVE
December 14, 1970: A back-page poster that addressed the frequent and illegal raids on the homes and offices of Black Panther members.

15 Erika Doss, "Revolutionary Art is a Tool for Liberation," in *Liberation, Imagination, and the Black Panther Party*, 183.

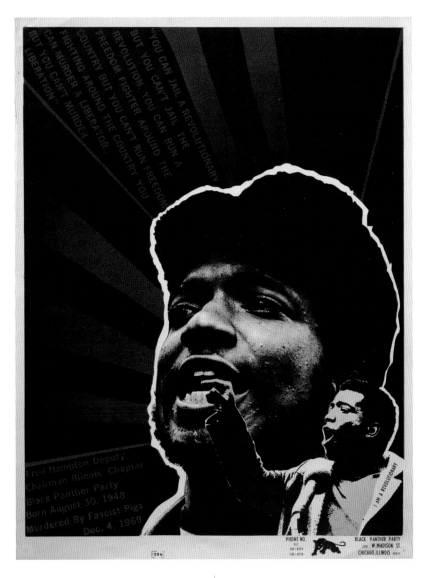

with plaster falling from the cracked walls and a well-used broom leaning against the wall.

Douglas's major artistic innovation was his combination of drawing and graphic design techniques. Even though his illustrations with thick lines are formally similar to Chicano poster art, the addition of texture and collage set his work apart from other protest art. Douglas remained true to a black aesthetic by reaching to the past and borrowing African abstraction techniques while incorporating twentieth-century graphic art innovations like rubdown textures and patterns and showing everyday black life.

During the heyday of the paper, Douglas was well known to his fellow party members and to the paper's readership. Though his name is not currently well known, the style he developed and art he created working for the *Black Panther* has been appropriated and absorbed into mainstream visual culture over the years. Popular culture generally favors the sensational, and the images of Douglas's that persist in our collective memory are the most controversial and subject to misinterpretation. Few people are aware of the hundreds of drawings of ordinary black people that Douglas published. Many more people are familiar with the angry revolutionary icon, which continues to evolve in our visual vocabulary.

In the 1960s, images of the attractive and charismatic Cuban Communist Che Guevara, Newton, and Seale in black berets came to represent revolutionary ideology. Alberto Korda's famous stylized black-and-white photograph from 1960 of Che, shot from a low angle making his face seem even larger, is still a popular icon. Building on the Che icon and invoking the beret's military associations, Douglas created a similar image of Newton, which appeared several times at full-size on the *Black Panther*'s cover and eventually became part of the paper's masthead. The image that persists even thirty years after the dissolution of the party is this one—the mythological armed, beret-wearing hero fearlessly fighting for justice in the black community and defying law enforcement authorities. To many people, both black and white, Newton was Superman, the "chief god in the pantheon of Panthers," and Douglas helped cultivate his persona through images.[16]

As Douglas was influenced by other artists before him, his important work has influenced and been appropriated by contemporary artists, designers, and advertisers who have incorporated some of Douglas's visual language into their work and products. Some of these works are created with the same intention as Douglas's—to effect social change through art. One reading of these images interprets them as respectful homage to Douglas's work and his visual legacy of creating lasting cultural icons. Alternate readings suggest that decontextualizing and presenting these icons to a generation with no real-time memory of the historical situation to which Douglas's work responded results in confusion between the myth of the Black Panthers and their true history.

Regardless of how this contemporary work is read, it is true that the black revolutionary's carefully cultivated image, which was initially terrifying to white Americans and perceived as counterproductive to most middle-class African Americans, lost its power over time. As the original Black Panthers slowly died, went to jail, into exile, or disappeared from public life and their perceived threat waned, the iconic black revolutionary image re-emerged as a benign and romantic signifier of defiance.

Media representations of American racial conflict have shifted over time "to include a desire to elevate … radicals to celebrity status."[17] References to these idealized heroes became part of 1980s and '90s hip-hop culture and were subsequently appropriated by advertising. Clothing companies marketed their products to followers of the urban hip-hop scene using ads featuring stern black men in a military stance or with arms defiantly crossed (the "radical pose"). These images clearly referenced Douglas's art from the *Black Panther*.

One example of Douglas's influence on contemporary graphic work that continues the spirit of his activism is a recent poster for the Denver Pan African Arts Society, which metaphorically turns film into a revolutionary weapon. It recalls both Douglas's bold use of line and color and the OSPAAAL aesthetic. The warrior is a woman, cheerfully marching into battle, which is typical of 1960s revolutionary imagery.

The contemporary Portuguese-born artist Rigo 23 carries on the tradition of activist art that Douglas described in his 1968 manifesto "On Revolutionary Art." In addition to creating numerous politically charged public art projects, Rigo 23 continues to work on raising consciousness about black political

16 Don A. Schanche, *The Panther Paradox: A Liberal's Dilemma* (New York: David McKay Company, 1970), 98.
17 Jane Rhodes, "Fanning the Flames of Racial Discord: The National Press and the Black Panther Party," *Harvard International Journal of Press Politics* 4, no. 4 (1999): 95.

prisoners, particularly the Angola 3, who organized the Angola prison chapter of the Black Panther Party in 1971. In 2002 Rigo 23 and other activists persuaded San Francisco's mayor to declare April 22 "Robert King Day" in honor of Robert King Wilkerson, one of the Angola 3, who was released in 2001. Wilkerson was incarcerated for robbery and subsequently convicted of a prison murder for which he spent twenty-nine years in solitary confinement. He was exonerated after it was revealed that prison officials coerced the testimony used to convict him, presumably because of his affiliation with the Black Panther Party.

To commemorate the San Francisco event, Rigo 23 created a mural on a building facing City Hall that simply read "TRUTH." An image of over two hundred bags of groceries arranged on the grounds at San Francisco's United Nations Plaza, part of the Robert King Day celebration, could represent a conceptual installation homage to the Black Panther Party's grocery giveaways and the Panther logo's lasting signifying power. But, like Douglas, who has been a mentor to the younger artist, Rigo 23's art is an extension of his activism. The bags of groceries were given away to the many homeless people who use the grounds of the plaza daily.

It is works like these and other examples of contemporary art that reference Douglas's art in style or spirit that are keeping his work from the 1960s and '70s in our current visual lexicon. Without them, Douglas's prolific body of work from that time could have easily remained known only to dedicated radicals or the relatively small number of people who have seen the originals. The inevitable disintegration of newsprint and an unwillingness to look at the harsh realities of race and inequality could have easily conspired to keep much of Douglas's work in relative obscurity.

Emory Douglas's art today often depicts happy children, reflecting the party's successes and his personal hopes for the future. His recent drawings show how Douglas's work has always responded to the society he sees around him. When it was necessary, he imagined self-defense and revolution through his work. Because of his role in raising consciousness about brutal and inhumane conditions, Douglas can now imagine what a compassionate and just society might look like.

His images came into my life when I was a teenager in the early 1970s and permanently changed my political and artistic worldview. I am sure the work presented here will have a resonating effect on those who are viewing it for the first time, the same way the images continue to inspire me. The work's power is in its integrity of purpose; to make life better for all disenfranchised people in the world, in particular for African Americans. In representing the quantity, quality, and range of Douglas's work in this book, perhaps there will be a broader understanding of his true legacy as a courageous and brilliant designer and artist "for the people." ●

**ABOVE**
*TRUTH* dedication event by Rigo 23,
at the United Nations Plaza in San Francisco, April 22, 2002.

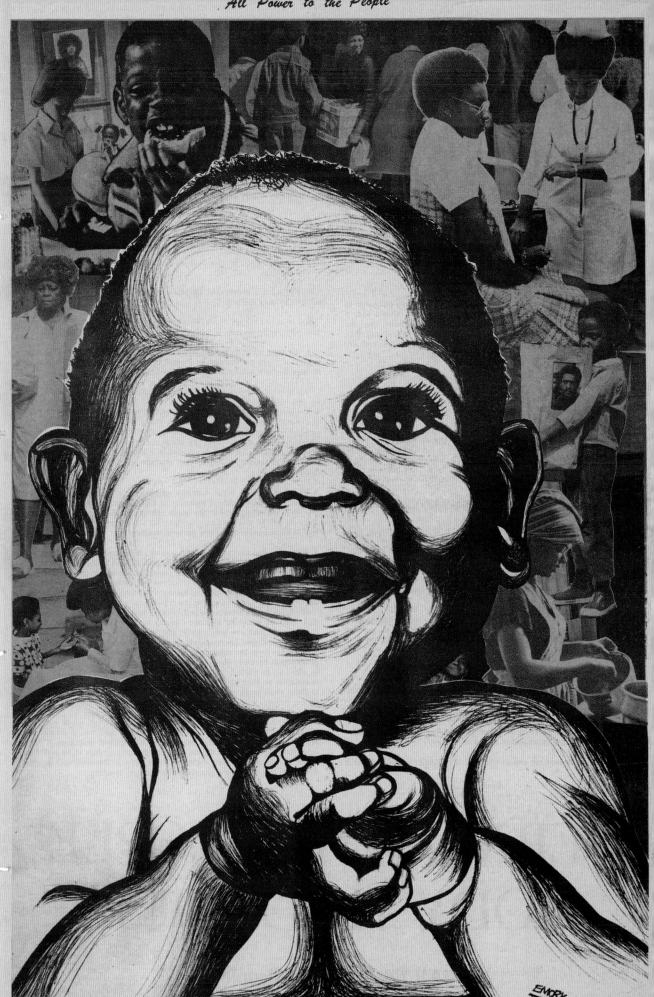

All Power to the People

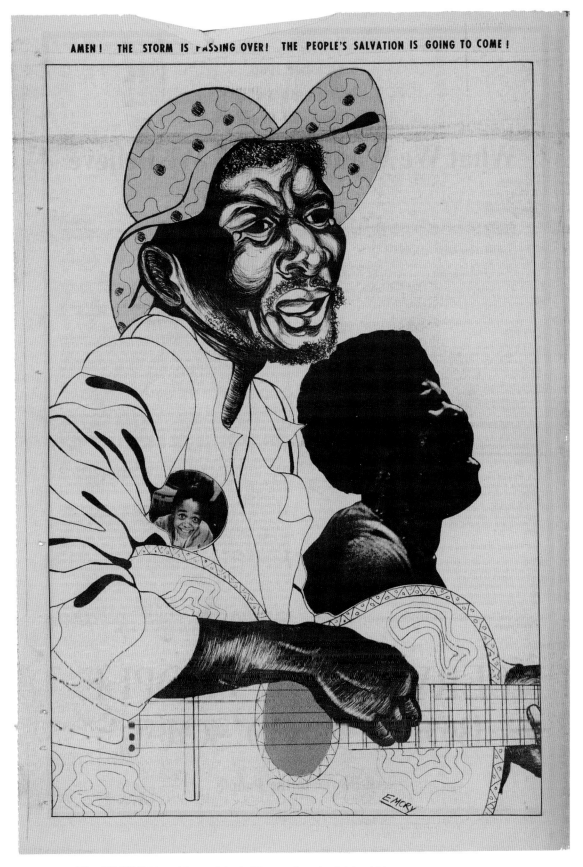

AMEN! THE STORM IS PASSING OVER! THE PEOPLE'S SALVATION IS GOING TO COME!

*Opposite page* **May 22, 1971:** Many of the party's Survival Programs focused on helping children.

**June 5, 1971:** The celebratory tone of the images on pages 110–117 were meant to both inspire and reflect an attitude of self-determination and triumph.

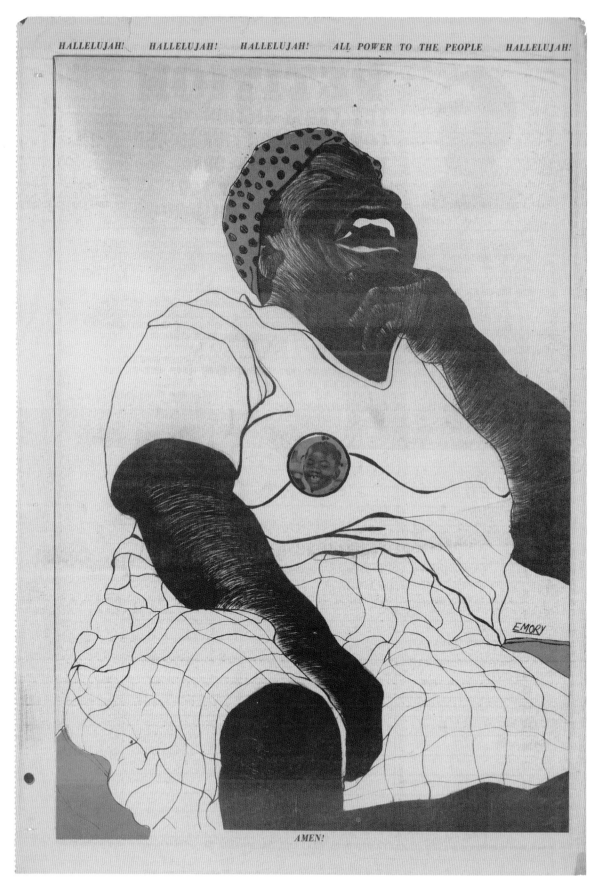

AMEN!

July 10, 1971

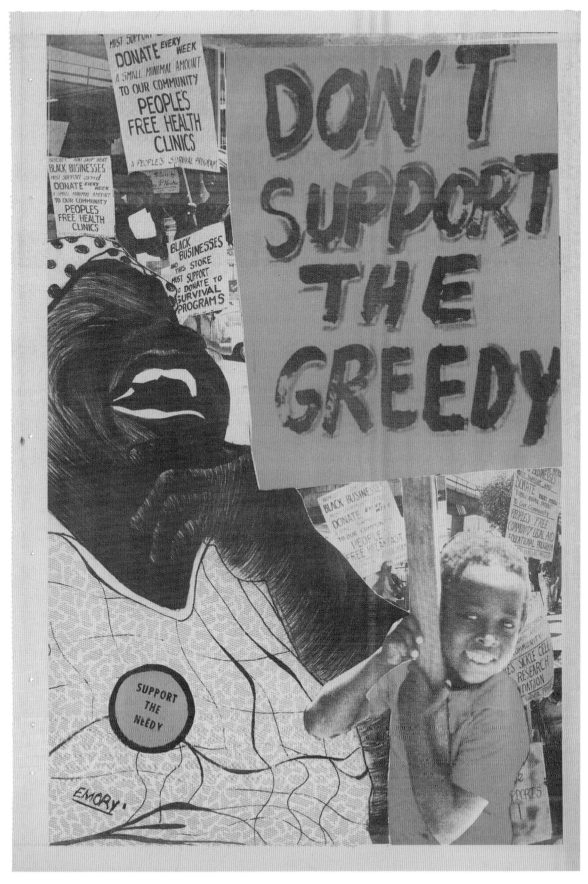

August 9, 1971

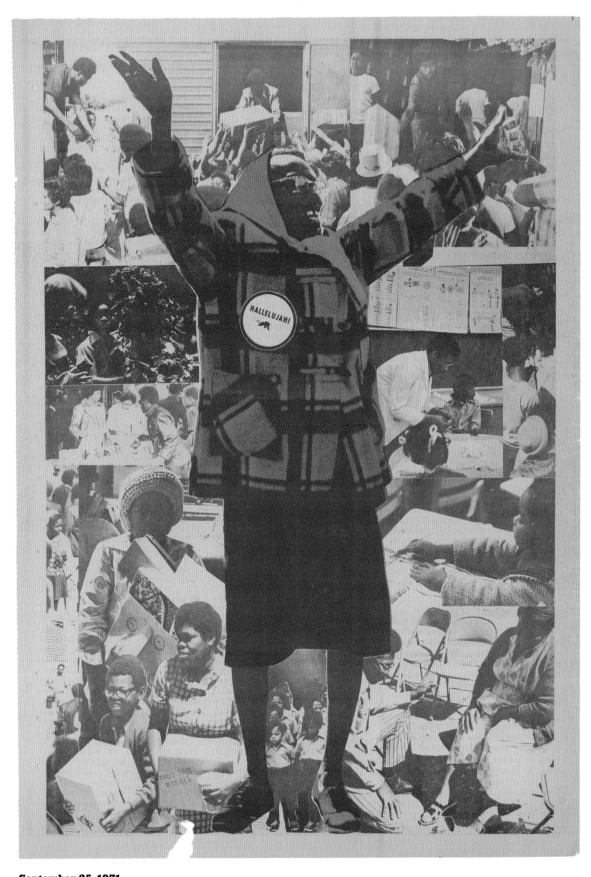

September 25, 1971

*Opposite page* August 21, 1971

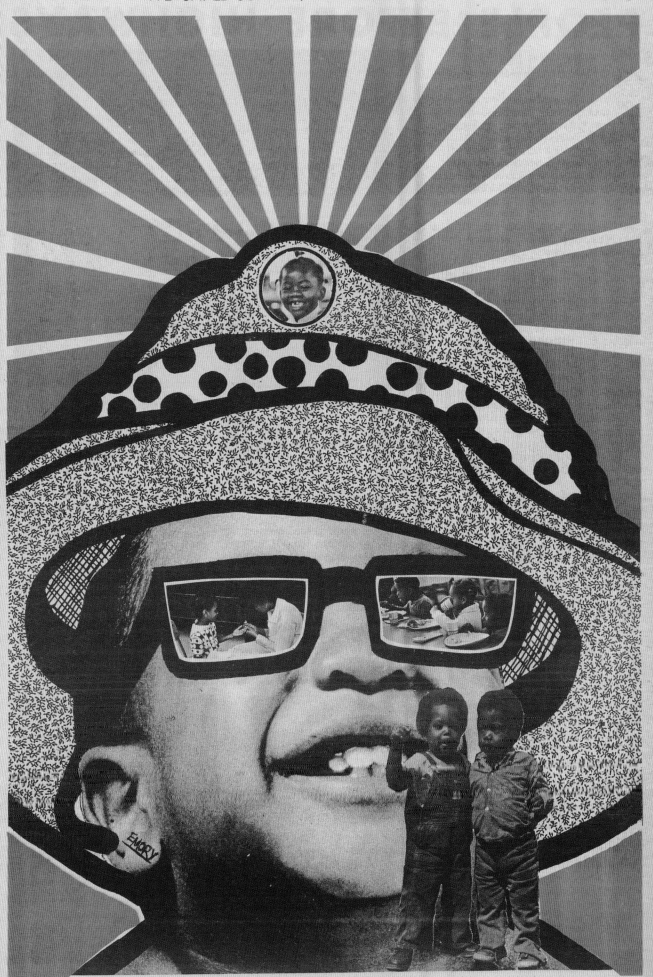

THEY BLED YOUR MAMA    THEY BLED YOUR PAPA    BUT HE WONT BLEED ME

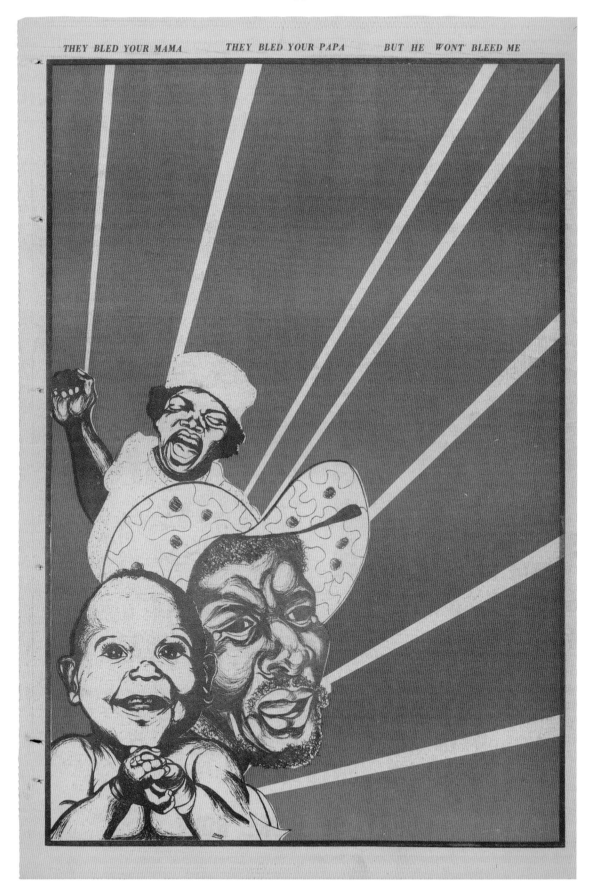

**June 19, 1971**

WE'RE GOING TO KEEP ON STRUGGLING FOR BRIGHTER DAYS
WE'RE GOING TO KEEP ON STRUGGLING UNTIL WE WIN YOUR LOVE.

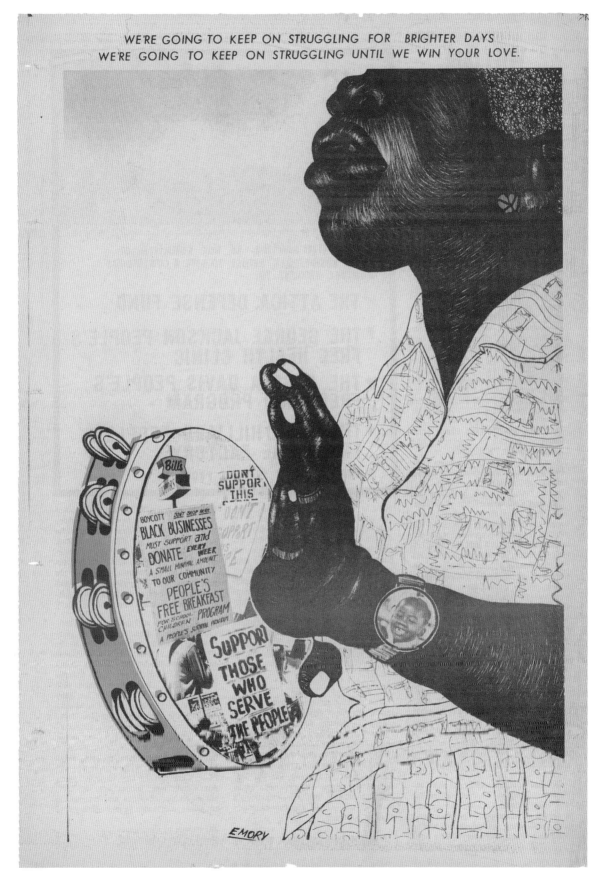

October 4, 1971

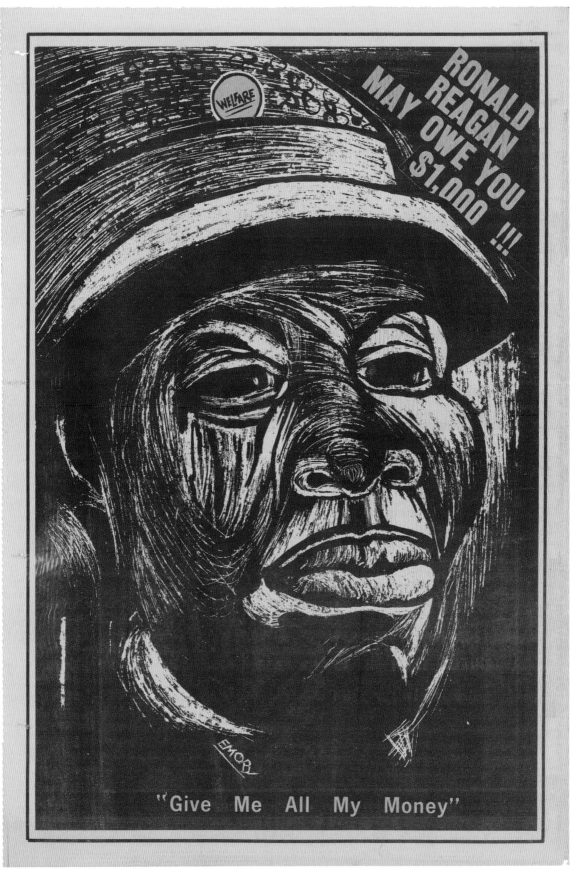

**July 19, 1971:** Ronald Reagan was then governor of California.

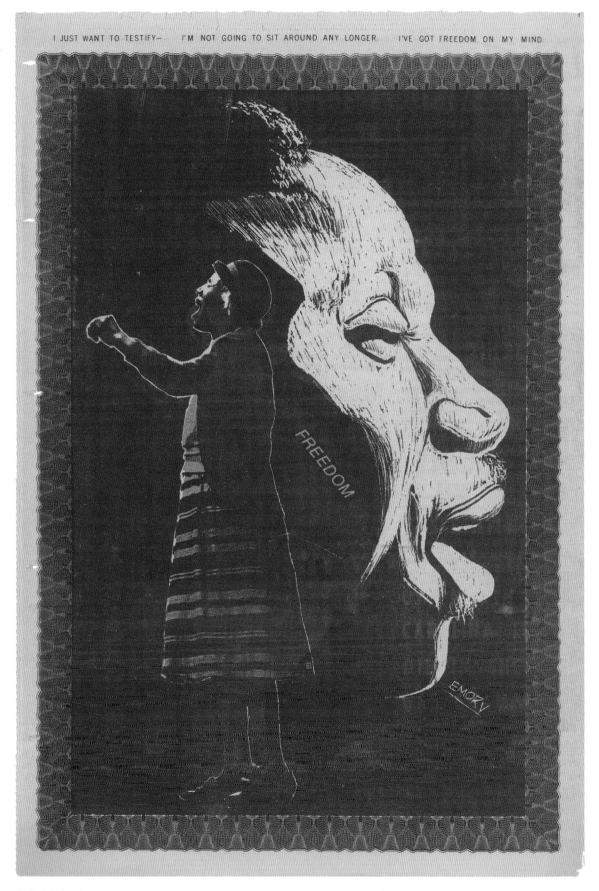

I JUST WANT TO TESTIFY—    I'M NOT GOING TO SIT AROUND ANY LONGER.    I'VE GOT FREEDOM ON MY MIND.

**July 24, 1971:** Inspired by the Civil Rights Movement, this drawing was made in the spirit of Martin Luther King Jr.

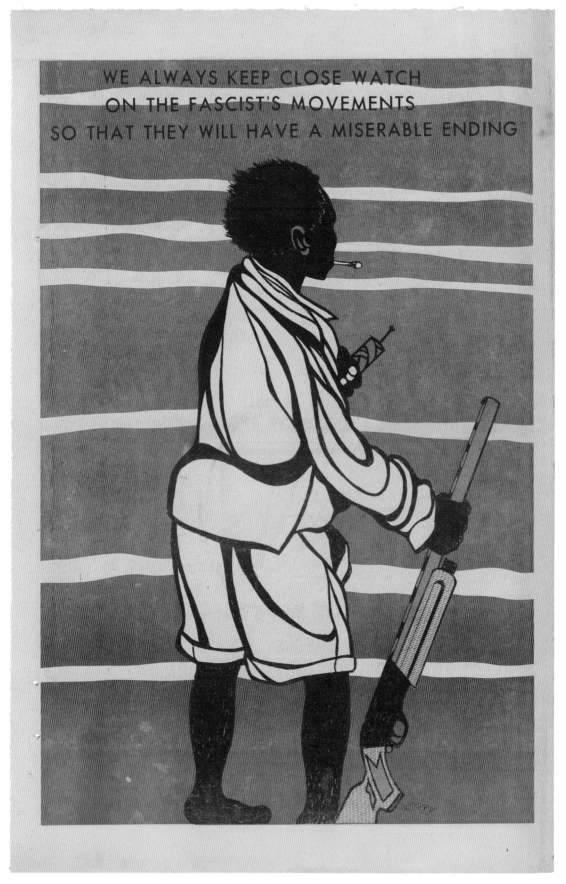

January 16, 1971

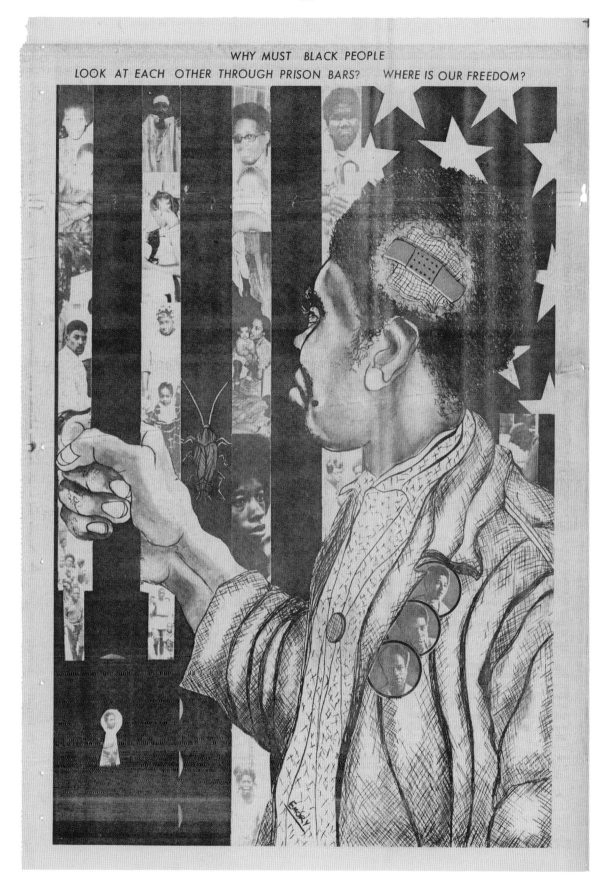

**August 14, 1971:** This image shows an incarcerated man in maximum security. Behind the bars, the community is shown in minimum security. The buttons on the figure contain the faces of the Soledad brothers: George Jackson (top), John Clutchette (middle), and Fleeta Drumgo (bottom).

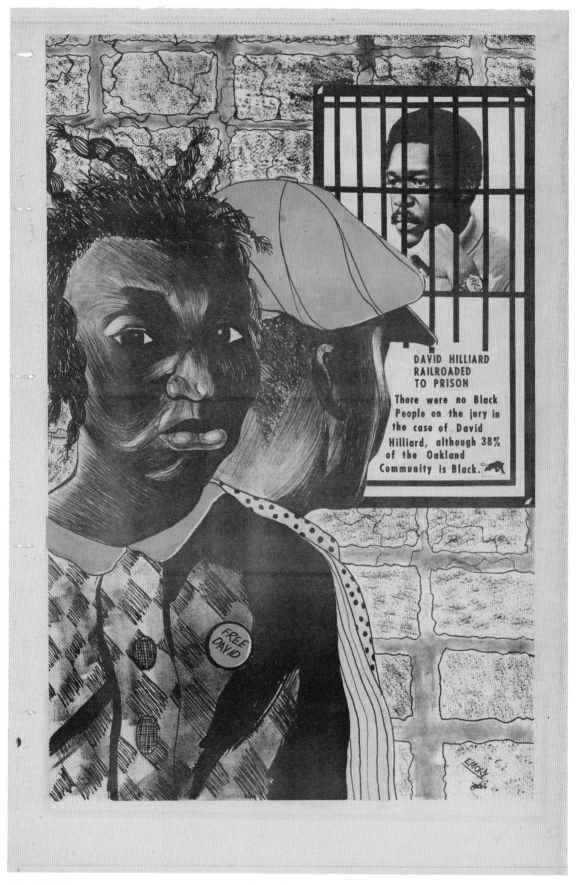

DAVID HILLIARD
RAILROADED
TO PRISON

There were no Black
People on the jury in
the case of David
Hilliard, although 38%
of the Oakland
Community is Black.

**July 3, 1971:** The images on pages 121–25 revisit point number nine of the Ten-Point Platform and Program, illustrating the racist nature of the American justice system. David Hilliard was the Black Panther Party's Chief of Staff, another party leader imprisoned during this period.

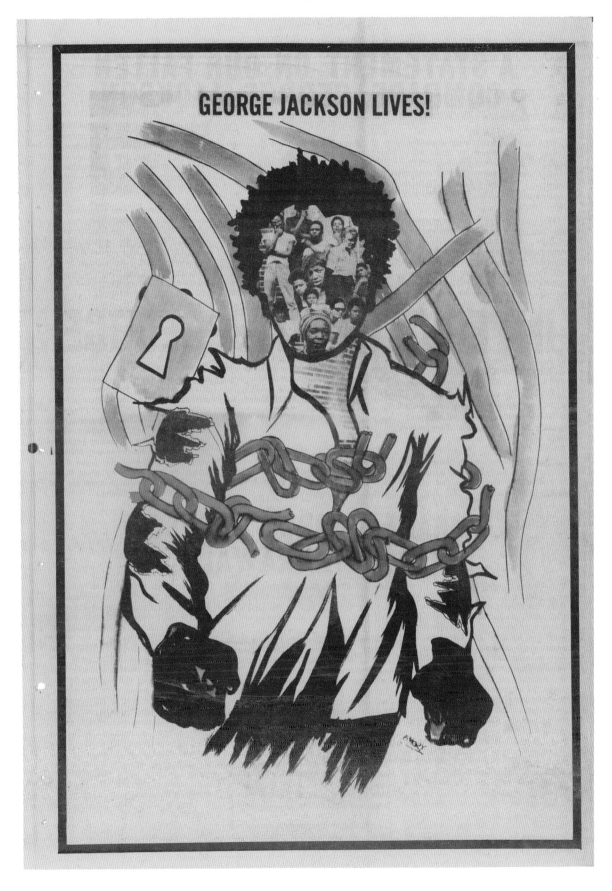

**August 28, 1971:** Remembering George Jackson, author of *Blood in My Eye* and *Soledad Brother,* killed in 1971 in the prison yard at San Quentin.

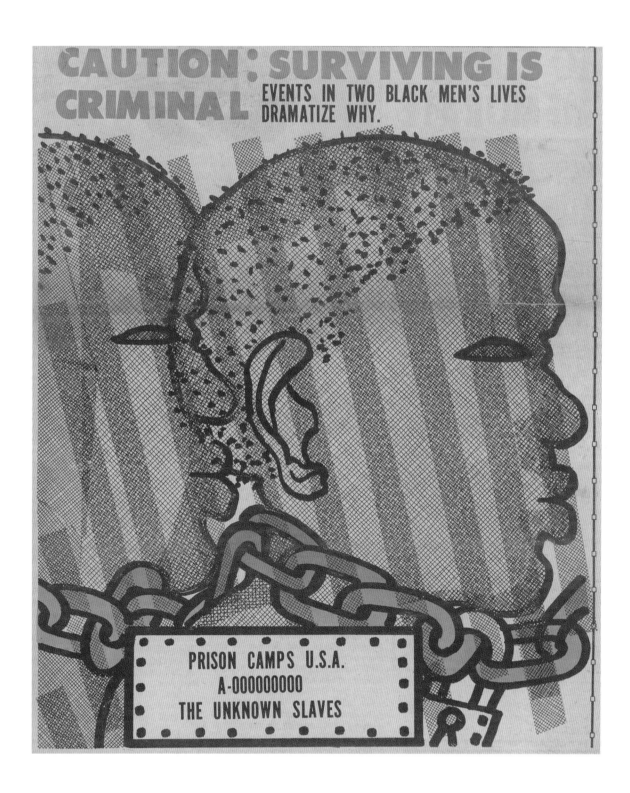

**February 19, 1972:** The headlines above this image refer to two ordinary men
who exemplify the countless "unknown slaves" who suffer unjust incarceration.

MY SUFFERING, MY BITTERNESS, MY LONELINESS; I'M NOT GOING TO LET IT
GET ME DOWN, I'M NOT GOING TO LET IT TURN ME AROUND

MEDIA: PHOTGRAPHIC COLLAGE

August 23, 1972

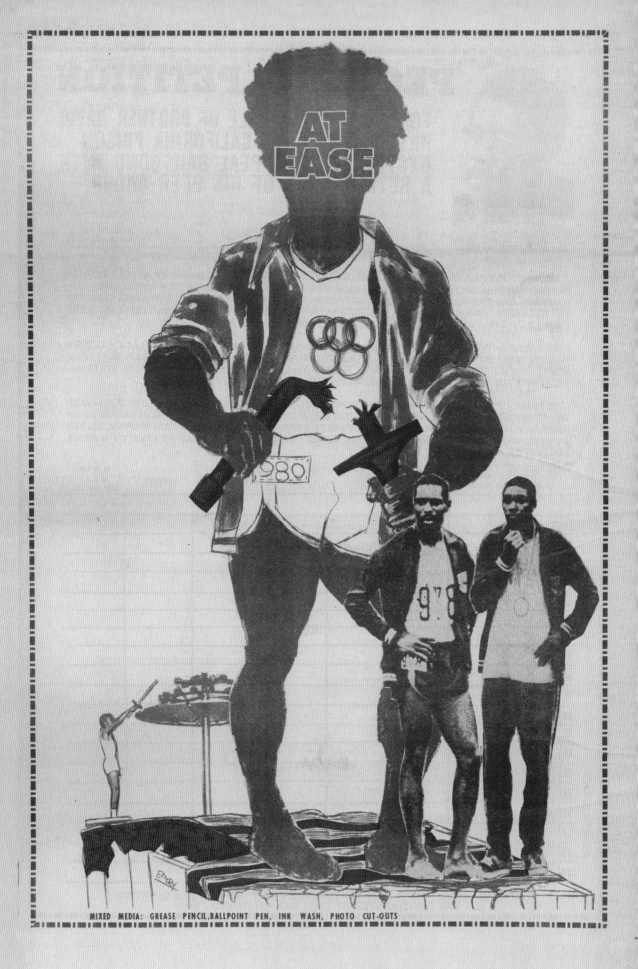

AT EASE

MIXED MEDIA: GREASE PENCIL, BALLPOINT PEN, INK WASH, PHOTO CUT-OUTS

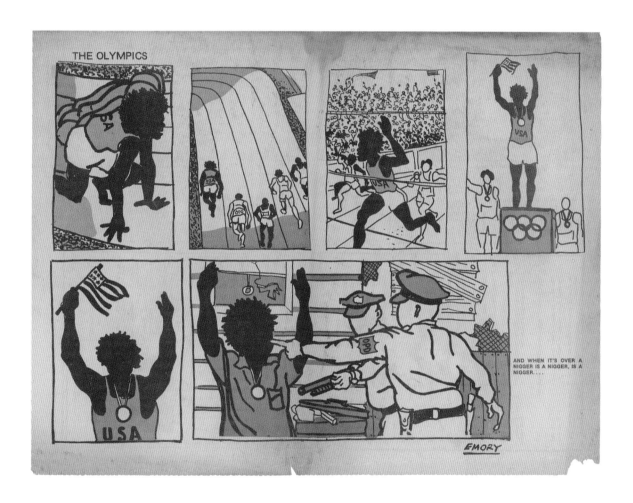

*Opposite page* **September 16, 1972:** Inspired by John Carlos and Tommy Smith's actions in the 1968 Olympics, these two athletes protested during the medal ceremony by not standing at attention during the playing of the national anthem.

**August 7, 1976:** In this drawing, Douglas shows that despite a black athlete's achievements at the Olympics, his victory does not shield him from the effects of racism.

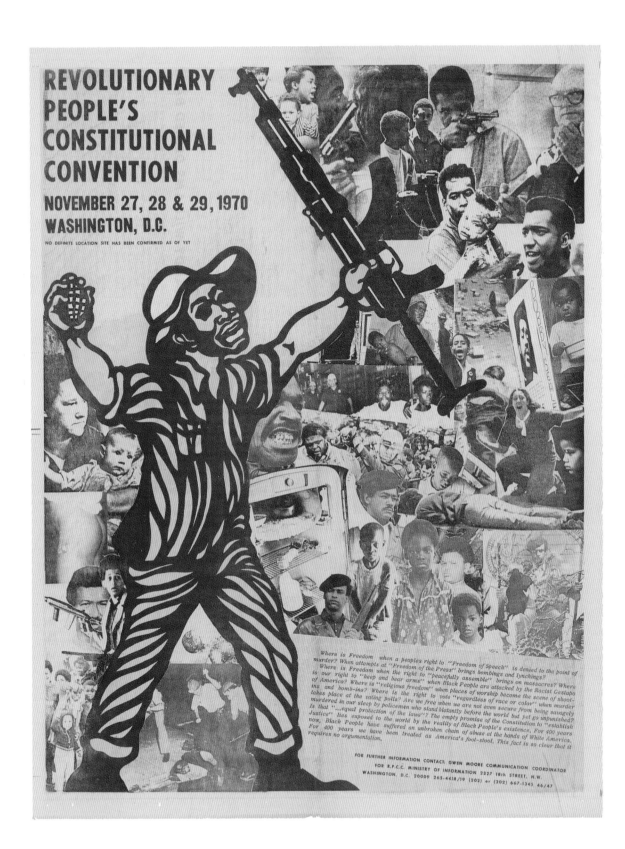

**October 24, 1970:** Fifteen thousand people representing a multitude of progressive political groups and ideological positions went to Washington, D.C., to attend the Revolutionary People's Constitutional Convention. Douglas made this poster to advertise the event.

*GREG JUNG MOROZUMI*

# EMORY DOUGLAS AND THE THIRD WORLD CULTURAL REVOLUTION

***Palante ... Getting Together ... Kalayaan ... Basta Ya! ... The New African ... The Black Panther***—Third World America shouted from newsprint mastheads calling for a common agenda in the late '60s— REVOLUTION! In days not too long before the "Digital Divide," America's urban landscape was plastered with mimeographed flyers and silkscreened posters while independent tabloids were regularly hawked on neighborhood street corners. The proliferation of Movement newspapers expressed the political dissent and creative defiance of awakening Black communities and other minorities who now began to identify themselves as part of the Third World, the nations of Asia, Africa, and Latin America fighting for liberation from the Western colonial powers.

It was during the heady days of the late '60s that a militant underground press and an alternative graphic culture thrived. While mainstream historians often romanticize and more often demonize that period, it's clear now that it must be reexamined to help make sense of today's suffocating world of declared "war without end" and its dire consequences. Revisiting the intellectual will and creative imagination that spurred the idealism of legions of people to engage in the real world, and to fight to change it, may still offer some clarity and direction for the current international situation.

Today's generation of arts activists frequently question how we've come to this reactionary climate of political and cultural repression after such a dynamic era of revolutionary activism. The world was a very different place in the '60s when national liberation movements and anticolonial struggles rose up throughout Asia, Africa, and Latin America and reverberated across the globe. It was a time of political upheaval and armed revolution against Western empires. Some historians have termed this the Bandung Era—a continuum of the internationalist spirit that lasted until the mid-1970s and originated at the 1955 Bandung Conference in Indonesia where Asian and African nations first gathered in solidarity against Western colonialism, calling for both Third World cooperation and self-determination. The incendiary international situation sent powerful currents to an anesthetized American public whose newly conscious world perspective would never again be diverted from its own government's imperialistic foreign policies and the apartheid-like domestic race relations, which were facing angry confrontations at home and abroad. No sector was as galvanized into action as the African American masses, and inevitably into the fray was born the Black Panther Party.

Emory Douglas, the Panthers' Revolutionary Artist and Minister of Culture, eventually sat on the Central Committee alongside the more recognized spokespersons Huey P. Newton, Bobby Seale, Eldridge Cleaver, David Hilliard, and Kathleen Cleaver. In contrast to the other Panthers' duties, Emory's role was to *visu-*

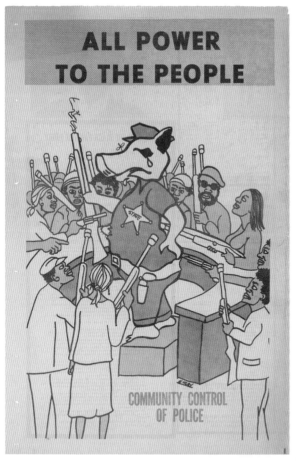

ALL POWER
TO THE PEOPLE

COMMUNITY CONTROL
OF POLICE

incisive cartoons were as anxiously anticipated by its broad readership as the regular updates it provided on the domestic and worldwide social uprisings. Its popular, mass style appealed both to the illiterate and to the newly awakened intelligentsia.

Emory was especially adept at conveying the inflamed sentiment of the grassroots Black community, who were keenly aware of the racism which kept them disempowered and the mass media that made them voiceless and invisible. His depictions of militant resistance further emboldened the community to take action and support the new Black insurgency. The Panther program, in particular, found guidance in Mao Zedong's writings on mass organizing and Frantz Fanon's *Wretched of the Earth*, the acclaimed "handbook of the Black Revolution."

In this manifesto critiquing colonialism and neo-colonialism, Fanon stresses the importance of culture to solidify a collective national consciousness, and the Panthers understood that Black identity by itself was not enough. While calling for a unified Black community to play a vanguard role against systemic racism, the Black Panther Party believed in alliances with all nationalities. "All Power to the People" subsumed chants of "Black Power!" But it was not contradictory that the instinctively gritty emphasis of Emory's graphics bolstered Black national consciousness and mocked the values of White supremacy. There could be no multinational united front without simultaneous Black unity. Emory's drawings for the paper also famously represented another Fanonian principle—advocating armed self-defense and revolutionary violence against the oppressors. In his images everyday Black people had guns—workers, housewives, grandmothers, the newspaper boy—and they were not to be messed with. The very appearance of guns in mobilized Black hands—like the Panthers' community police patrols—would deter state violence and heal the battered Black psyche (today an untenable concept since the fratricidal wars that broke out in the '80s), victimized from years of White racist terror. Fanon recognized the psychological distinction between collectively turning weapons against an oppressive system rather than succumbing to the colonial mentality of dog-eat-dog violence.

*ally* articulate the revolutionary ideology and program of the party, and his primary canvas was the *Black Panther* newspaper.

Emory was responsible for most of the provocative guerrilla graphics of the *Black Panther*, already a weekly by 1968, with potent images of Black militants armed with carbines, Black community residents retaliating against greedy landlords, "pig" cops, bought judges, and paid-for politicians, who were identified as symbols of a decaying capitalist system. The front and back pages were boldly designed with amplified slogans and magnified icons and cartoons. Most impressive were Emory's press-type layouts with full-page graphics and photomontages that moved beyond the era's psychedelic Haight-Ashbury poster designs, fueled by the rebellious heat of San Francisco's Black Fillmore culture. The offset newspaper, technically a printmaking process, became his original artwork. Centerfold pages functioned as large political posters, which plastered bedroom and living-room walls throughout Oakland as a daily reminder that The Revolution was imminent. The newspaper's arresting graphics and

But the Panthers' heroic symbols and satirized cartoons became the ideal political propaganda to catalyze the sentiment of the tumultuous times. It reverberated throughout the Movement, especially with newly radicalized Third World activists ready to move beyond the pacifist civil rights proclamations that previously dominated the scene.

## THE INFLUENCE OF MALCOLM X

Setting the stage for a new direction in the Black Liberation Movement, Malcolm X, the brilliant spokesman for the Nation of Islam, electrified Harlem rallies and mesmerized grassroots Black audiences across the country by exposing America's racial dynamics and articulating the aspirations of the common folk for fundamental change. Malcolm X represented a philosophical departure from the mainstream Civil Rights Movement which relied heavily on nonviolent civil disobedience and legislative reform to redress a history of institutionalized racism; but its Christian-based leadership, led by the deified Dr. King, was rapidly losing its moral authority over the frustrated Black masses who regularly faced down unfriendly troops, truncheons, firehoses, and attack dogs. The country was at war and the bloody violence did not subside with their nonviolent tactics, but only seemed to invite more violent reaction from both the state police and vicious, racist vigilantes. After Malcolm's

break from the Nation of Islam, his potential to lead a national Black revolutionary organization was rightly viewed as a great threat by the government's security agencies. But the assassination of Malcolm X on February 21, 1965 was a grave error on the part of the guardians of capitalism and White supremacy, as his martyrdom would forever symbolize the African American quest for liberation "by any means necessary" for generations to come.

Bobby Seale, the soon-to-be founder of the Black Panther Party, recounts how at the very moment upon hearing of Malcolm's death, he became catalyzed into seeking something more radical and militantly action-oriented that would justly represent the revolutionary principles Malcolm articulated. The program of Malcolm X's secular OAAU (Organization of Afro-American Unity) called for Self-Respect, Self-Defense, and Self-Determination for the African American people, and it provided a basic framework for the Black Panther Party. It also included a section on revolutionary culture which declared: "Culture is an indispensable weapon in the freedom struggle"—a principle Emory would take to heart in his visual representations of Malcolm as the embodiment of Black liberation.

Another seminal influence on the formation of the Black Panther Party for Self-Defense was Robert Franklin Williams, the former NAACP head of Monroe, North Carolina, who gained notoriety for confronting the local KKK with guns and advocating armed self-defense in the late 1950s. However, he was forced into exile in 1961 along with his family and sought refuge in Cuba and then the People's Republic of China, where they were treated as diplomats. Williams, like Malcolm, began to align Black liberation in the U.S. with national liberation movements in the Third World rather than the reformist civil rights campaign, and he found an audience with such iconic revolutionaries as Che Guevara, Fidel Castro, Julius Nyerere, Ho Chi Minh, and Mao Zedong.

From overseas, Williams and his wife, Mabel, produced the *Crusader*, a small-format newsletter that was sent back to the states to internationalize the Black cause and was mainly illustrated with poignant cartoons condemning American racism by Anne Lim, a Chinese Canadian artist. Robert F. Williams and Malcolm X, both key inspirations for the Black Panther Party, set the nonpacifist, unsubmissive tone for the emerging Black Power Movement. Significantly, Bobby Seale read Williams's influential book *Negroes With Guns* and became a member of his Revolutionary Action Movement (RAM) before leaving the organi-

zation to form the Black Panthers in Oakland along with Huey P. Newton. The Watts uprising happened the same year as Malcolm's assassination (1965), and dozens of other cities went up in angry flames, most notably, Newark in '67 and Detroit in '68, and the scorching scent of rebellion was in the air.

Integral to the groundswell of activity, the growing Black Arts Movement became a cultural springboard for Black Power consciousness, spearheaded by the always controversial poet and playwright Amiri Baraka (then known as LeRoi Jones), again as a response to Malcolm's untimely death. Baraka came west to teach theater workshops at San Francisco State University and to contribute to the Black House, a cultural space founded by the young poet Marvin X, spreading the Black arts renaissance with injections of national consciousness in the performing, visual, and literary arts. An inspired Emory met Baraka and began designing stage sets and publicity brochures. Emory soon joined the Panthers after they provided an armed escort for Malcolm's widow Betty Shabazz from the San Francisco airport.

The Black Panthers weren't the only Black organization that would claim to be the heirs of Malcolm X's legacy, and suddenly his name, face, and words were ubiquitous in publications and organizational programs across the nation. And as the influence of Malcolm X was felt by the Black Panther Party and other groups like it, the party in turn influenced their Asian American and Latino counterparts, as evidenced by their presence on the bilingual pages of Third World revolutionary newspapers.

### THIRD WORLD ORGANIZATIONS

The Black Panther Party was but one of many new African American revolutionary organizations that emerged post-Malcolm, and the full momentum of the Black Liberation Movement had a profound impact on the rise of the new Third World Left in the U.S. But the bold vision of armed, disciplined, and even uniformed ranks of militant Black Panthers brazenly confronting "The Man" quickly sparked the imaginations of angry, progressive ghetto youth and students from coast to coast. Other Black, Latino, and Asian groups modeled their political programs almost verbatim after the widely publicized Ten-Point Platform and Program of the Black Panther Party. They all called for self-determination for their people, for decent housing, for community control of their education, for free health

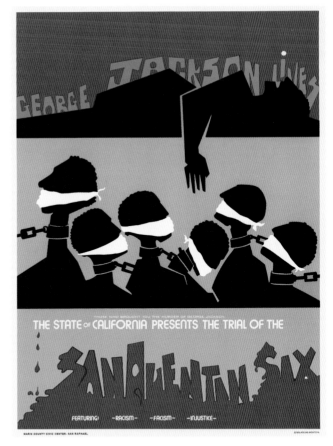

and childcare, an end to police brutality and prisons, exemption from military service, and an end to the war in Viet Nam. They all declared themselves internationalists and they demanded a socialist society.

Just like the Panthers' Survival Programs in the Black communities, the Young Lords organized free breakfast and free literacy programs in the Puerto Rican barrios of East Harlem and the South Bronx in New York City; the Brown Beret distributed free clothes and free food to Chicanos in East L.A.; The Red Guard and I Wor Kuen provided free health clinics and free legal aid in San Francisco and New York Chinatowns.

The widespread circulation of multilingual revolutionary newspapers helped the groups to branch out and build alliances. Their publications even resembled the *Black Panther* newspaper, imitating Emory's graphic format, covering common issues, and occasionally exchanging articles. The publication *Basta Ya!* of Los Siete de la Raza, a revolutionary Chicano organization in San Francisco, was actually incorporated into the *Black Panther* for several weeks in 1969 (see page 135).

---

**ABOVE**
*George Jackson Lives*, 1976, offset lithograph.
George Jackson, recruited by the Black Panthers in prison,
became a revolutionary martyr for prisoners' rights when he was gunned
down by guards at San Quentin in 1971. This poster is by Chicano
poster artist Malaquias Montoya, who helped form the Mexican American
Liberation Art Front in Oakland, California, in 1968, an organization
that found political inspiration in the Black Arts Movement.

# OCTOBER 1966 BLACK PANTHER PARTY PLATFORM AND PROGRAM

**WHAT WE WANT**

**WHAT WE BELIEVE**

1. We want freedom. We want power to determine the destiny of our Black Community.

We believe that black people will not be free until we are able to determine our destiny.

2. We want full employment for our people.

We believe that the federal government is responsible and obligated to give every man employment or a guaranteed income. We believe that if the white American businessmen will not give full employment, then the means of production should be taken from the businessmen and placed in the community so that the people of the community can organize and employ all of its people and give a high standard of living.

3. We want an end to the robbery by the white man of our Black Community.

We believe that this racist government has robbed us and now we are demanding the overdue debt of forty acres and two mules. Forty acres and two mules was promised 100 years ago as restitution for slave labor and mass murder of black people. We will accept the payment in currency which will be distributed to our many communities. The Germans are now aiding the Jews in Israel for the genocide of the Jewish people. The Germans murdered six million Jews. The American racist has taken part in the slaughter of over fifty million black people; therefore, we feel that this is a modest demand that we make.

4. We want decent housing, fit for shelter of human beings.

We believe that if the white landlords will not give decent housing to our black community, then the housing and the land should be made into cooperatives so that our community, with government aid, can build and make decent housing for its people.

5. We want education for our people that exposes the true nature of this decadent American society. We want education that teaches us our true history and our role in the present-day society.

We believe in an educational system that will give to our people a knowledge of self. If a man does not have knowledge of himself and his position in society and the world, then he has little chance to relate to anything else.

6. We want all black men to be exempt from military service.

We believe that Black people should not be forced to fight in the military service to defend a racist government that does not protect us. We will not fight and kill other people of color in the world who, like black people, are being victimized by the white racist government of America. We will protect ourselves from the force and violence of the racist police and the racist military, by whatever means necessary.

7. We want an immediate end to POLICE BRUTALITY and MURDER of black people.

We believe we can end police brutality in our black community by organizing black self-defense groups that are dedicated to defending our black community from racist police oppression and brutality. The Second Amendment to the Constitution of the United States gives a right to bear arms. We therefore believe that all black people should arm themselves for self defense.

8. We want freedom for all black men held in federal, state, county and city prisons and jails.

We believe that all black people should be released from the many jails and prisons because they have not received a fair and impartial trial.

9. We want all black people when brought to trial to be tried in court by a jury of their peer group or people from their black communities, as defined by the Constitution of the United States.

We believe that the courts should follow the United States Constitution so that black people will receive fair trials. The 14th Amendment of the U.S. Constitution gives a man a right to be tried by his peer group. A peer is a person from a similar economic, social, religious, geographical, environmental, historical and racial background. To do this the court will be forced to select a jury from the black community from which the black defendant came. We have been, and are being tried by all-white juries that have no understanding of the "average reasoning man" of the black community.

10. We want land, bread, housing, education, clothing, justice and peace. And as our major political objective, a United Nations-supervised plebiscite to be held throughout the black colony in which only black colonial subjects will be allowed to participate, for the purpose of determining the will of black people as to their national destiny.

When, in the course of human events, it becomes necessary for one people to dissolve the political bands which have connected them with another, and to assume, among the powers of the earth, the separate and equal station to which the laws of nature and nature's God entitle them, a decent respect to the opinions of mankind requires that they should declare the causes which impel them to the separation.

We hold these truths to be self-evident, that all men are created equal; that they are endowed by their Creator with certain unalienable rights; that among these are life, liberty, and the pursuit of happiness. That, to secure these rights, governments are instituted among men, deriving their just powers from the consent of the governed; that, whenever any form of government becomes destructive of these ends, it is the right of the people to alter or to abolish it, and to institute a new government, laying its foundation on such principles, and organizing its powers in such form, as to them shall seem most likely to effect their safety and happiness. Prudence, indeed, will dictate that governments long established should not be changed for light and transient causes; and, accordingly, all experience hath shown, that mankind are more disposed to suffer, while evils are sufferable, than to right themselves by abolishing the forms to which they are accustomed. But, when a long train of abuses and usurpations, pursuing invariably the same object, evinces a design to reduce them under absolute despotism, it is their right, it is their duty, to throw off such government, and to provide new guards for their future security.

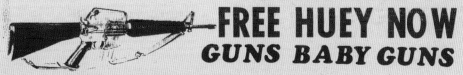

# FREE HUEY NOW
## GUNS BABY GUNS

**February 2, 1969:** The original Ten-Point Platform and Program as it was written in 1966. It was updated and modified as the party's positions evolved in response to changing social, political, and economic conditions.

**1971:** Third World organizations such as I Wor Kuen (Righteous Harmonious Fist) adopted programs modeled after the Black Panther Party. IWK merged with San Francisco's Red Guard Party in 1970 and distributed the *Getting Together* newspaper nationwide. Leland Wong's graphic depiction of avaricious businessmen and brutal police as pigs was an obvious nod to Douglas's political satire.

On one cover of *Getting Together*, the newspaper of I Wor Kuen (translated as "Righteous Harmonious Fist"), artist Leland Wong pays homage to Emory's cartoons with a caricature of armed Chinese citizens celebrating over a despised slaughtered pig, proclaiming "Year of the People—Off the Pig!" (opposite). It was an obvious reference to the rampant police abuse in Chinatown. Another I Wor Kuen cartoon depicts Richard Nixon as vermin in a Year of the Rat poster. Then-California governor Ronald Reagan made a feeble attempt to transform the denigrating pig symbol as an acronym for "Pride-Integrity-Guts," even distributing buttons, but it didn't fly. The universal image of cops as slovenly, brutal swine stuck, and it's no coincidence that even today, cops are commonly referred to as "puercos" or "chuletas" (porkchops) in the barrio.

But the famous pigs and hypothetical scenes of payback by the citizenry weren't the only images Emory created, and in fact existed only in the early years of the *Black Panther*. He portrayed the Survival Programs, the electoral campaigns, the political pris-

oners, the international liaisons, and always celebrated Black pride in his prodigious output of artwork.

Emory was impressed with the proliferation of revolutionary posters and publications coming out of Cuba, Viet Nam, and China, even reproducing some in the *Black Panther*. The Cubans recycled Emory's graphics, transforming one familiar Emory signature into a poster by OSPAAAL (Organization of Solidarity of the People of Asia, Africa, and Latin America). Consciously or unconsciously, the newly revived national movements in the United States that emerged post-Malcolm became part of the Bandung era.

Emory's creative efforts didn't go unnoticed by the government keepers of the order who were determined to undermine the Panther Party infrastructure through both covert infiltration and overtly violent assaults. Entire issues of the newspaper would be seized or destroyed, offices ransacked, financial records stolen, and finally the *Black Panther* distribution manager, Sam Napier, was tortured and murdered. The FBI even created their own acrid comics with the

 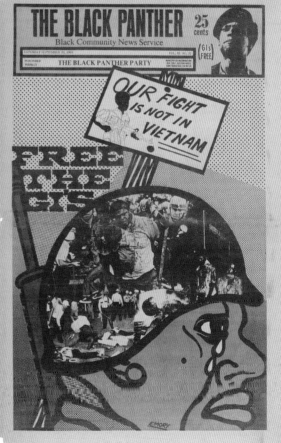

**ABOVE**
September 20, 1969: The Black Panthers influenced other revolutionary groups in the U.S., such as the Young Lords, the Brown Beret, the Red Guard, I Wor Kuen, and Los Siete de la Raza, whose newspaper *Basta Ya!* was published together with the *Black Panther* for a short time in 1969.

GREG JUNG MOROZUMI

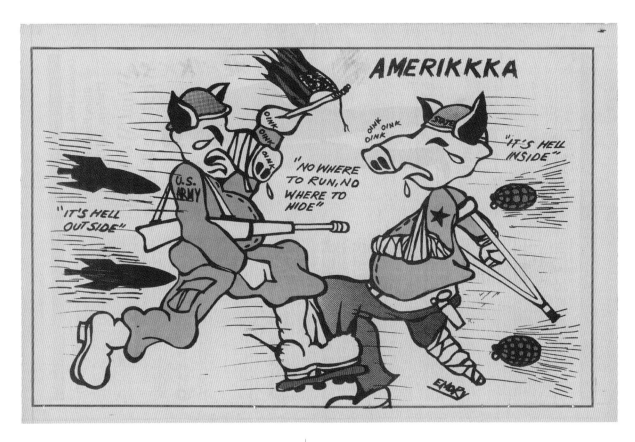

explicit aim of inciting bloody warfare between Black Liberation Movement factions. Ultimately, the Black Panther Party was dismantled by internal splits and through the divisive manipulations of government agents. As the aging Panthers gathered in Oakland for their fortieth anniversary reunion in 2006, they were compelled to take stock of both their contributions and their errors, faced with the reality that many of their comrades did not survive the ride, and dozens of ex-Panthers remain incarcerated as political prisoners even today.

The timeless relevance of Emory Douglas compels us to reexamine the very function and purpose of art and its transformative powers. Rather than reinforcing the cultural dead end of "post-modern" nostalgia, the inspiration of his art raises the possibility of rebel-

lion and the creation of new revolutionary culture. Emory's resolve is simply his confidence in the people even in this repressive era of shrinking democratic space. It is the role of a conscious artist to encourage mass defiance against the "Paper Tiger" (Mao's belittling of U.S. imperialism), vulnerable even in its stubborn determination to wage war once again.

Emory's graphics captured the imagination of an entire generation of new radical activists in the '60s, especially inspiring Third World movements, and significantly his art still resonates with contemporary hip-hop culture and its caustic lyrics of urban strife. One bold headline from the *Black Panther* poses a challenge for the next generation with the courage to dream: DARE TO STRUGGLE—DARE TO WIN! ●

**ABOVE**
January 17, 1970

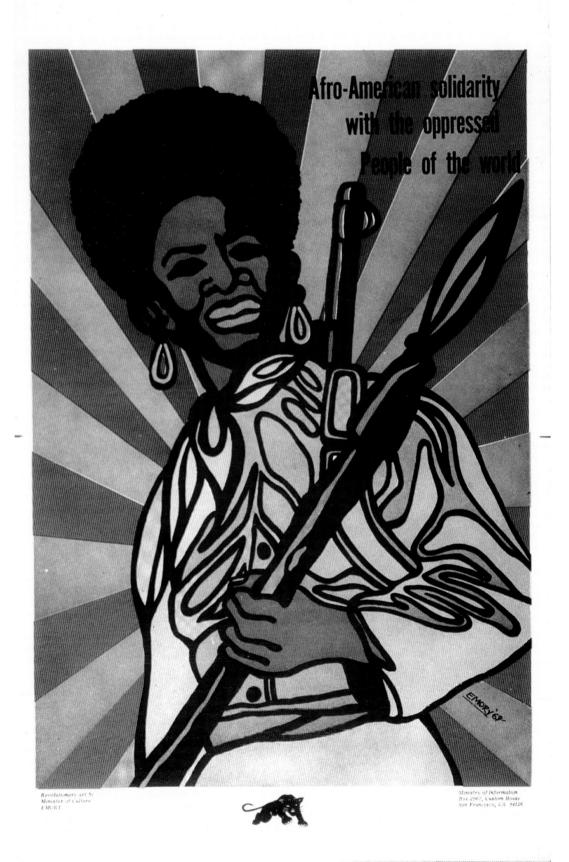

**1969:** This image was reworked from an earlier version that was published in the *Black Panther* newspaper.

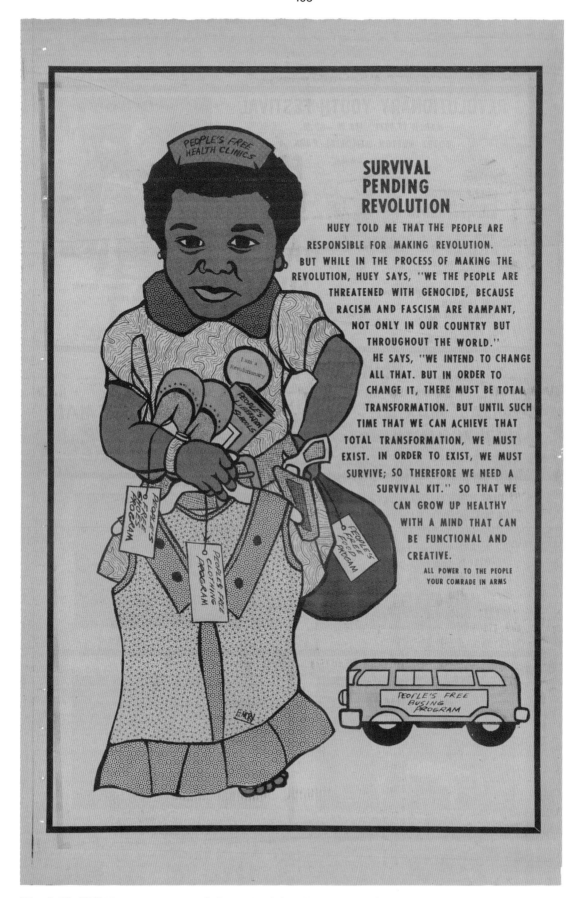

## SURVIVAL PENDING REVOLUTION

HUEY TOLD ME THAT THE PEOPLE ARE RESPONSIBLE FOR MAKING REVOLUTION. BUT WHILE IN THE PROCESS OF MAKING THE REVOLUTION, HUEY SAYS, "WE THE PEOPLE ARE THREATENED WITH GENOCIDE, BECAUSE RACISM AND FASCISM ARE RAMPANT, NOT ONLY IN OUR COUNTRY BUT THROUGHOUT THE WORLD." HE SAYS, "WE INTEND TO CHANGE ALL THAT. BUT IN ORDER TO CHANGE IT, THERE MUST BE TOTAL TRANSFORMATION. BUT UNTIL SUCH TIME THAT WE CAN ACHIEVE THAT TOTAL TRANSFORMATION, WE MUST EXIST. IN ORDER TO EXIST, WE MUST SURVIVE; SO THEREFORE WE NEED A SURVIVAL KIT." SO THAT WE CAN GROW UP HEALTHY WITH A MIND THAT CAN BE FUNCTIONAL AND CREATIVE.

ALL POWER TO THE PEOPLE
YOUR COMRADE IN ARMS

**March 20, 1971:** The images on pages 138–60 illustrate the Black Panther Party's Survival Programs. Long before the government initiated similar programs, the Panthers' programs provided free food, free health clinics, free breakfast for children, free clothing and shoes, and schools, among other services.

# MY MAMA TOLD ME THAT, "THERE ARE SOME PEOPLE WHO ARE REALLY SERVANTS OF THE PEOPLE".

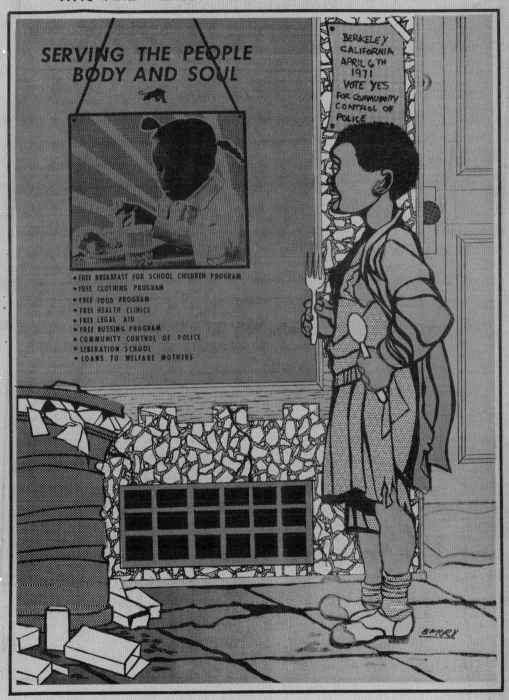

March 27, 1971

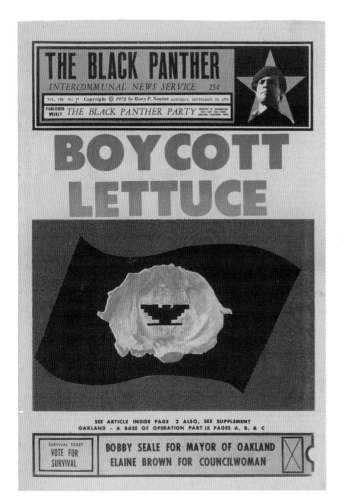

*Left* **September 23, 1972:** The Black Panther Party expresses solidarity with the boycotts initiated by Cesar Chavez and the United Farm Workers as they sought better protections for workers against harmful pesticides used in the fields.

*Right* **October 28, 1972**

*Opposite page* **November 29, 1971**

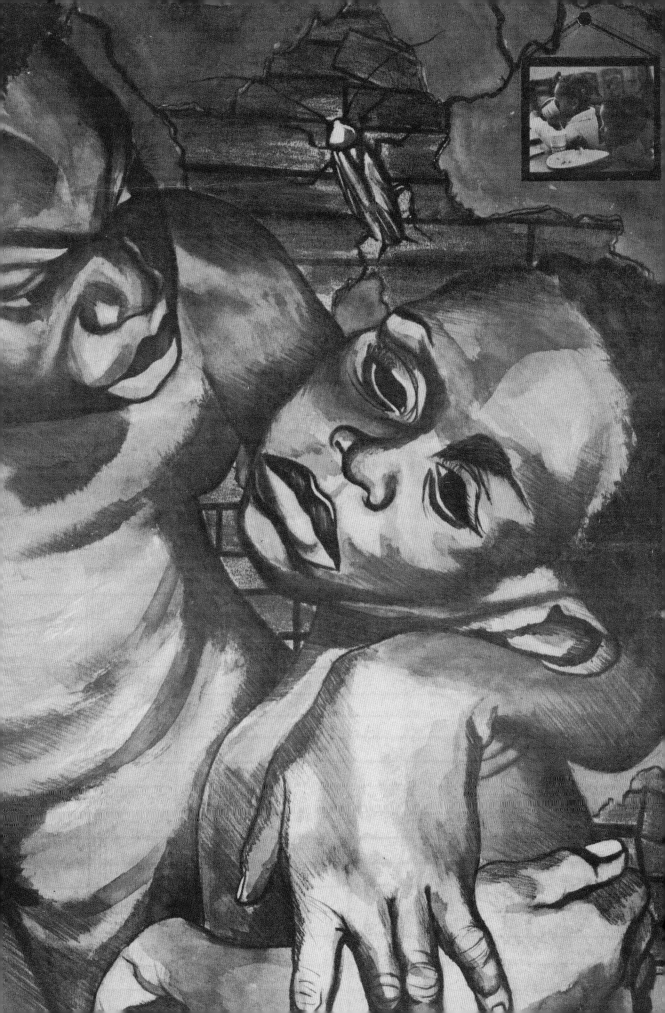

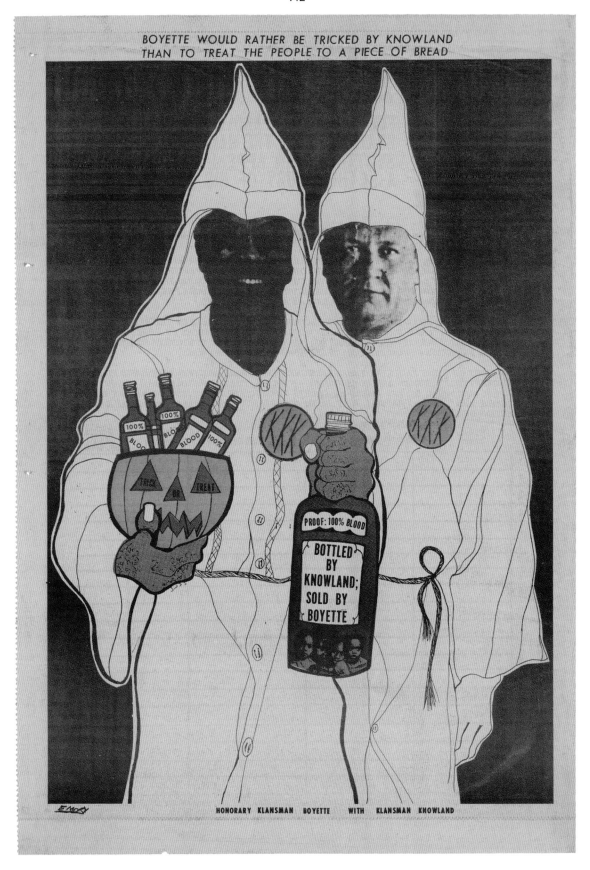

BOYETTE WOULD RATHER BE TRICKED BY KNOWLAND
THAN TO TREAT THE PEOPLE TO A PIECE OF BREAD

HONORARY KLANSMAN BOYETTE WITH KLANSMAN KNOWLAND

**October 30, 1971:** Bill Boyette, the president of Cal-Pak, a group of small, black-owned retail liquor stores asked the Black Panther Party for their support in a boycott against the discriminatory practices of Mayfair Supermarkets. After the successful Mayfair boycott, the party asked Boyette to make a donation to their Survival Programs. When Boyette refused, the party boycotted his stores. William Knowland, owner of the *Oakland Tribune*, along with the city's chamber of commerce, opposed the party and bankrolled Boyette in the unsuccessful effort to thwart the Panthers' boycott.

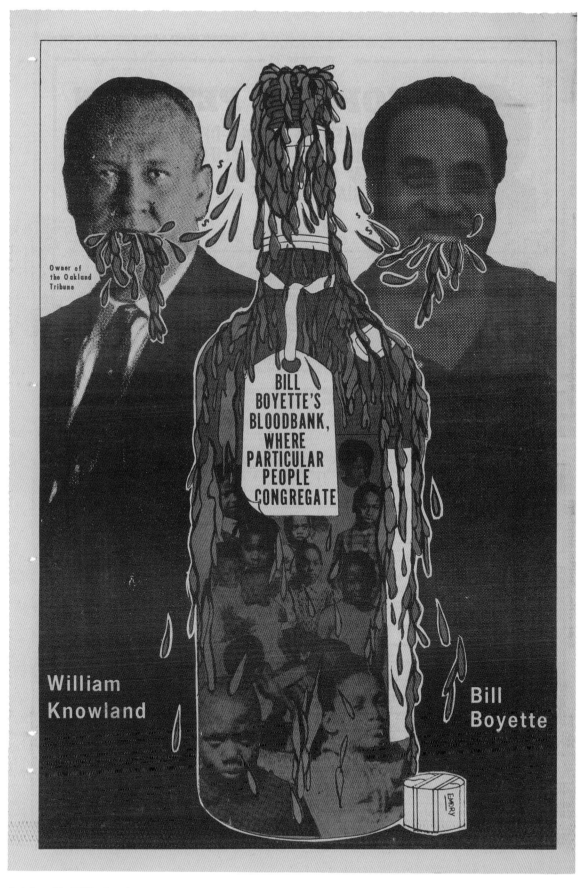

**October 16, 1971:** After a five-month boycott, with the help of Congressman Ronald Dellums,
Boyette and the party reached a settlement, in which he agreed to make disbursements to the party's
Survival Programs as well as to other organizations helping the community.

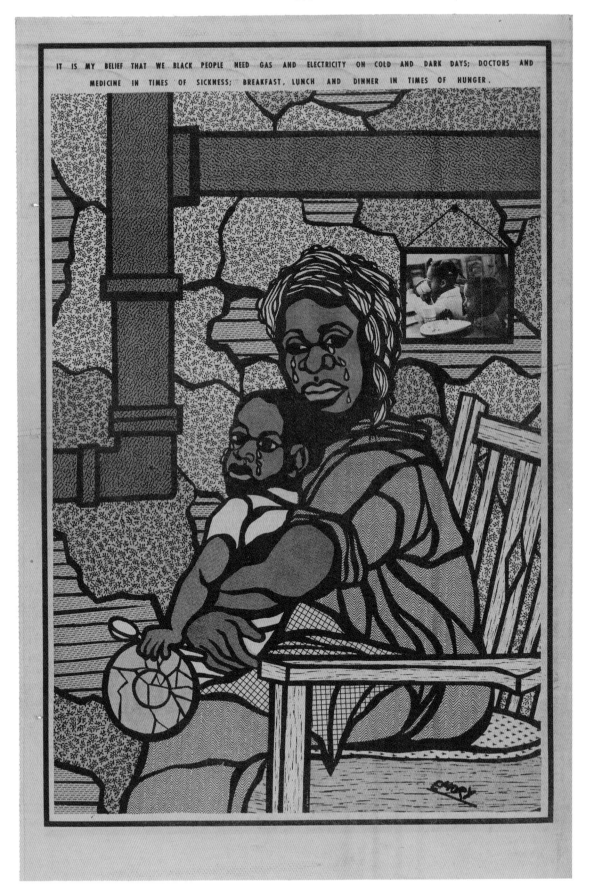

IT IS MY BELIEF THAT WE BLACK PEOPLE NEED GAS AND ELECTRICITY ON COLD AND DARK DAYS; DOCTORS AND MEDICINE IN TIMES OF SICKNESS; BREAKFAST, LUNCH AND DINNER IN TIMES OF HUNGER.

**April 17, 1971**

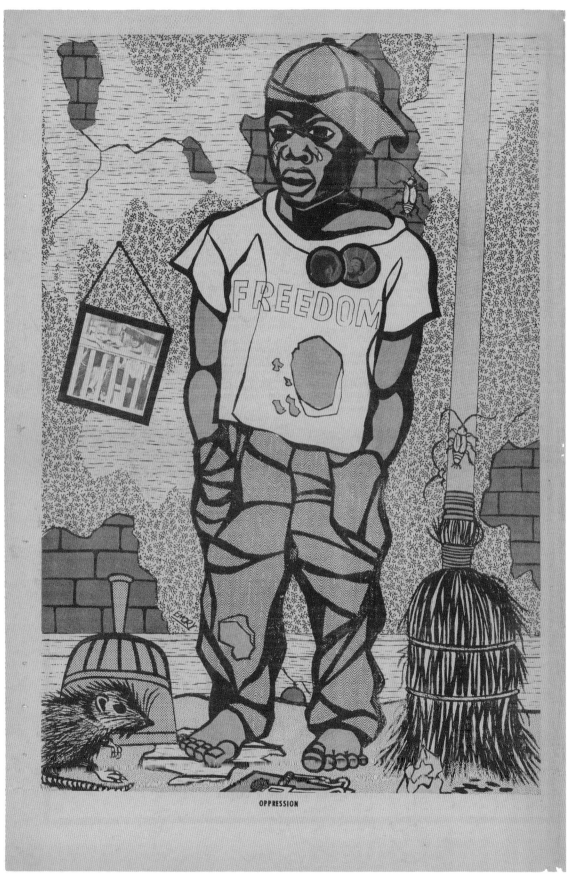

OPPRESSION

May 15, 1971

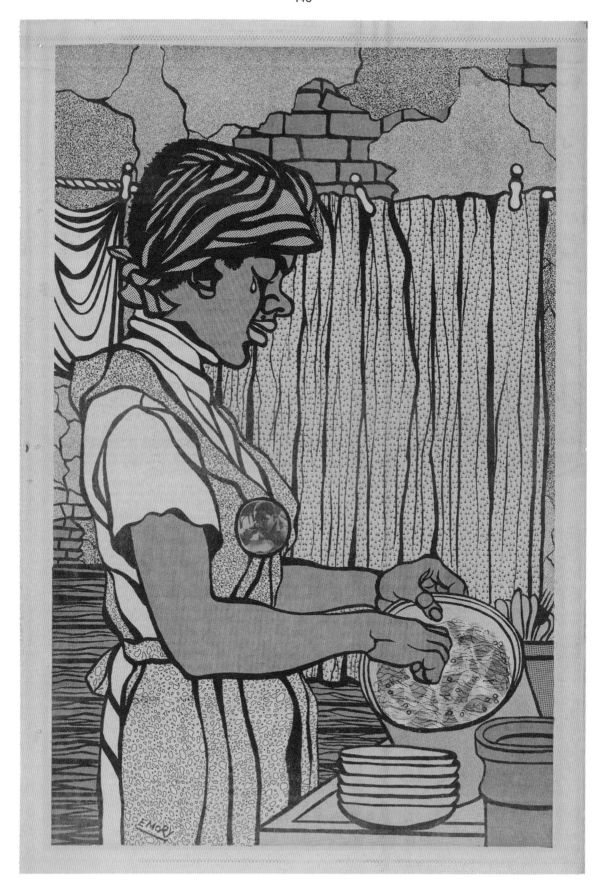

May 8, 1971

ALL I WANT TO DO IS SERVE THE PEOPLE BODY AND SOUL.

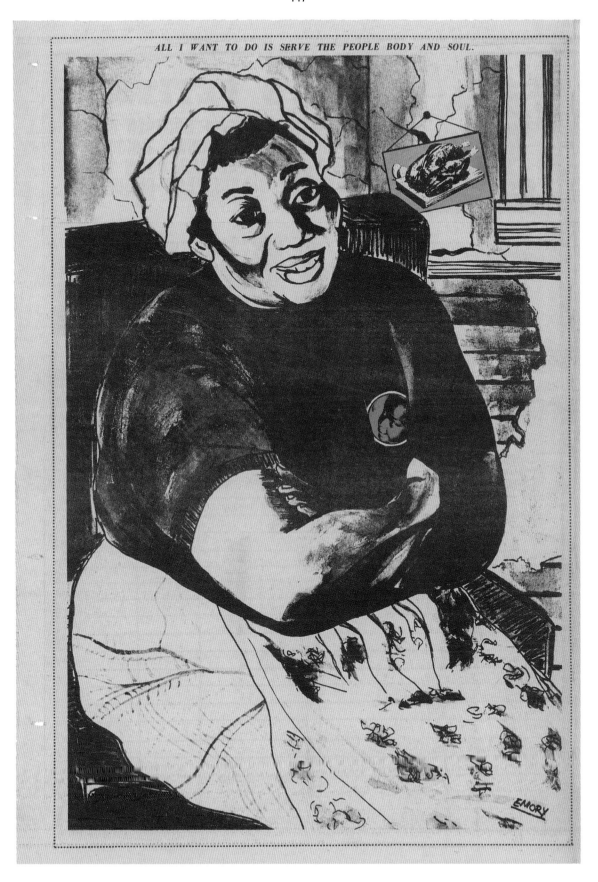

January 29, 1972

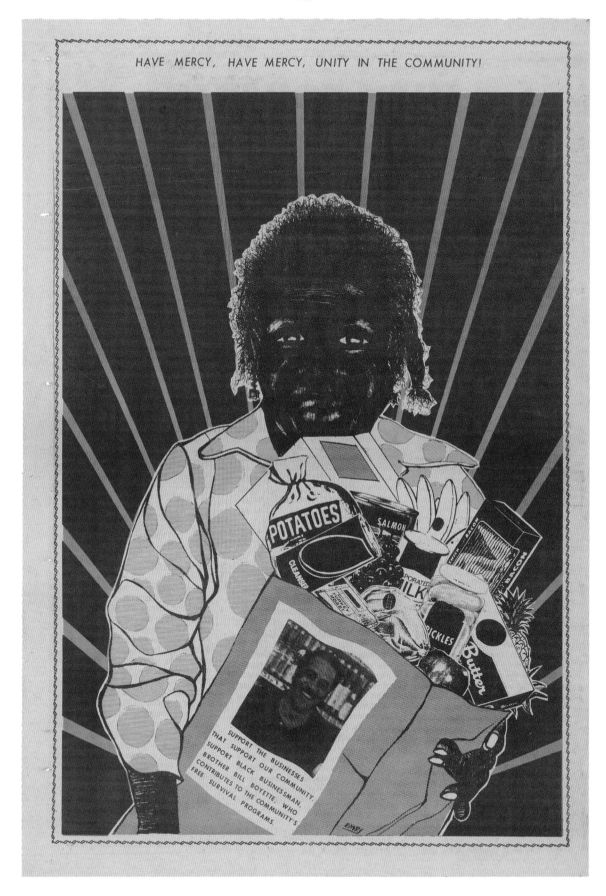

**January 22, 1972:** Douglas shows support for Bill Boyette after the boycott was resolved.

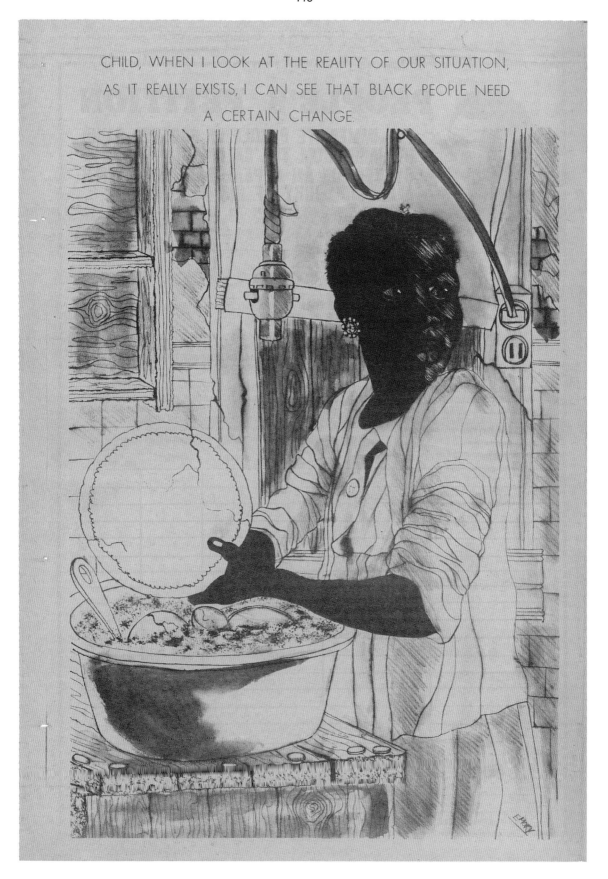

CHILD, WHEN I LOOK AT THE REALITY OF OUR SITUATION,
AS IT REALLY EXISTS, I CAN SEE THAT BLACK PEOPLE NEED
A CERTAIN CHANGE.

**February 5, 1972**

MY MOTHER TOLD ME THAT WE MAY BE BARE-FOOTED AND HUNGRY,
BUT THAT WON'T STOP OUR STRUGGLE FOR FREEDOM.

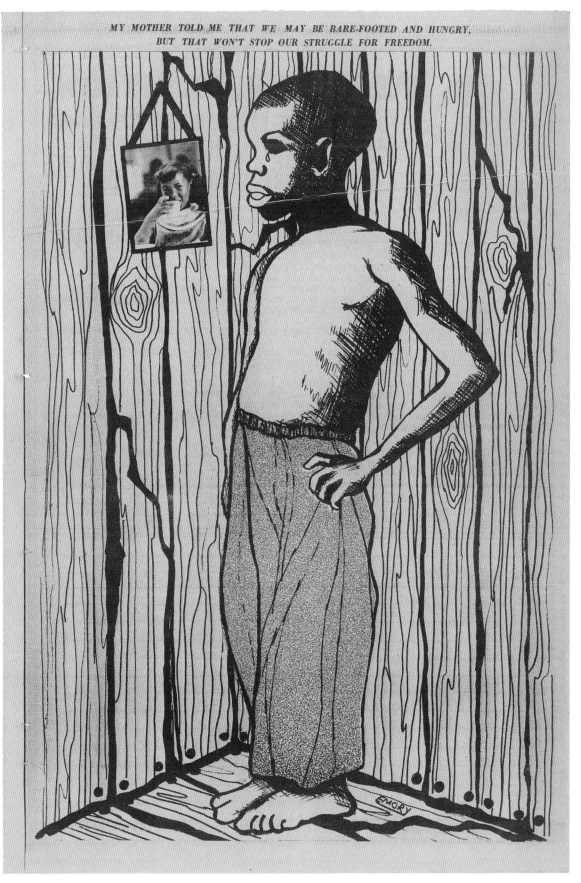

March 4, 1972

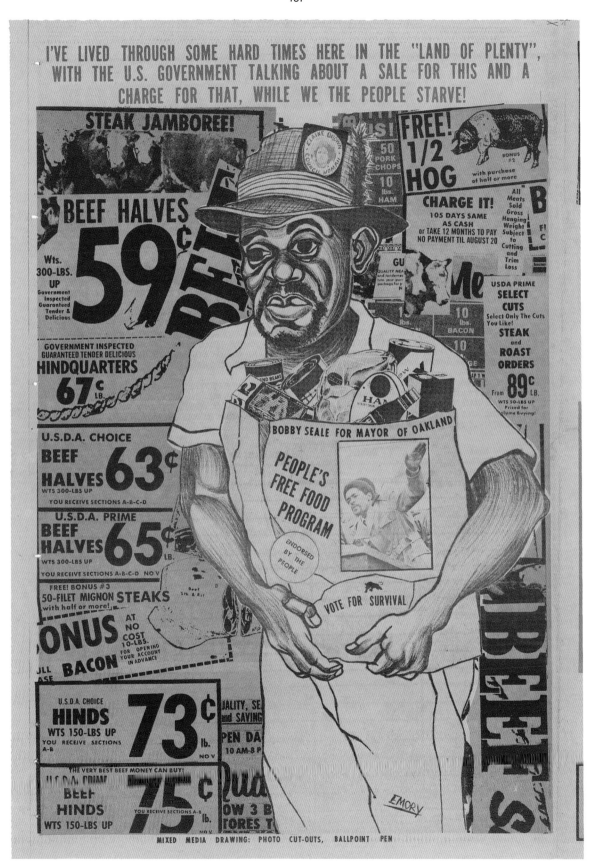

**July 22, 1972:** On his work for the paper, Douglas often indicated the medium and techniques used to make his artworks to help readers understand how they were created. The grocery bag in this image combines the need for electoral politics—Bobby Seale for Mayor—with other Survival Programs.

152

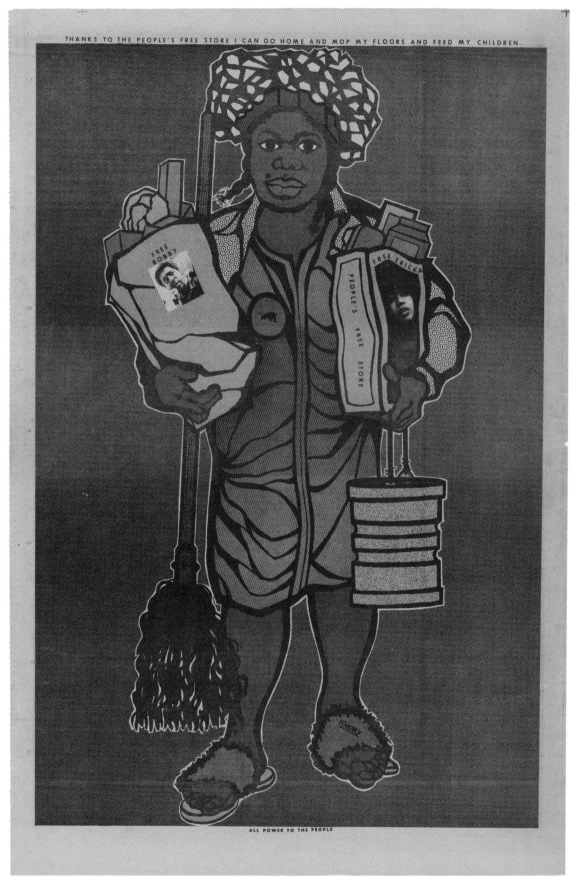

THANKS TO THE PEOPLE'S FREE STORE I CAN GO HOME AND MOP MY FLOORS AND FEED MY CHILDREN.

ALL POWER TO THE PEOPLE

**April 10, 1971:** The grocery bags in this image remind readers of the continuing plight of political prisoners Bobby Seale and Ericka Huggins.

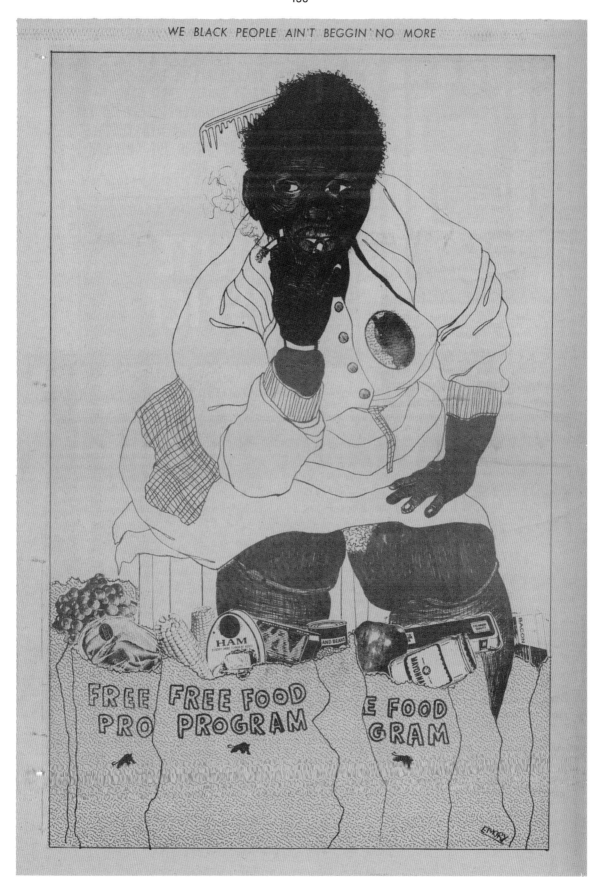

**April 22, 1972**

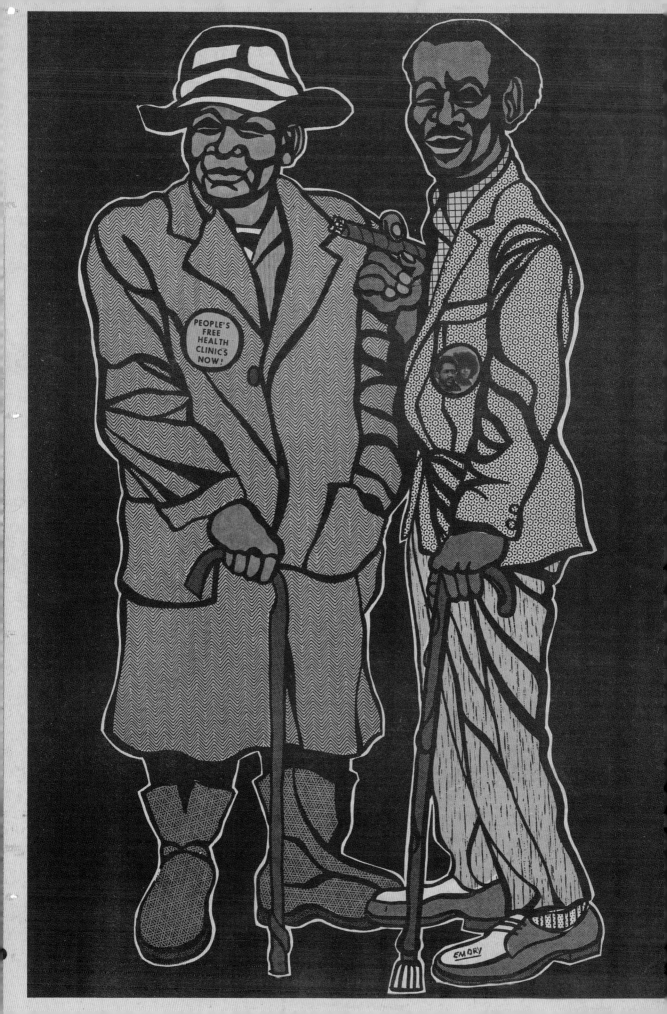

... BUT I HAVE NO MONEY

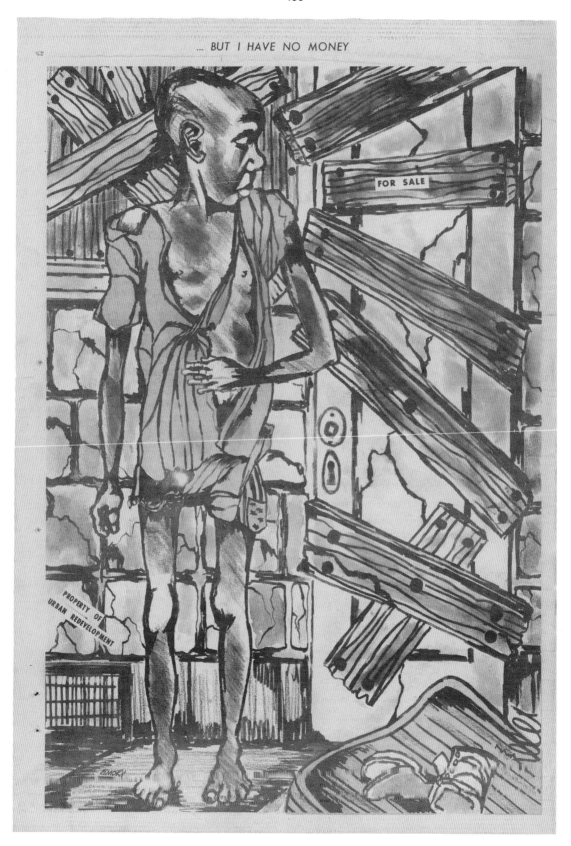

FOR SALE

PROPERTY OF URBAN REDEVELOPMENT

EMORY

*Opposite page* **May 1, 1971:** The button on the left draws readers' attention to the need for the Free Health Clinics, while linking this struggle for survival to the greater struggle for freedom from all kinds of oppression. Photographs of political prisoners Bobby Seale and Ericka Huggins are seen in the other button.

**February 26, 1972**

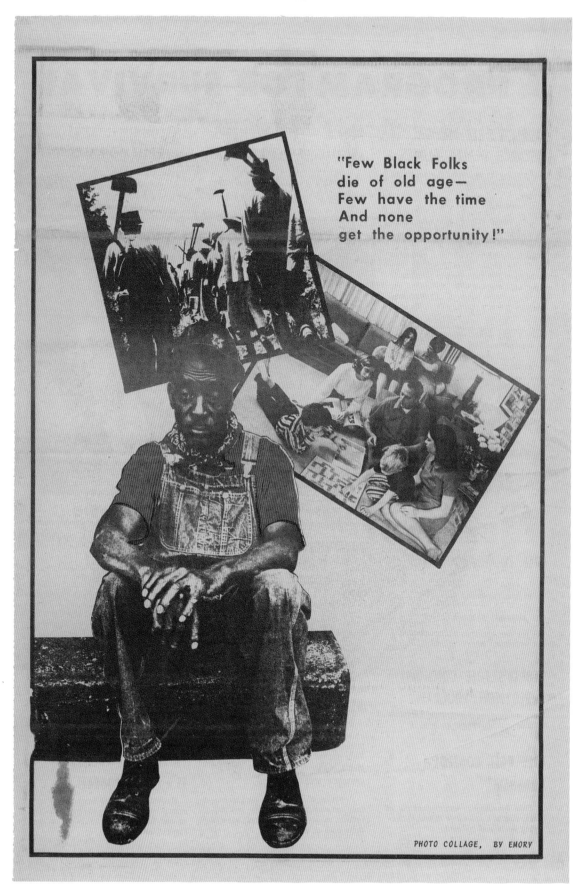

"Few Black Folks
die of old age—
Few have the time
And none
get the opportunity!"

PHOTO COLLAGE, BY EMORY

**July 28, 1973:** Douglas used striking juxtapositions to underscore the economic disparity between classes
during the 1960s and '70s. In this collage, a photo of a middle-class white family enjoying leisure time in an idyllic
home is placed next to an image of black field workers and an exhausted elderly man.

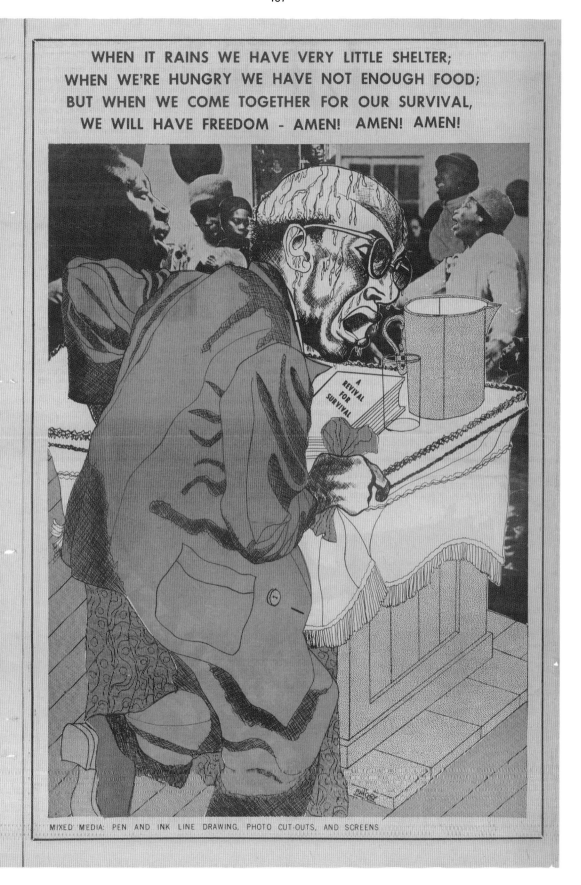

**September 2, 1972:** This image illustrates the alliance between the Black Panther Party and progressive religious communities. From its inception, the party was strongly supported by many liberal and progressive ministers and churches.

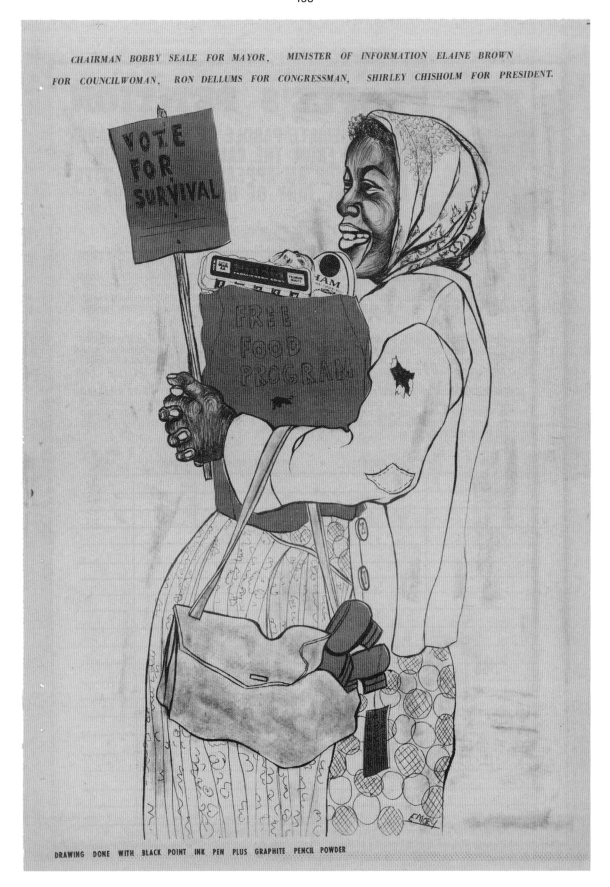

CHAIRMAN BOBBY SEALE FOR MAYOR, MINISTER OF INFORMATION ELAINE BROWN FOR COUNCILWOMAN, RON DELLUMS FOR CONGRESSMAN, SHIRLEY CHISHOLM FOR PRESIDENT.

DRAWING DONE WITH BLACK POINT INK PEN PLUS GRAPHITE PENCIL POWDER

**May 27, 1972:** This drawing brings together many facets of the black community's struggle for freedom. While addressing the basic needs of the people, the party also actively joined electoral politics, running their own candidates as well as supporting nonparty members such as Ron Dellums and Shirley Chisholm.

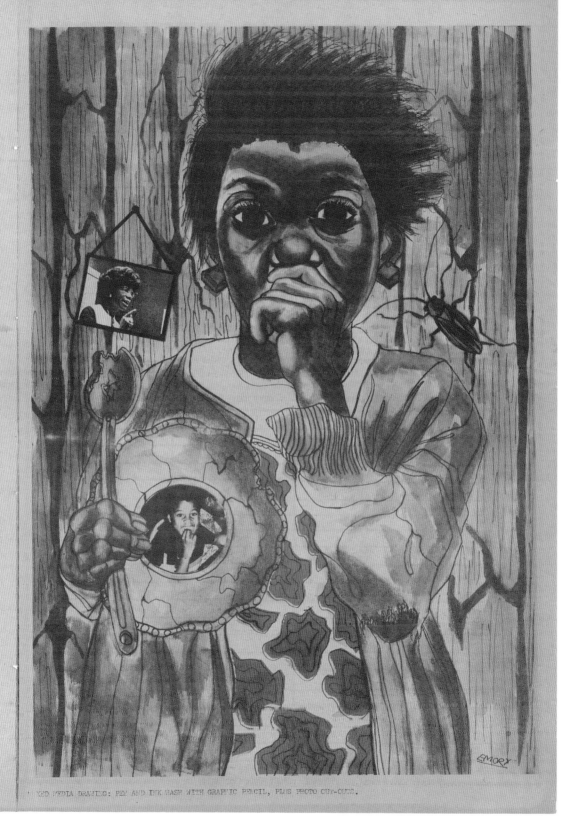

**May 13, 1972:** Shirley Chisholm was the first black woman elected to Congress.
She also ran for president in 1972.

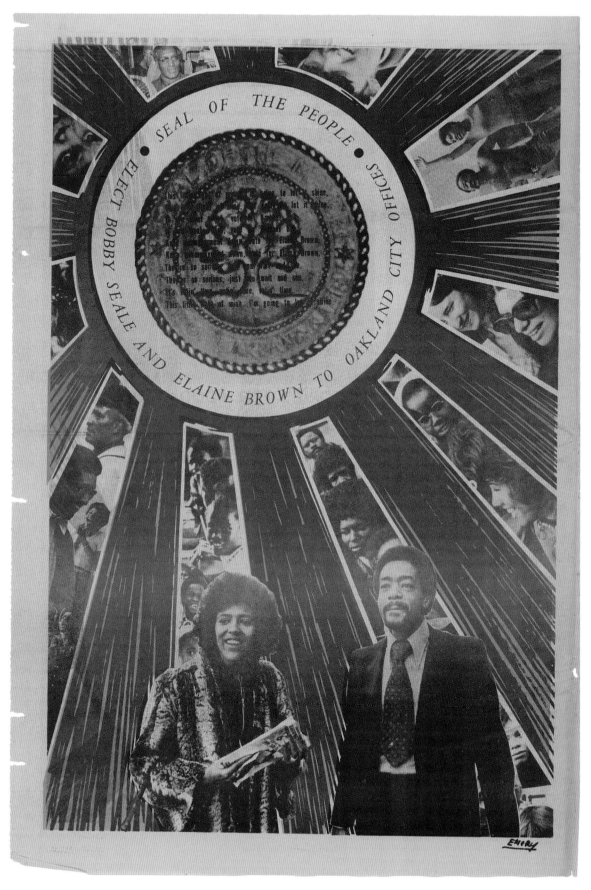

**April 7, 1973:** This image shows the political campaigns of Bobby Seale
for Mayor of Oakland and Elaine Brown for Councilwoman.

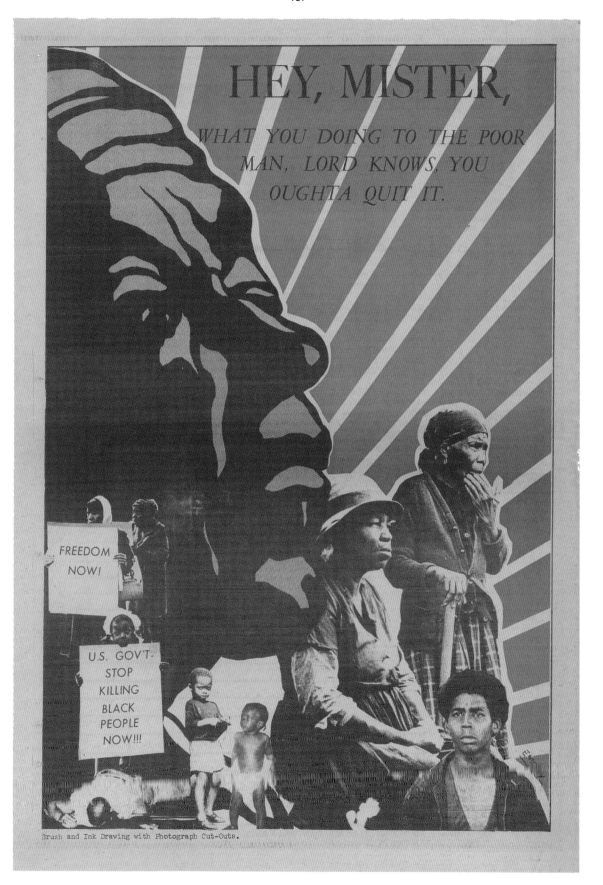

Brush and Ink Drawing with Photograph Cut-Outs.

**May 6, 1972**

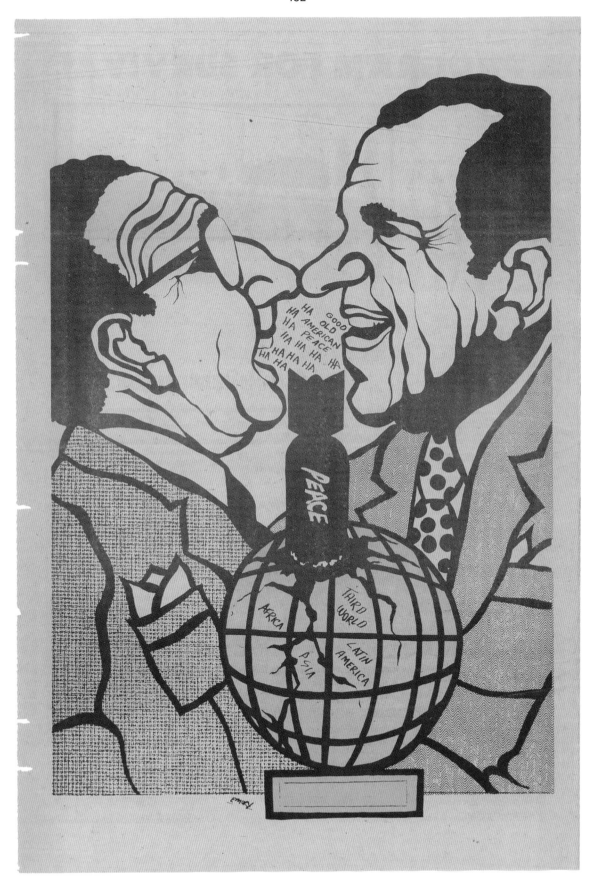

**February 17, 1973:** This image shows Secretary of State Henry Kissinger on the left with President Richard Nixon, laughing as they bring war and destruction to Third World countries.

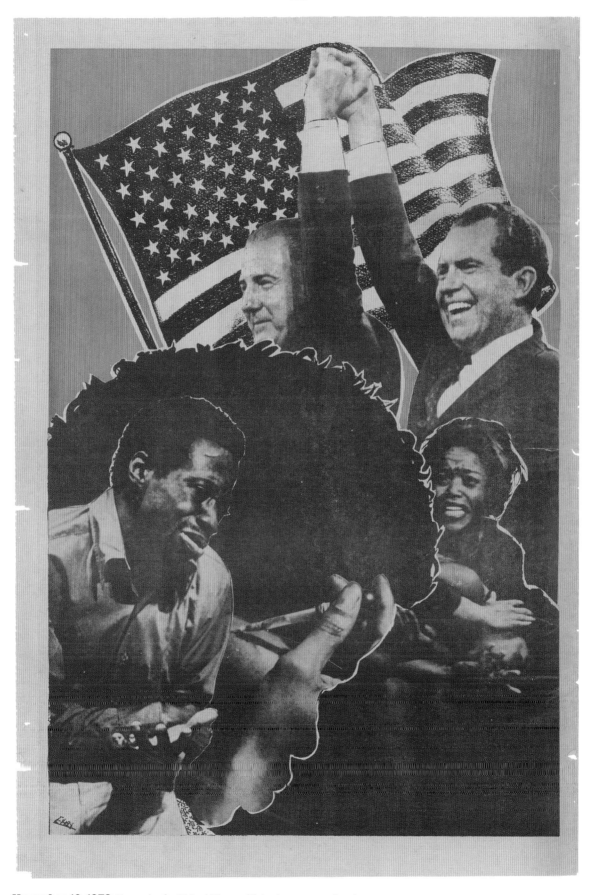

**November 16, 1972:** Two weeks after Richard Nixon and Spiro Agnew were reelected
in 1972, Douglas made this photo collage, reusing an earlier drawing (see page 105).

# CLASS BROTHERS

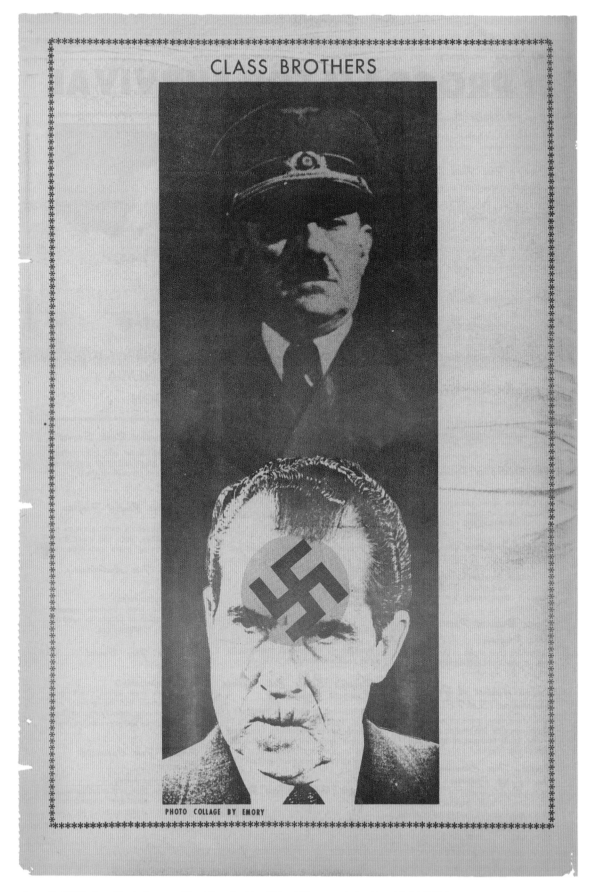

PHOTO COLLAGE BY EMORY

**June 2, 1973:** A scathing indictment of Republican President Richard Nixon, associating him with Adolf Hitler.

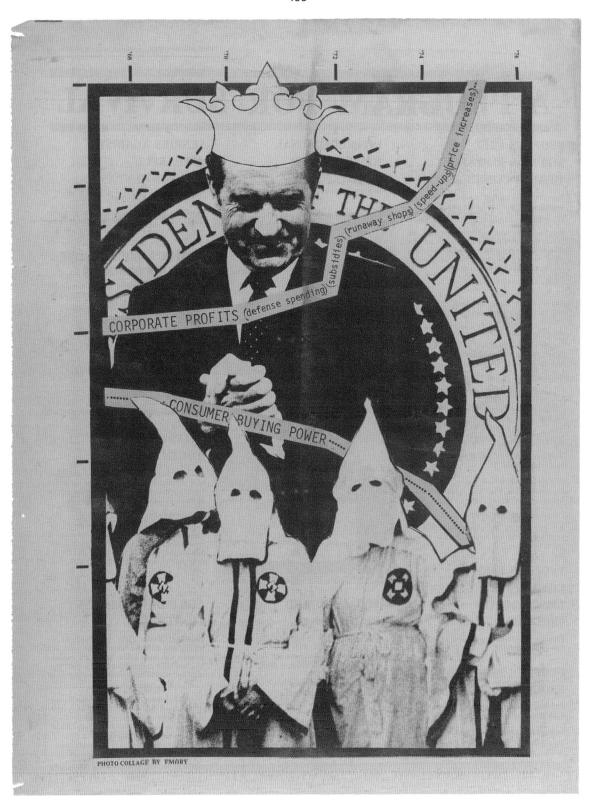

PHOTO COLLAGE BY EMORY

**March 16, 1974:** In this image, President Richard Nixon is satirized as a royal member
of the KKK while all serve their corporate masters.

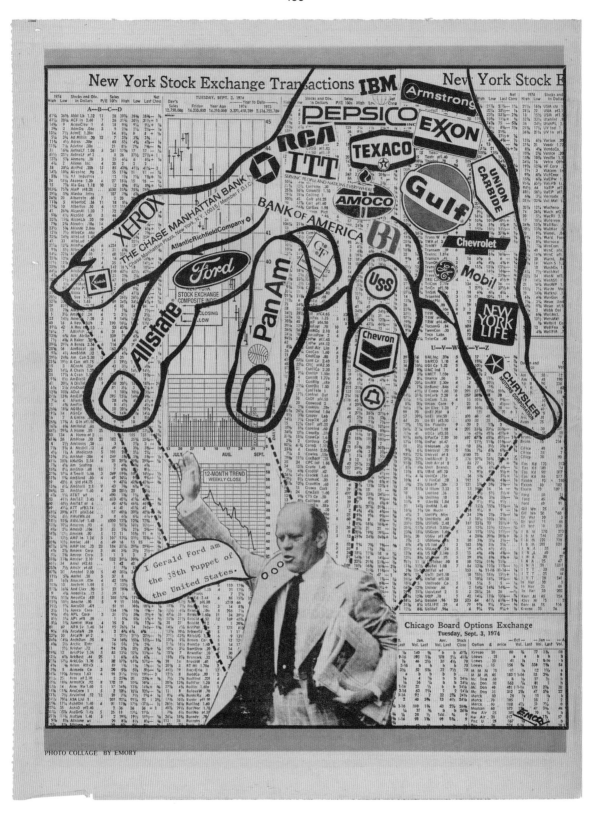

PHOTO COLLAGE BY EMORY

**September 21, 1974:** Illustrates how corporate interests control the office of the president.
Gerald Ford became president after Nixon resigned.

*Opposite page* **January 27, 1973:** This image refers to the ongoing Viet Nam War and the refusal of young
black men to participate in the war.

# "PEACE WITH HONOR"

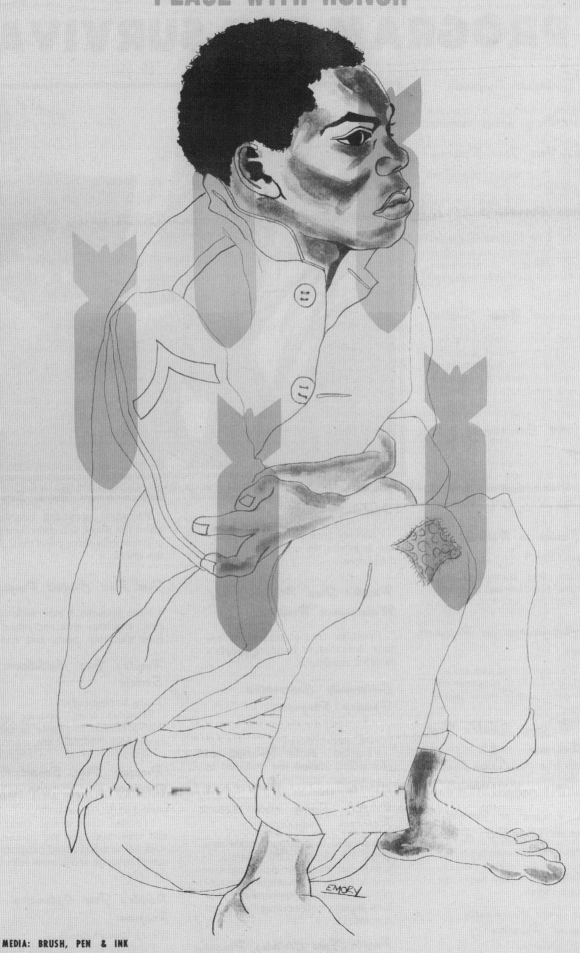

MEDIA: BRUSH, PEN & INK

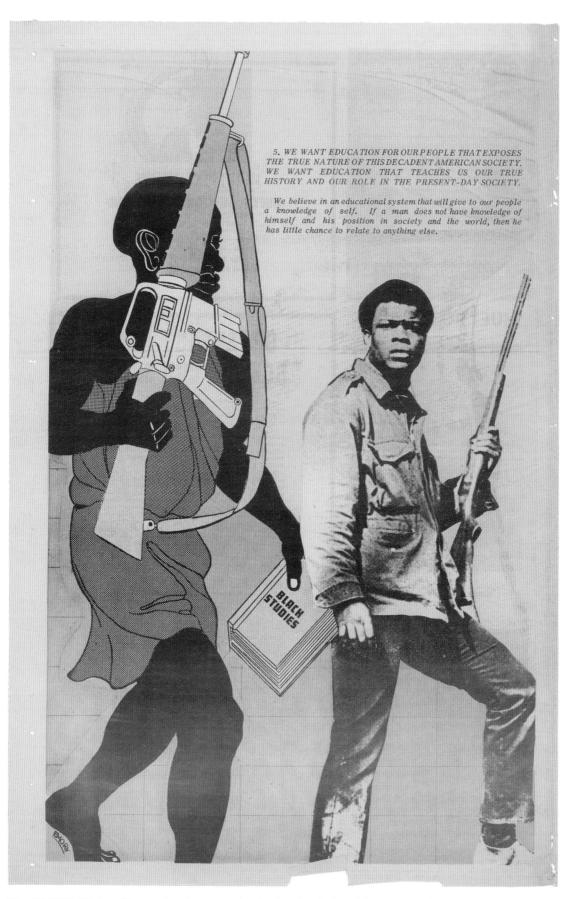

5. WE WANT EDUCATION FOR OUR PEOPLE THAT EXPOSES THE TRUE NATURE OF THIS DECADENT AMERICAN SOCIETY. WE WANT EDUCATION THAT TEACHES US OUR TRUE HISTORY AND OUR ROLE IN THE PRESENT-DAY SOCIETY.

We believe in an educational system that will give to our people a knowledge of self. If a man does not have knowledge of himself and his position in society and the world, then he has little chance to relate to anything else.

BLACK STUDIES

**May 11, 1969:** This image illustrates the student protests that often focused on the demand for the creation of Black Studies Programs in colleges and universities.

*AMIRI BARAKA*

# EMORY DOUGLAS: A "GOOD BROTHER," A "BAD" ARTIST

**EMORY AND I GO BACK,** not just "a minute" but "a few minutes." We first met in San Francisco, I guess, early 1967 when I'd come out to San Francisco State University as Visiting Professor, with my wife Amina, plus our oldest son, Obalaji, still in the hangar. At that time we had started the Spirit House, and lived on the third floor. The theater was downstairs which was the performance space for the Spirit House Movers, poetry, dance, films, forums & later, the Afrikan Free School.

Jimmy Garrett, the Chairman of the Black Student Union at San Francisco State, had come out to Newark, late 1966. Ron Karenga, the Chairman of the newly formed U.S. organization had come by unannounced about the same time, for one thing, because the 2nd Black Power Conference was scheduled summer of '67 in Newark. That was the first time I'd met either one, but it was characteristic of what was happening during that period.

Both had invited us to come out to the West Coast. Karenga came also, perhaps, to debate me casually on whether the Blues was heroic as I suggested in my book, *Blues People*, or was it, as he said, "submissive."

Garrett, on the other hand, came with a specific invitation, to come out to San Francisco State, as a Visiting Professor, and actually, as I understood, to begin the movement for the first collegiate Black Studies Program. Sonia Sanchez was also invited.

One often reads or hears about "the Sixties" and the images provided to give flesh to the phrase differ very widely according to the describer. By now, for some parts of the mainstream, it means the Beats, flower children, the Beatles, Elvis Presley. But at the base of that turbulent period was the Civil Rights and Black Liberation Movements here in the U.S., as part of the worldwide Anti-Imperialist upsurge. That in fact when Mao Zedong declared, "Countries want Independence, Nations want Liberation, People want Revolution," which he

characterized by trumpeting, "Revolution Is The Main Trend In The World Today." And millions of people around that world were the exemplary paradigm confirming Mao's wisdom.

At State I proposed to the student union that my residency be used to organize and carry out a "Black Communications Project," utilizing willing volunteers from the Black student body and Black activists from the area (San Francisco-Oakland, &c) to bring programs of Black culture (e.g., theater, poetry, music) to the various campuses in the area, and to other venues we might develop.

Using the campus facilities at State and actually headquartered in the Black House, a venue sprung out of the Black arts renaissance in San Francisco's Black Fillmore District, we began to organize the Black Communications Project. That "We," the core of the project, was Sonia Sanchez, Nathan Hare & as soon as we arrived, writer-activists Ed Bullins, Marvin X, Duncan Barber, Hilary Broadus, Rosita Broadus, Carl Boissiere (who had just formed Black Arts West), along with my soon to be bride, Sylvia Jones (a little later, Amina Baraka). Indispensable was the energetic Black student leadership headed up by Jimmy Garrett, which included George Murray who was the first minister in Ben Caldwell's *The First Militant Preacher* as we called it (the official title is *Prayer Meeting, or the First Militant Minister*). Murray later became the Black Panther Party's Minister of

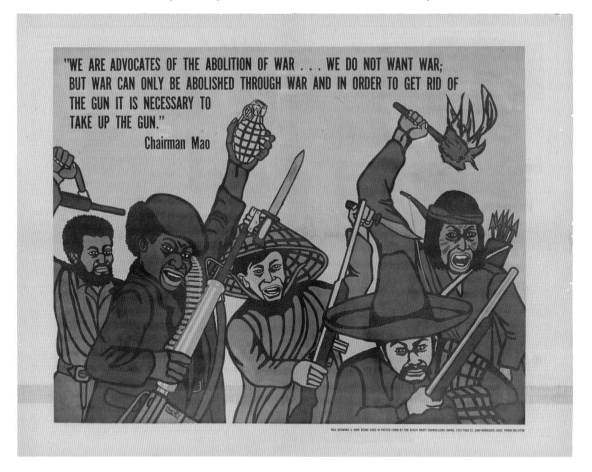

**ABOVE**

September 28, 1968: The influence of Mao Zedong's writings on the Black Panther Party was considerable, as we see in this image in which Douglas includes a quote from the Chinese leader.

Education. Emory Douglas became our resident set designer, later the Minister of Culture and primary artist (or "Revolutionary Artist") for the Black Panther Party newspaper.

The cutting edge of the Black Communications Project was the plays we toured with, Bullins's *How Do You Do & The Electronic Nigger*; Marvin X's *Flowers for The Trashman*; Caldwell's *The First Militant Minister*; *Papa's Daughter* (with Danny Glover as Papa) by Dorothy Ahmad, Jimmy Garrett's *We Own The Night* (which premiered at a Black Panther Benefit in San Francisco at which Ike & Tina Turner also performed); and my own, *Madheart*. We performed these plays plus the poetry readings, African dancers, singers at State, at the Black House, at several outdoor venues, at colleges like Laney and Merritt and other places up and down the coast. The sets were always Emory's, though sometimes scaled down, by his design, to a practical minimalism, depending on the requirements of the different venues.[1]

The inspiration for the Black Communications Project was the work we had done in Harlem in the summer of 1965 with the Black Arts Repertory Theater School (BARTS). The theater had opened that spring, and after Malcolm's murder, ignited the national Black Arts Movement.

That summer of 1965 we had outfitted five trucks with stages made from banquet tables, created by painter Joe Overstreet, microphones, easels, paintings, musicians, poets, dancers, actors and sent them all over Harlem, to do drama at one site, poetry at another, the music somewhere else, and an exhibition of Black graphic arts at another. All of it under a black-and-gold flag heralding the Black Arts Repertory Theater School, created by painter William White.

The most important things we wanted to do were: 1. Create an art that was "Black" in form, feeling, and content. 2. We wanted to bring that art "into the streets." We wanted a "mass art," out of the little elitist dens of ambiguity. And so we performed in parks, on the streets and on the sidewalks (literally), in vacant lots, housing projects, playgrounds, in front of bars and supermarkets.[2]

The most important point 3. We wanted a Revolutionary Art, not just skin flicks. We were Malcolm's Children, and we wanted a Malcolm Art! One that was itself an example of Malcolm X's call for Black Self-Determination, Self-Respect and Self-Defense plus W.E.B. DuBois's "True Self-Consciousness."

So that the practical paradigm BARTS provided, though limited, was vital enough to ignite Black intellectual and artistic minds around the world. In much the same way, I can presume, the Harlem Renaissance in the '20s set off *Négritude* in the West Indies and Africa, *Indigenisme* in Haiti, and *Negrismo* in the Latin-speaking Caribbean.

However, at base, it is the very motion of the people themselves that creates the initial shock wave that the most sensitive artists and intellectuals respond to.

Although BARTS lasted as an organization a little over a year, destroyed by internal ideological and political struggle that grew antagonistic, more than likely intensified by some variation of the U.S. government's COINTEL program, one of it's operations was called Operation KAOS.

But this about that organization (union should have been nurtured into a

---

1 There was a film made of this attempt at Black consciousness raising shot by a graduate student, called *Black Spring*, which has since disappeared from view. The copy I had was lost apparently when a film storage company in New York, *Newsreel*, went out of business, or at least moved without giving any notice.
2 That's why we were happy when rapping showed, because we felt it carried one element of mass intent.

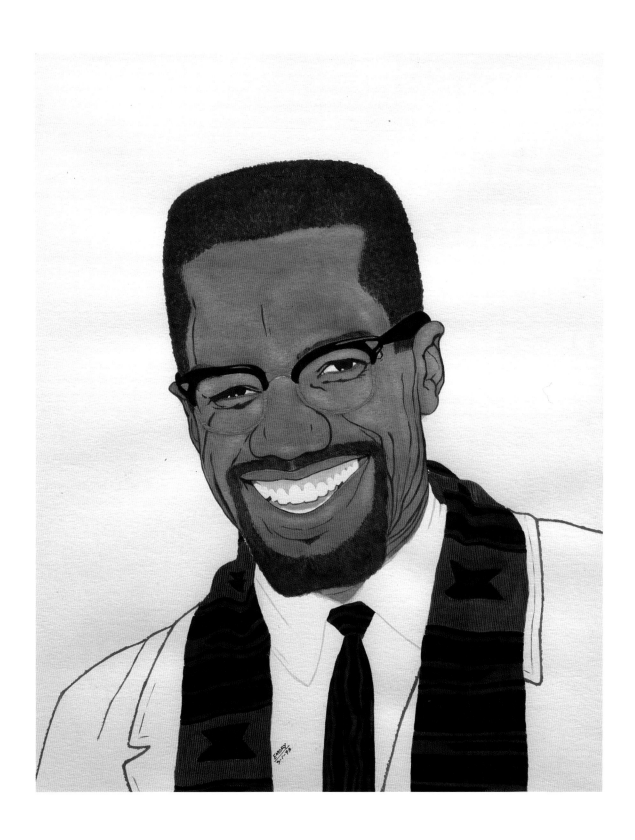

**1993:** Malcolm X (El-Hajj Malik El-Shabazz) had a profound impact on the Black Panther Party's revolutionary mission. This watercolor portrait shows him in contemporary dress wearing a kente cloth scarf.

permanent institution) sparked a series of like organizations across the country, creating what was called the Black Arts Movement. One of the most energetic aspects of that movement was theater. Similar groups began to operate very soon in Detroit, Chicago, San Francisco, Philadelphia, Atlanta, New Orleans, Pittsburg, the number continuously rising until the '80s when like the rest of the Black National Movement for equal rights and self-determination, it suffered from what DuBois called "the Sisyphus Syndrome," where having been punished by the "Gods" for refusing to die, we are fated to roll the huge boulder of our struggle up the great mountain of real life only to have it rolled back down on us. This is supposed to go on forever, at least that's what the people who taught us that myth said.

When BARTS split apart, I went back to Newark and opened the Spirit House, where the Black arts could move, influence, and teach Black people. What continued that influence, kindled by the very heat and motion of the times themselves, the Spirit House Movers, began to travel and bring Black theater to cities and institutions, sponsored in the main by liberation & civil rights organizations and student groups. We also performed in the streets and school auditoriums and even in people's apartments.

Going to San Francisco State was part of that burgeoning movement. And in some ways the forces we encountered there were thematic characteristics of much of the movement itself. The Communications Project combined the Black Student Union and the full up energy of a student movement fueled by notions of actual revolution. The Black Panther Party for Self-Defense was in its initial stages, militant young intellectuals (Huey Newton was a law student, Bobby Seale a standup comedian), and a sampling of a cross-class spectrum of the "national movement" though its developing political line drew a large sector of Black working-class youth, and with the addition of Eldridge Cleaver, began to attract, like himself, the lumpen.

LET US HOLD HIGH THE BANNER OF REVOLUTIONARY INTERCOMMUNALISM AND THE INVINCIBLE THOUGHTS OF HUEY P. NEWTON, SERVANT OF THE PEOPLE, BLACK PANTHER PARTY.

That "dangerous class," as Marx described them, those he described as "already broken by capitalism," but Cleaver made this group a focus of his propaganda, in parts dipping into the rhetoric of the Russian Anarchists, Kropotkin and Bakunin.

When Huey Newton and Bobby Seale and some others created the Black Panther Party for Self-Defense, it was like many of us as the children

**ABOVE**

February 19, 1972: A portrait of Black Panther Party leader Huey P. Newton. The original version of this drawing was done in acrylic and hung at the Lamppost, the nightclub and restaurant that was co-owned by the party.

**October 31, 1970:** Douglas managed the Lumpen, the Black Panther Party's singing group, coordinating their local and national appearances. They were known for their songs that used revolutionary lyrics set to the music of well-known pop and R & B tunes.

"The students focus their rebellions on the campuses, and the Working Class focuses its rebellions on the factories and picket lines. But the LUMPEN finds itself in the peculiar position of being unable to find a job and therefore is unable to attend the Universities.
The LUMPEN has no choice but to manifest its rebellions in the University of the Streets."

THE LUMPEN

**May 31, 1970:** The lumpen was a term frequently invoked by the party to describe the black under class and other oppressed communities in the U.S.

of Malcolm X. For the young intellectuals of my generation it was Malcolm who literally moved us. From wherever we were to wherever our listening to him told us we needed to be. Myself, as a bohemian writer in New York's Greenwich Village to Harlem, Huey and other young folks in the Bay Area from places like Laney Jr. College, Merritt and San Francisco State, from undergraduates to soldiers in the Black Liberation Movement. Emory Douglas was one of those actually very courageous young folks.

I say this because I remember first meeting Bobby Seale some years before when he came to me to get an autograph on *Blues People*. He was doing a gig as a standup comedian. George Murray, another San Francisco State student, a mild-mannered history major, the Communications Project cast him as the first militant preacher, in Ben Caldwell's work. Emory Douglas made a similar initial transition when he became the set designer for the Black Communications Project. Before that project was completed, the Black Panthers had grown significantly because of their take no b.s. new style militance. Word that Huey Newton and the new organization were actually intervening in police harassment, Huey pulling out a law book and deconstructing their would-be charges, as illegal and fundamentally racist, ran through the Bay Area, and indeed began to burn across the country. So some who had made the initial leap from student to Black Militant Actor, began to want to really act upon the reality of our time.

Not only the students were moved with the continuing spirit of Malcolm X now being hoisted in sharp continuum by these new Black Panthers, but more and more Black people, as the word spread, and certainly even a significant number of whites and others, even finally across the world.

Remember, this was a period when the image of people struggling was heroic, "Revolution is The Main Trend in The World Today!"

When I could dialogue with a young brother who used to stand outside our rehearsal site, who admittedly was standing there just so he "could dig the babes," and without harangue get him to come into the place by asking, "Didn't he want to do something for the people?" So that Danny Glover, became an actor by wanting to do something "for the people."

When analyzing anything the Marxist teachers tell us we must always use "time, place & condition." So the many revolutionary movements, organizations, formations, events, actions, people throughout the world were part of the whole of that revolutionary time, place, and condition. During such periods, Lenin said, things that ordinarily take quite a long time to develop would come to fruition in a short time. Everything is speeded up, hyped, exaggerated, exploding, minimally sizzling with dynamic prognosis.

The Black Communications Project was born of that combination of elements running straight up the revolutionary Richter scale. The Black Panther Party for Self-Defense was born in Oct '66, a year after Malcolm's murder and the Watts Rebellion. A year later Detroit and Newark would go up in smoke.[3] A month after we got to San Francisco, in May '67, Emory went with Bobby Seale and a group of Panthers to the California state legislature in Sacramento. They were carrying weapons (which were then legal) and read a statement to protest the state assembly's preparing to pass a law saying the carrying of guns was illegal.

3 H. Rap Brown said, "They used to call it Detroit, now they call it Destroyed!"

On the way out of town they were all arrested but the publicity from the event made the Black Panthers known worldwide. It seemed to me that that was, like they say, the *denouement*, the climax of one period and the beginning of another.

Emory had been doing sets, actually flats that could be put up and taken down very quickly and without too much fuss. They had to be moved by small truck and auto. Plus the sets had to be transformational, to serve for a play like Bullins's *How Do You Do* and Caldwell's *The First Militant Minister* or my *Madheart*. Plays, that while they had some general theme of Black liberation, minimally freeing one's mind from dupery, they had dissimilar settings, though come to think about it, the main thrust was the text, the sets Emory managed to create a one (almost) fits all design.

Emory was very dutiful as set designer, full of ideas, innovative, and more art than construction. Plus there was no strife between us because having discussed the plays and given him the scripts, there was little else to be done since he cheerfully gave us what we thought we wanted. Add to this that the kind of gypsy company we put together was not the usual drama group, so that it was all somewhat new. Interestingly, I learned years later, when my wife and I traveled to his birthplace, that García Lorca's traveling drama group, which moved about Spain in an old bus, was called "Baraka."

When we first put together the Black Communications Project, and performed at the Black House, the early Panthers stood security for us. I remember "Little Bobby" Hutton as one of those pulling security for a poetry reading at the

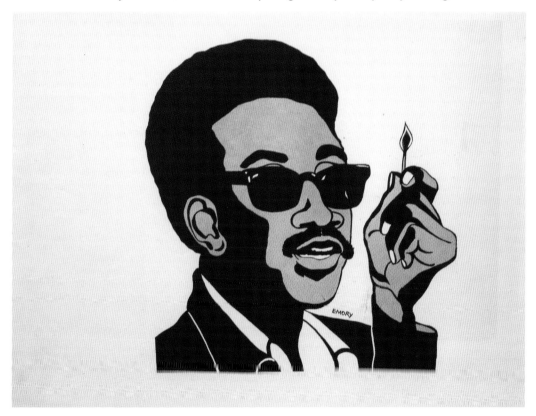

Black House, he even got into discussion with my wife, Amina, about the uses of poetry, &c in a revolution.

But certainly while there was an overt consciousness of our differences, contrasting to the earlier days during the Black Arts Repertory Theater School, when "Black" was supposed to be an ideology, there was none of the fierce contention that seemed to have developed in the Cleaver era, which emerged when both Huey Newton and Bobby Seale were in jail. 1967 was also the year Rap Brown and I went to jail.

This context is so important because brothers like Emory Douglas, who were themselves artists, like those of us in the Black Communications Project, Spirit House, and indeed the other Black arts organizations that sprung up during the period, thought of ourselves as revolutionaries.

The brothers and sisters who had recently formed Black Arts West, Ed Bullins, Marvin X, Hilary Broadus, Duncan Barber, Carl Boissiere certainly considered themselves revolutionaries, even the leading students in the Jimmy Garrett–led Black Student Union of San Francisco State. The latter was the broad coalition of forces that Emory Douglas came out of and where some of his revolutionary zeal was intensified.

We did fundraisers with the Panthers in San Francisco and in New York before that. The historic San Francisco gathering, at the old Fillmore auditorium was when the Panthers "drafted" Rap Brown and Stokely Carmichael as Minister of Justice and Prime Minister (of "Colonized America"). Ike and Tina Turner were on that program (Ike, in his flower-child haircut, made a fool of himself lurching back and forward backstage haranguing the Panthers about "his money"). The

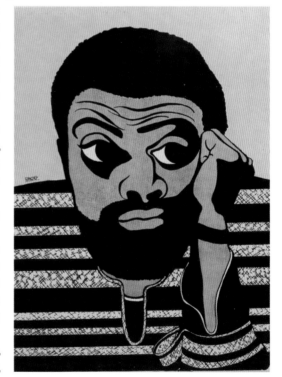

Black Communications Project put on Jimmy Garrett's explosive one-act play *We Own The Night*. The title was taken from a poem of mine (from *Home*). I was the director and Emory Douglas the set designer. The set a slice of the ghetto in the midst of a Black uprising!

A year after Emory and I were no longer working together, he wrote, "Besides fighting the enemy, the Black Panther Party is doing propaganda among the masses of black people ...

"The form of propaganda I'm about to refer to is called art ...

"The Black Panther Party calls it revolutionary art—this kind of art enlightens the party to continue its vigorous attack against the enemy, as well as educate the masses of black people.

"We, the Black Panther artists, draw deadly pictures of the enemy,

# Revolutionary Posters

## By The Minister of Culture EMORY $1.00 each

EXCEPT FOR #4 and #6 WHICH ARE 75¢ EACH    25¢ EXTRA FOR OUT-OF-STATE DELIVERY

SEND CHECK OR MONEY ORDER TO EMORY DOUGLAS, P.O. BOX 8641, EMERYVILLE BRANCH, OAKLAND, CALIFORNIA 94608

ALL POSTERS ARE 17x22 EXCEPT FOR #4 and #6 WHICH ARE 8-1/2x22

**1**

No longer

available

This space has previously been used for "Free Huey" posters. But now that the world is awaiting the verdict-Free Huey-or the sky is the limit!

**2**
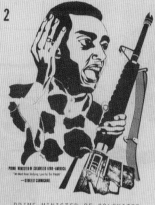
PRIME MINISTER OF COLONIZED AFRO-AMERICA STOKELY CARMICHAEL

**3**

MINISTER OF JUSTICE H. RAP BROWN

**4**
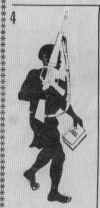
BLACK STUDIES

**5**
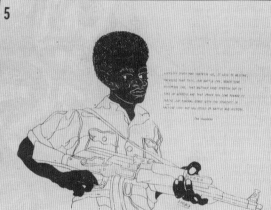
REVOLUTIONARY

**6**
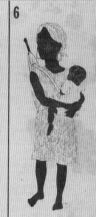
MOTHER AND CHILD

**7**
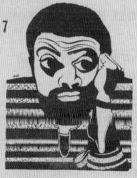
BLACK POET AND PLAYWRIGHT LEROI JONES

**8**
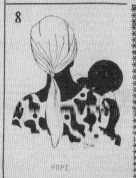
HOPE

Check number of article(s) ordered and indicate quantity of each beside number:
FROM SEPTEMBER 28, 1968 ISSUE
REVOLUTIONARY POSTERS

| ___ 1 | ___ 3 | ___ 5 | ___ 7 | TOTAL NO. |
|---|---|---|---|---|
| ___ 2 | ___ 4* | ___ 6* | ___ 8 | OF POSTERS |

($1.00 each: $1.25 outside Calif.)
(75¢ (#4, #6) each $1.00 outside Calif.)

TOTAL AMOUNT OF MONEY SENT-$_____
Send check or money order to
BLACK PANTHER PARTY, P.O. BOX 8641
EMERYVILLE BRANCH, OAKLAND, CALIF.

NAME_____
ADDRESS_____
CITY_____ STATE_____

**September 28, 1968:** These were some of the first drawings that Douglas made as he transitioned from the Black Arts Movement to the Black Panther Party. They were the first works to be mass-produced as posters. They were sold at various events and rallies to fundraise for the party.

pictures that show him at his death door or dead—his bridges are blown up in our pictures—his institutions destroyed—and in the end he is lifeless."

This statement titled "REVOLUTIONARY ART/BLACK LIBERATION" (*The Black Panther*, May 18, 1968 ... the day before Malcolm X's birthday) could be a statement by any of the Black arts organizations, certainly those coming after BARTS, because those were our intentions exactly. Emory even quotes from a poem of mine popular during the period "Who will Survive America?"... Black people will survive.

To show the nature of the objective united front that existed to a certain extent in the BLM then, Emory also quotes from Carmichael, talking about "undying love for the people" and Rap's "We shall conquer without a doubt." Emory's posters showed this alliance of struggle he describes, "Minister of Justice H. Rap Brown burning America down ... Prime Minister Stokely Carmichael with hand grenade in hand pointed at the Statue of Liberty ... Minister of Defense Huey P. Newton defending the Black community."

The quote of mine was associated with the drawing on the poster Emory did of me, which ironically enough became the cover, years later, for the first version of the poem, "Somebody Blew Up America!"

The *Black Panther* newspaper, indeed all its propaganda that utilized Emory's art was always dynamically effective. He gives paradigms for the kind of work he and other revolutionary artists should be doing, in this same manifesto "We draw pictures that show Standard Oil in milk bottles launched at Rockefeller with the wicks made of cloth from I Magnin ... pictures of pigs hanging by their tongues wrapped with barbed wire connected to your local power plant ... This is revolutionary art—pigs lying in alley ways of the colony dead with their eyes gouged out—autopsy showing cause of death: They fail to see that majority rules."

Emory's art was a combination of expressionist agitprop and homeboy familiarity. I always felt that Emory's work functioned as if you were in the middle of a rumble and somebody tossed you a machine pistol. It armed your mind and demeanor. Ruthlessly funny, but at the same time functional as the .45 slugs pouring out of that weapon.

A drawing like "Revolution In Our Lifetime" (p. 17 *The Black Panthers Speak*, P. Foner, ed. Lipincott, 1970) is so effective because it looks like it comes from the revolutionaries themselves, that they actually have drawn pictures of themselves!

The signature image that Emory created was, of course, "The Pig," the Panthers' term for the killer police force "occupying" the Black ghettoes of America. In May '67, a very early issue of the newspaper (first published April 25, 1967 which screamed headlines about the murder of Denzil Dowell) gives this definition of a pig, "a pig is an ill-natured beast who has no respect for law and order, a fool traducer who's usually found masquerading as a victim of an unprovoked attack."

Emory's "pig" was a nasty scrawny filthy creature with the projected sensibility that was mostly slime lover and animal slacker, if you will. The bravura touch was the flies that always circled the creature's nasty self. Whatever one thought of the Panther philosophy as a whole, I did not meet anyone among any

_181_

sector of the Movement that did not dig that pig, just looking at it would crack you up in a mixture of merriment and contempt!

Of the two artists I most identify with the hottest revolutionary images used in Black Liberation Movement journals, Emory Douglas and the Nation of Islam's Gerald 2X, with his ubiquitous "devil" in *Muhammad Speaks*, with fangs hanging out of each side of his George Bush-like mouth, as I said in a poem, "used for sucking oil and blood," plus the little "devil" tail sticking out his hiney. Emory together with Gerald 2X were, without a doubt the baddest political graphic artists in journalism. As seemingly contradictory as their ideologies were (are) they were the substance of the goodness of a national liberation united front. A double-barreled art gun.

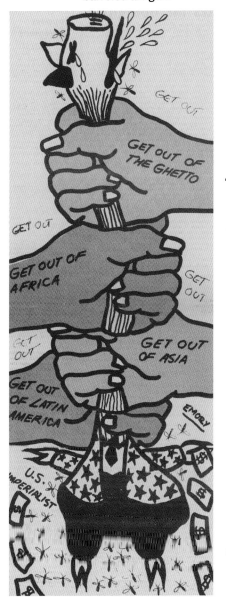

That "homeboy" quality of Emory's art makes it harder to ignore, since it is not delivered with the customary art-gallery panache, these come on like drawings, straight out of the hood. Emory's international hands choking the pig out of shape even while his gaggle of flies still circulate around his snout, and dollar bills fly out of his pocket, the hands of all colors, squeeze and choke the pig, with his American flag stars coat, and written on the strangling hands "Get Out of The Ghetto" ... "Get Out of Africa," "Get Out of Asia," "Get Out of Latin America," squeezing tears out of his terrorized shut eyes, juice out of his choking snout and mouth, and the ill-gotten super profits out his pockets. This is an international cry against U.S. imperialism.

As Emory stated, this is the function of Revolutionary Art, to expose the lies and oppression of the enemy, and in so doing win the minds of the people. That's what Mao's Cultural Revolution was, actually an extension of what Lenin called for seeing the lack of revolutionary culture as one chief obstruction to carrying out the complete mandate of the Bolshevik revolution. That was why the Harlem Renaissance and the Black Arts Movement were important. That's why in such a retrograde period as we are in, when the huge Sisyphus rock we rolled up the mountain of our struggle in "the 60s" for Equal Citizenship rights and Self-Determination ... i.e., a People's Democracy, a necessary stage before socialism, has been, like the Greek myth DuBois likened to the National Black Struggle, rolled back down on our heads. A new renaissance of Revolutionary Art to help roll that rock up the mountain, one (we hope) more time is absolutely necessary and know that digging Emory Douglas's "Badness" indeed his "Terribleness" will help in that struggle. ●

**ABOVE**
October 19, 1968

AMIRI BARAKA

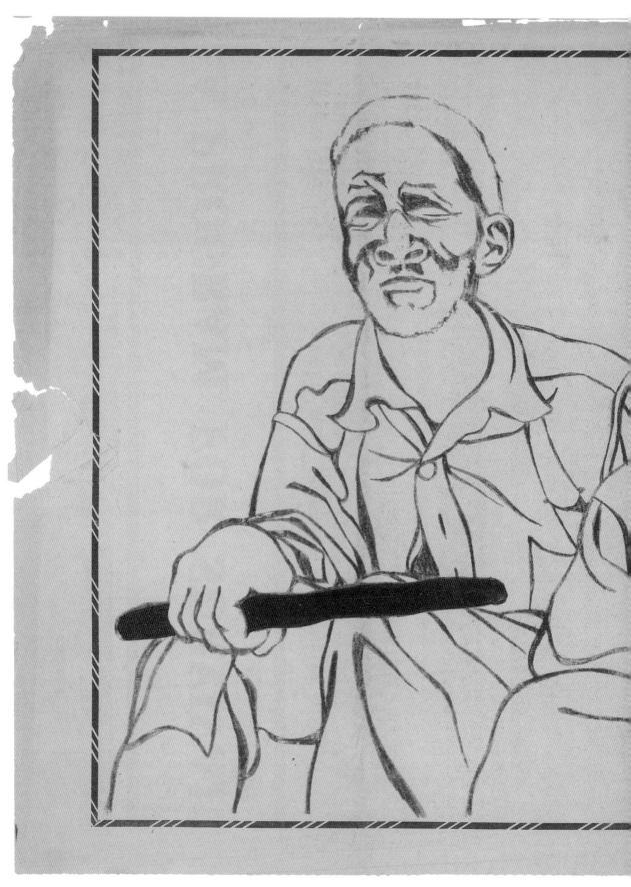

**February 2, 1974:** Douglas uses the lyrics from an old slave song on this center spread from the newspaper, connecting one of the earliest forms of resistance to the struggles of contemporary black people.

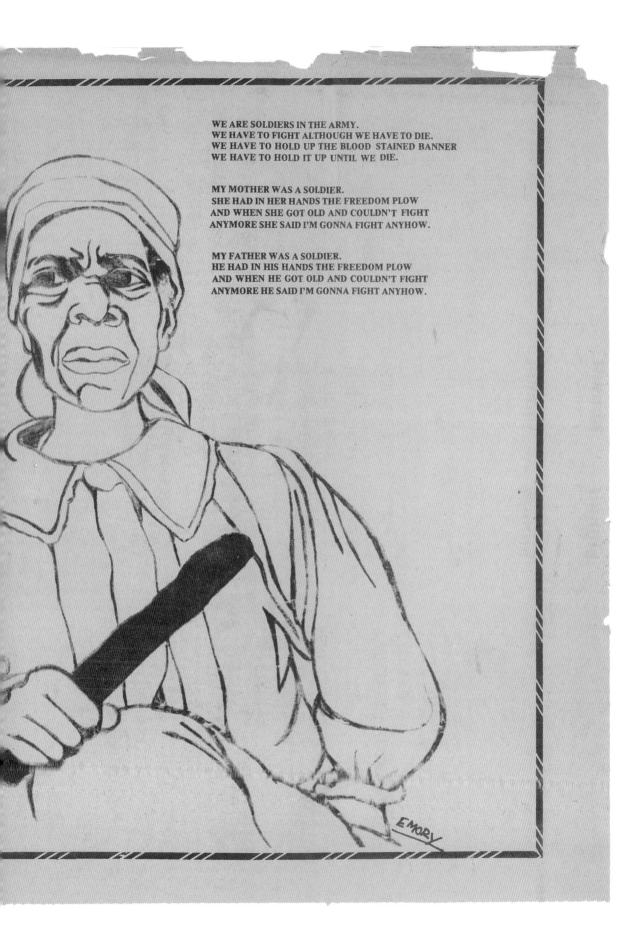

WE ARE SOLDIERS IN THE ARMY.
WE HAVE TO FIGHT ALTHOUGH WE HAVE TO DIE.
WE HAVE TO HOLD UP THE BLOOD STAINED BANNER
WE HAVE TO HOLD IT UP UNTIL WE DIE.

MY MOTHER WAS A SOLDIER.
SHE HAD IN HER HANDS THE FREEDOM PLOW
AND WHEN SHE GOT OLD AND COULDN'T FIGHT
ANYMORE SHE SAID I'M GONNA FIGHT ANYHOW.

MY FATHER WAS A SOLDIER.
HE HAD IN HIS HANDS THE FREEDOM PLOW
AND WHEN HE GOT OLD AND COULDN'T FIGHT
ANYMORE HE SAID I'M GONNA FIGHT ANYHOW.

EMORY

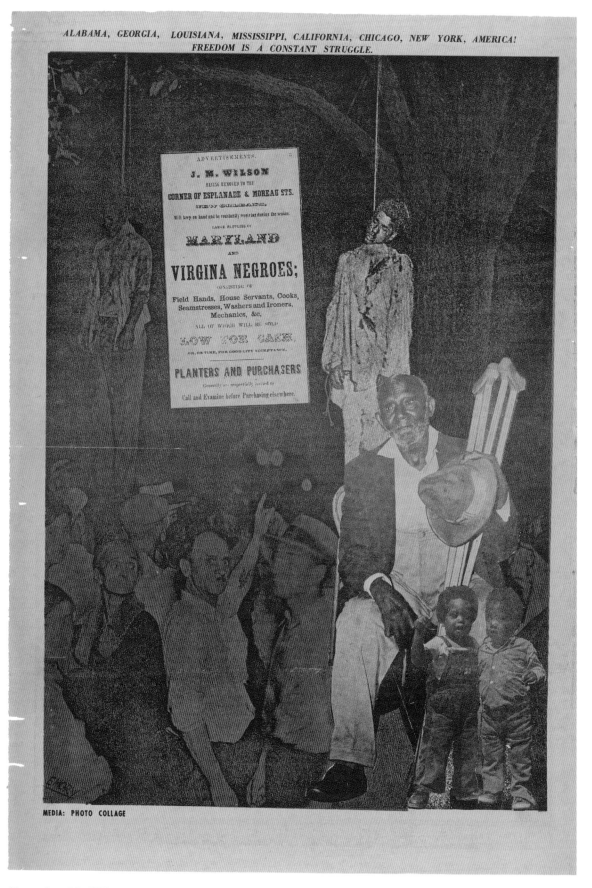

**November 23, 1972:** Douglas connects an infamous, historic image of a lynching
with contemporary struggles against oppression.

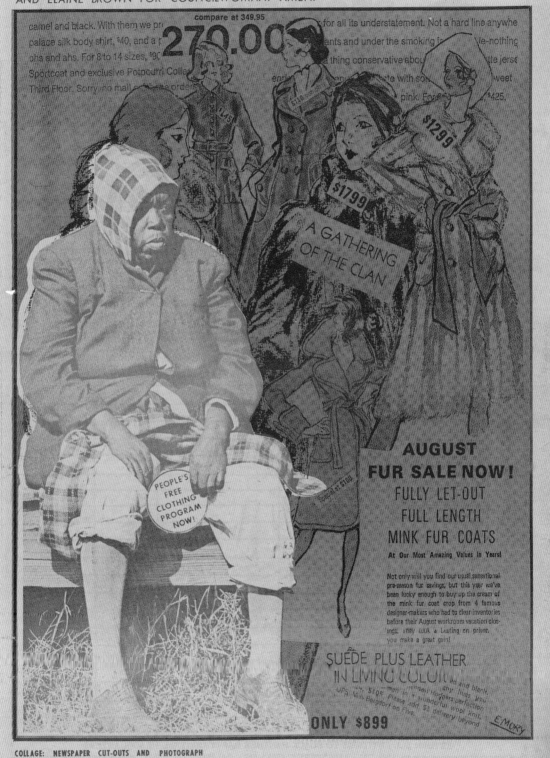

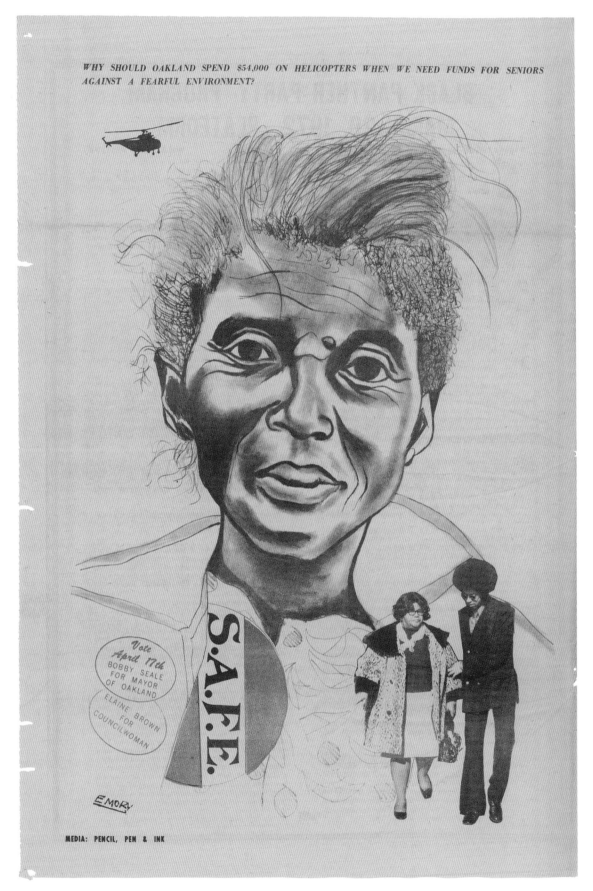

**January 13, 1973:** S.A.F.E. (Seniors Against a Fearful Environment) was a local citizens group.
Demonstrating the party's involvement in grassroots political issues, the poster makes a case for a more responsible
use of Oakland's public funds.

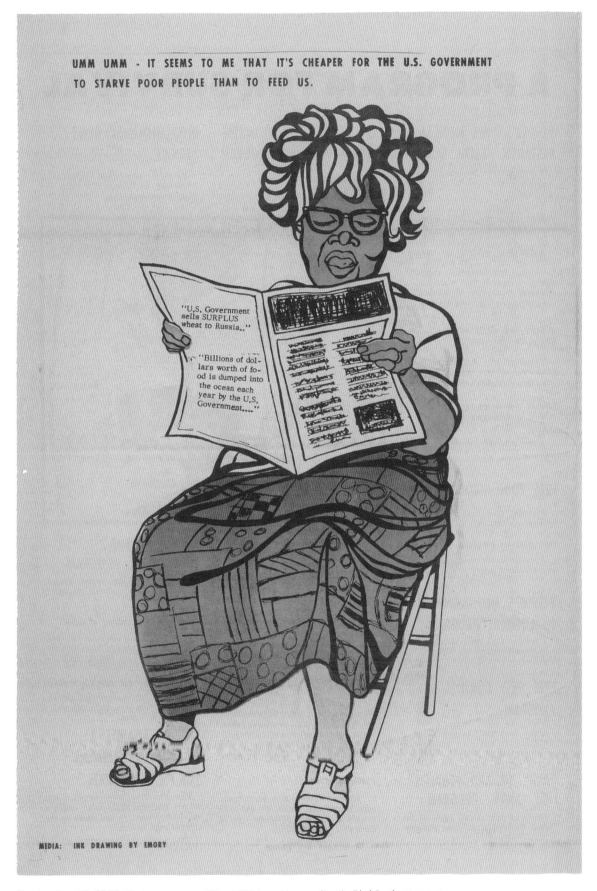

September 15, 1973: The images on pages 187 and 188 show citizens reading the *Black Panther* newspaper and becoming informed on important political issues.

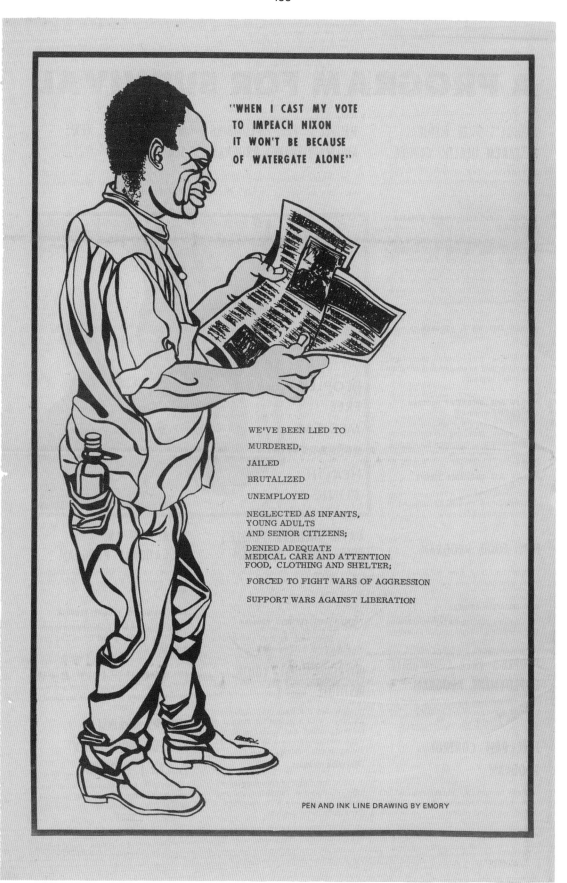

"WHEN I CAST MY VOTE
TO IMPEACH NIXON
IT WON'T BE BECAUSE
OF WATERGATE ALONE"

WE'VE BEEN LIED TO

MURDERED,

JAILED

BRUTALIZED

UNEMPLOYED

NEGLECTED AS INFANTS,
YOUNG ADULTS
AND SENIOR CITIZENS;

DENIED ADEQUATE
MEDICAL CARE AND ATTENTION
FOOD, CLOTHING AND SHELTER;

FORCED TO FIGHT WARS OF AGGRESSION

SUPPORT WARS AGAINST LIBERATION

PEN AND INK LINE DRAWING BY EMORY

**August 25, 1973**

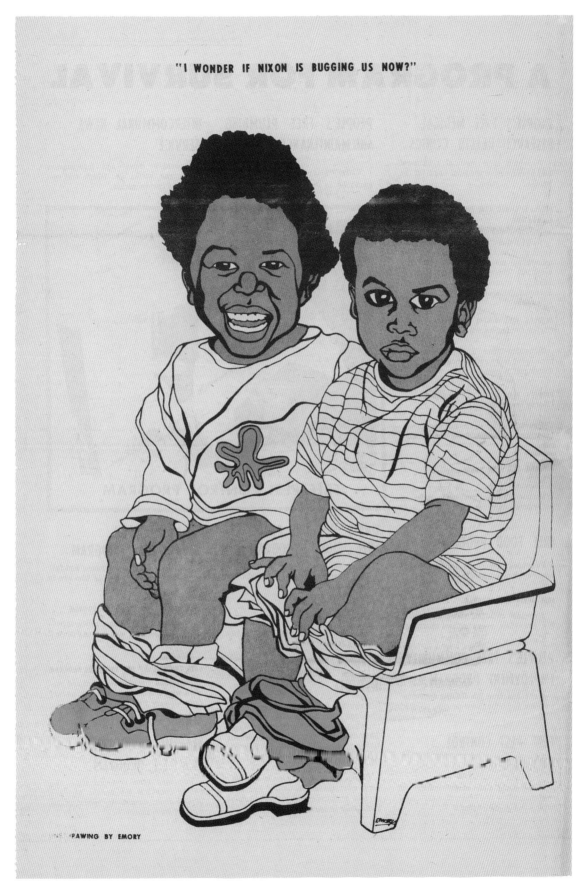

**September 1, 1973:** A humorous reference to the COINTELPRO (Counter Intelligence Program) wiretapping of the Black Panther Party.

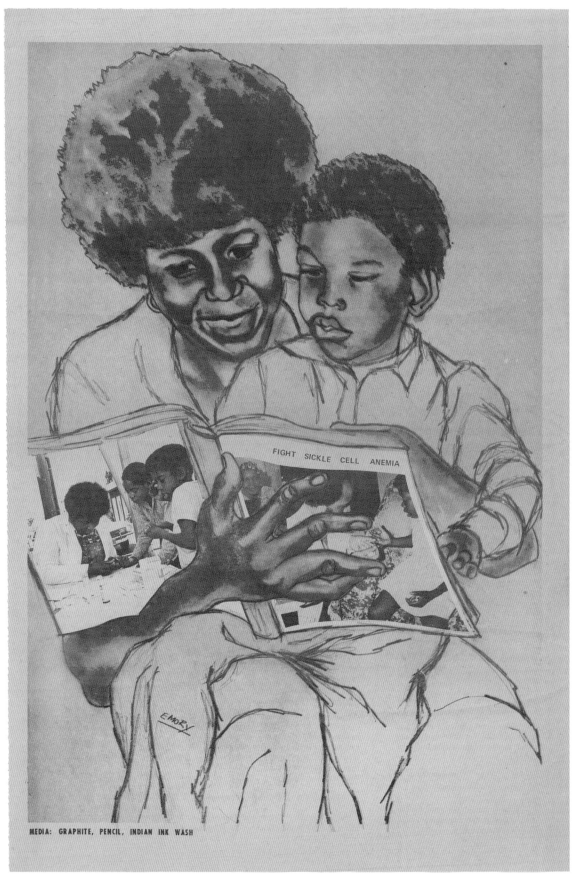

MEDIA: GRAPHITE, PENCIL, INDIAN INK WASH

**June 16, 1973:** The Black Panther Party conducted a nationwide awareness and testing program for sickle-cell anemia, a disease that mainly affects the black population. Douglas also designed information kiosks that were placed throughout local black communities.

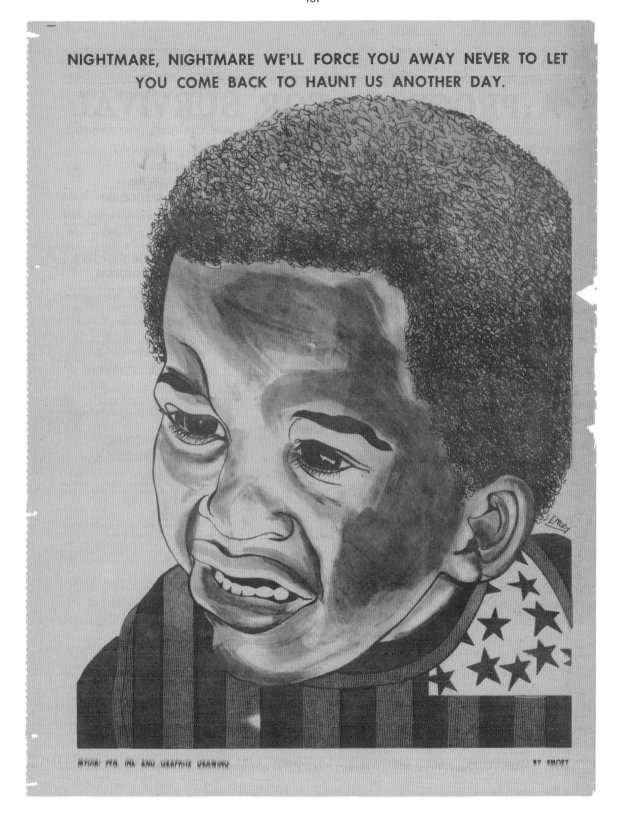

**April 13, 1974:** The burden of being born black in America.

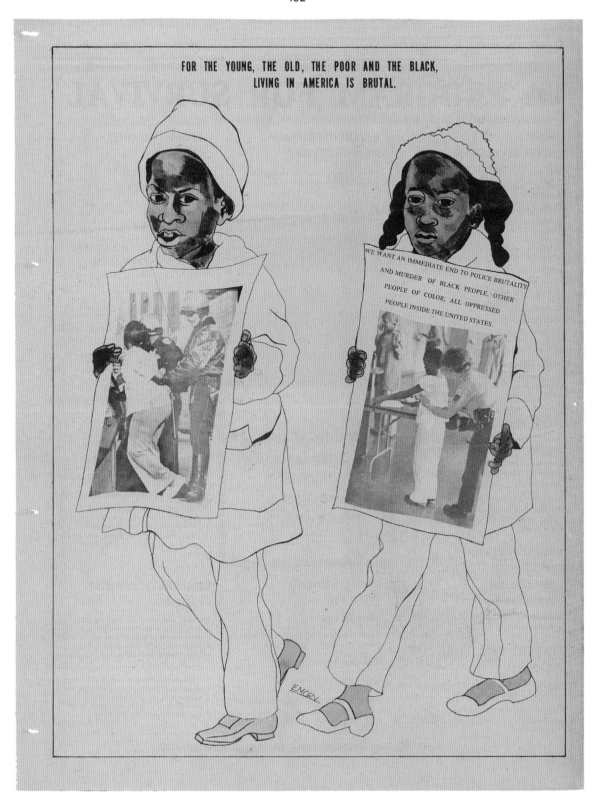

FOR THE YOUNG, THE OLD, THE POOR AND THE BLACK,
LIVING IN AMERICA IS BRUTAL.

WE WANT AN IMMEDIATE END TO POLICE BRUTALITY AND MURDER OF BLACK PEOPLE, OTHER PEOPLE OF COLOR, ALL OPPRESSED PEOPLE INSIDE THE UNITED STATES.

**March 27, 1975:** This image addresses the physical and psychological effects of police control. In the drawing, two children hold signs containing photographs of a young woman being arrested and children being searched as they wait to attend the San Quentin 6 trial, which included George Jackson.

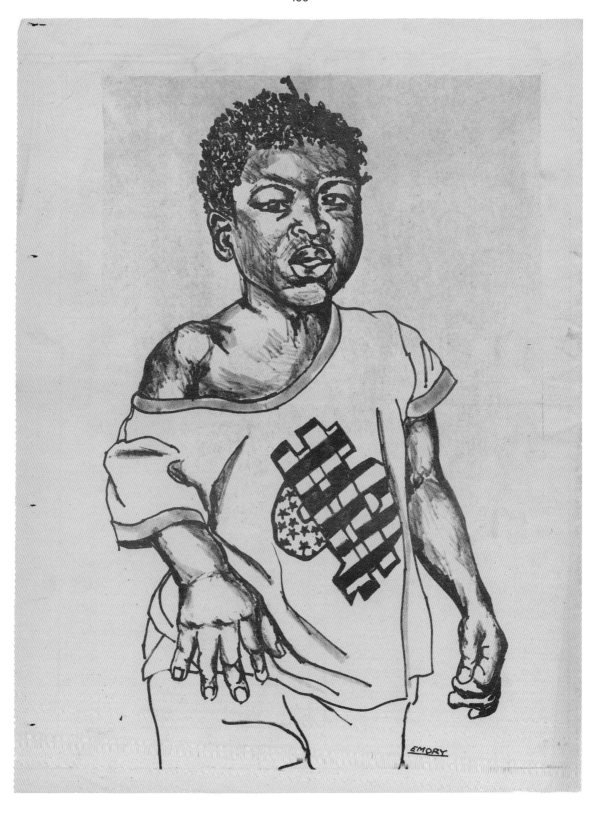

**December 6, 1975:** A young boy wearing a T-shirt emblazoned with a dollar sign decorated with the American flag's stars and stripes is meant to serve as an indictment of how the capitalist system disenfranchises the black community.

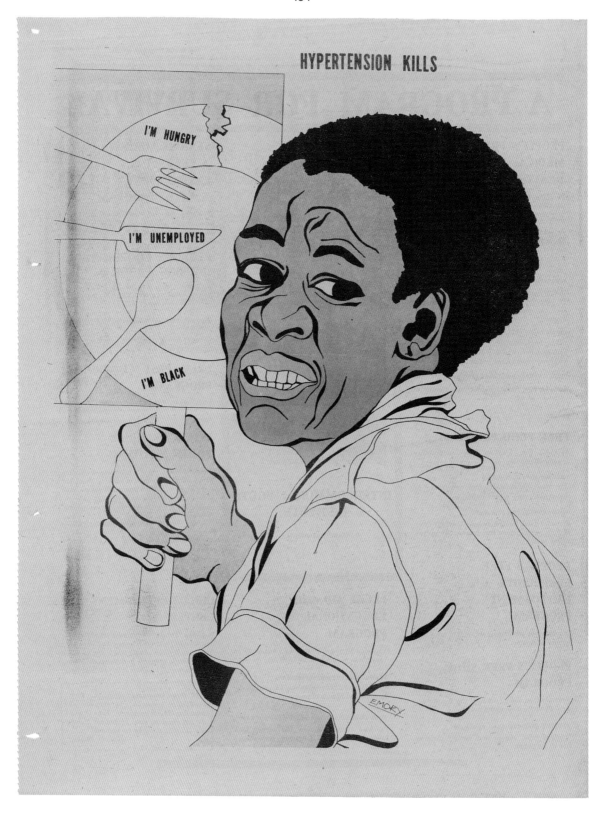

**July 21, 1975:** Another example of the party's health awareness and quality-of-life campaigns.

# PUBLIC HOUSING U.S.A.

STORY BY THE PEOPLE,
ILLUSTRATIONS BY EMORY

"HELLO, PUBLIC HOUSING AUTHORITY.
THIS IS A TENANT OF YOUR SLUM HOUSING
CALLING YOU AGAIN."

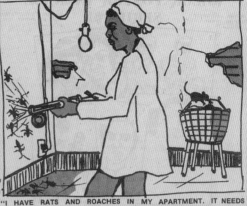

"I HAVE RATS AND ROACHES IN MY APARTMENT. IT NEEDS
EFFECTIVE EXTERMINATION."

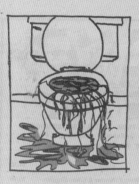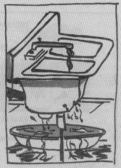

"I HAVE A STOPPED UP TOILET AND A LEAKY SINK."

"MY HOUSE HASN'T BEEN PAINTED IN YEARS."

"WE NEED MORE GARBAGE PICK-UP."

"I AM DISABLED, LIVE ON THE THIRD
FLOOR, HAVE NO ELEVATOR AND VERY
POOR LIGHTS."

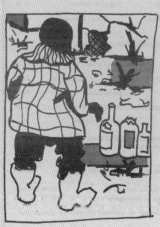

"MY CHILDREN HAVE NO PLACE TO PLAY."

"STAIRS THAT NEED REPAIR ARE
HAZARDOUS TO OUR HEALTH."

"STOP THE POLICE HARASSMENT."

YEARS PASS AND NOTHING HAPPENS.

ACTION

TO BE CONTINUED

**July 24, 1976:** Using the storyboard technique in the work on pages 195–97, Douglas outlines the story
of the struggle with the public housing system and corrupt city government to get decent housing for all people.

# PUBLIC HOUSING U.S.A.
## PART TWO

STORY BY THE PEOPLE
ILLUSTRATIONS BY EMORY

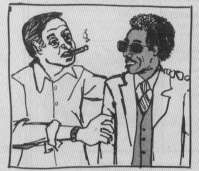

WHY MR. SELLOUT, YOU'RE OUR KIND OF NIGGRA TO HEAD THE SLUM PUBLIC HOUSING.

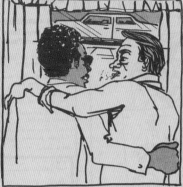

DIDN'T WE GIVE YOU A NEW CAR?

PLENTY OF MONEY AND A BARBEQUE JOINT?

YES SUH, BOSS.
YES SUH, BOSS. YES SUH.

LET YOU STAY NEXT DOOR TO US AND INTRODUCE YOU TO THE FINER THINGS IN LIFE?

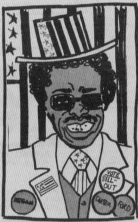

LET YOU VOTE?

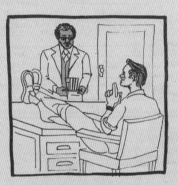

NOW YOU GO DOWN TO THE VILLA SLUM AND COOL DOWN THE NIGGRAS AND FOOL THE PRESS.
YES SUH, BOSS. YES SUH.

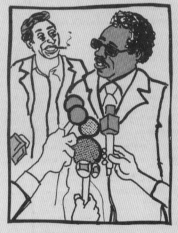

MR. SELLOUT, HOW'S THINGS IN THE SLUM PUBLIC HOUSING?

FINE, FINE, NICE PLACE TO LIVE.

SOME OF MY BEST FRIENDS LIVE THERE.

TO BE CONTINUED

Public Housing U.S.A.
May Not Appear Each Week But Will Be An Ongoing Series.

July 31, 1976

# PUBLIC HOUSING U.S.A.

STORY BY THE PEOPLE
ILLUSTRATIONS BY EMORY

**PART 3**

WE TOOK OUR PROBLEMS TO THE SLUM PUBLIC HOUSING AUTHORITY AND NOTHING HAPPENED.

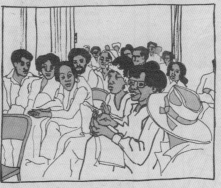

WE GOT THE RUN-AROUND FROM THE HOUSING COMMISSIONERS AND NOTHING HAPPENED

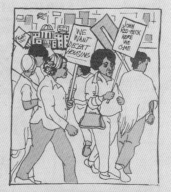

WE MUST NOT GIVE UP. WE WILL FIGHT.
MAYOR JOHN RED NECK HERE WE COME!

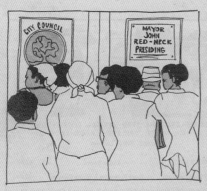

SH! SH! LISTEN.

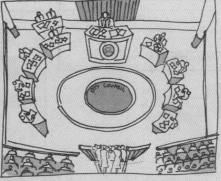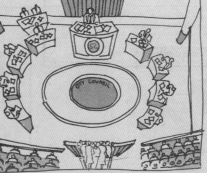

HMM, ISN'T THAT SOMETHING?

LET'S GO IN.

THE GOOD LAW-ABIDING CITIZENS OF MIDDLE AND UPPER CLASS AVENUE RECEIVE FOR THE 15TH CONSECUTIVE YEAR THE AWARD FOR NEIGHBORHOOD BEAUTIFICATION.

OKAY, WHO'S NEXT?

MAYOR JOHN RED NECK, WE ARE HERE AS CONCERNED CITIZENS OF THE CITY OF OAKLAND TO PROTEST THE GOVERNMENT'S SLUM PUBLIC HOUSING.

WELL! WHAT DO YOU NIGGERS WANT? SOME TREES, A NEW FREEWAY, MORE POLICE PROTECTION OR A CIVIC CENTER?

TO BE CONTINUED

Public Housing U.S.A.
Max And Apollo Each Week But Will Be An Series.

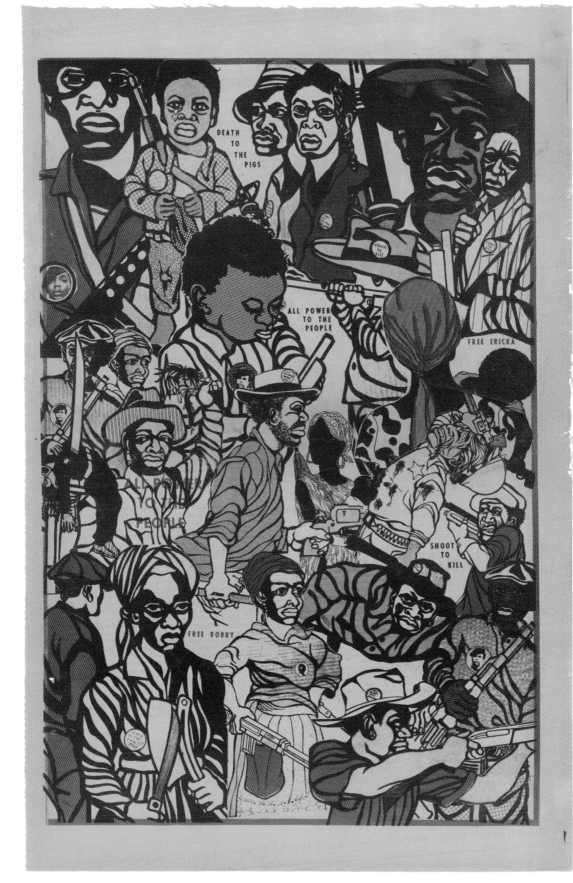

**January 23, 1971:** A collage of some of Douglas's drawings.

*ST. CLAIR BOURNE*

# An Artist for the People:
## An Interview with Emory Douglas

**ST. CLAIR BOURNE** *When did you realize you liked to draw? When you were a little kid?*

**EMORY DOUGLAS** Yeah. From a kid I used to draw, but it was just abstract, it was more like scenes, creating scenery, mountains. Not even getting into anatomy or any of those things at that particular time.

**SCB** *And where did you grow up?*

**ED** Well, I grew up here in San Francisco. I was born in Grand Rapids, Michigan. I came here in 1951. My mother had a sister here, and I had asthma as a child. The doctor said a climate change would be good for the asthma. So we came out here to San Francisco.

**SCB** *And did you run with some friends who were artists too, or did you just do it by yourself?*

**ED** I did it by myself, basically. Just like a lot of kids—you copy cartoons out of magazines.

**SCB** *OK, so when did you decide to go into it seriously?*

**ED** Well, when I went to City College. At that time, I was a juvenile delinquent so they suggested that I go to art school. And I went to City College, and when I talked to a counselor, he suggested advertising art. And so I got into that. And by taking up the commercial art you get a broad discipline, and you get the design elements, you get the anatomy, dealing with figure drawing … all these diverse elements in the print aspect. So you get a foundation in all of them. At City College of San Francisco at that particular time, they were considered one of the best junior colleges for the commercial arts. The teachers always compared your work to what was going on on a professional level.

**SCB** *What happened to make you take your art, which was essentially oriented toward commercial art, and become politicized?*

**ED** Well, what came first was just an awareness of wanting to do Black art, period. And then I got connected with this movement at City College to change the Negro Students Association to the Black Students Association. And I got involved with that movement doing some flyers and stuff like that.

I was involved with the Black Arts Movement, with the theater and all that, you see. And so being exposed to that was kind of an inspiration to want to do something. So therefore people knew that I had these skills, and they were organizing to bring sister Betty Shabazz to the campus, and they asked me to do the flyer and the poster for that event. And so I did the poster. Now, I was involved with that movement, but it didn't satisfy what I wanted to do. I went to the meeting, and Huey Newton and Bobby Seale came to that meeting. When I saw Huey and Bobby come over, that was when I asked about becoming a part of the Black

Panther Party. And they gave me their phone number, and it was at that point that I knew I wanted to be a part of the Black Panther Party.

**SCB** *So, you've got craft and skills, what happened next? And how did you go from that?*

**ED** From City College to the party?

**SCB** *Yeah.*

**ED** Huey and Bobby were trying to recruit Eldridge [Cleaver] as the writer for the newspaper for the Black Panther Party. Eldridge used to stay at the place they used to call, at one time, the Black House. Eldridge lived upstairs, and they used to have the cultural activity downstairs. Huey and Bobby used to come over there all the time to talk with Eldridge about becoming part of the party. And I used to come through there for the cultural events. And so one night I went over there, and it just so happened that Huey and Bobby were there trying to talk with Eldridge, and so when I came in Bobby was sitting down trying to do the first issue of the newspaper, trying to do the headlines with a pencil. And I told him I could help improve the quality of what was being done. And so I went to the other side of town to my house, came back, and they were impressed that I came back. They said they were going to start a newspaper. And they wanted me to be a part of the newspaper. And I would be considered the Revolutionary Artist for the newspaper.

**SCB** *That was your title, the Revolutionary Artist?*

**ED** Yes, yes.

**SCB** *Now, how did you take that?*

**ED** Well, I enjoyed it. You see, they had this whole vision about the [party's] Ministry of Information. It was going to be about revolutionary art. Huey talked about how pictures give you a visual interpretation of the struggle because people liked to look at photographs but they weren't the reading community. All these things he talked about were things he touched on when he was expressing a desire for me to be a part of the Black Panther Party and work on the newspaper.

**SCB** *Who was the main theoretician that you used as a source of your inspiration?*

**ED** Well, Huey was the chief theoretician of the party, but the actual inspiration came from the party and the people in the community.

**SCB** *I know that was part of the rhetoric, but whose idea was it to call the police "pigs"?*

**ED** Huey and Bobby. They used to call them pigs, swine. See, when it first started, Huey asked me to do a cartoon of a pig. And we were going to put the badge number on this pig each week, who was harassing people in the community. So after that, doing that pig, I had in my mind, how can I improve it? And it just came to me that I could just stand the pig up on his hoofs, and dress him up like a cop, but still have the character of a pig.

**SCB** *Your work does have a cultural mix. So how did you start with the cultural-nationalist base and then mix in Marxist elements?*

**ED** Well, it evolved from the party and being in the party. Because the first pictures you might have seen were the silhouettes of the Black woman with the baby and the gun, or the sister carrying the gun with the baby on her back, or the brother saying "Black studies" carrying the gun—it was a mixture of both the cultural thing and the determination to struggle at the same time. That came about out of the ideals of the Black Panther Party.

**SCB** *So, you basically took a basic concept and you improved it?*

**ED** Right. As I improved it, I also improved the quality of the work. The quality of the work was not that good at first. It was really on-the-job training.

**SCB** *As you look back, do you think that your work changed over a period of time?*

**ED** Yeah, the work changed as the party changed. It reflected the ideological position of the party. The first part of the artwork was the pig drawings. How that came about was that when Huey told me we're going to draw the police as pigs and each week we're going to put on this pig the badge number of the pig who is harassing people in the community, I started drawing. But the pig I drew, the skill level wasn't that good, and I evaluated and upgraded the quality of the work as it went along. You see, so that was the first pig.

**SCB** *So, the first phase would be the pig imagery. So, when did it change and where did it go?*

"BLACK PEOPLE CAN DESTROY THE MACHINERY THAT'S ENSLAVING THE WORLD. AMERICA CANNOT STAND TO FIGHT EVERY BLACK COUNTRY IN THE WORLD AND FIGHT A CIVIL WAR AT THE SAMETIME. IT IS MILITARILY IMPOSSIBLE TO DO BOTH OF THESE THINGS AT ONCE."

Quote From The Essays By The Minister of Defense Huey P. Newton

May 2, 1970

**ED** Well, then we started talking about the lumpen proletariat. Then I started drawing the figures of the people and some of the brothers and sisters in the community in combat poses. That's phase two.

**SCB** *So, how long do you think that lasted?*

**ED** When the gun laws began to change, we began to change. So Huey and Bobby said that we were going to work within the law. Yeah, they said it was time for us to put down the guns and get out there and start organizing the community around our other Survival Programs. And that's what we did.

**SCB** *So, you couldn't be blatant anymore?*

**ED** We still reflected the lumpen attitude because that was the way the community felt, and there was still police brutality across the country. So, you had people who were talking about resistance, particularly in the student movement in this country. And so, we did reflect the feelings and expressions coming from the community and the lumpen proletariat kind of ideal in the artwork.

**SCB** *Now, where did it go after that?*

**ED** OK, in '69 Huey and Bobby said that we were going to focus our attention on building the community Survival Programs. So the art began to reflect those Survival Programs: the Breakfast Programs, electoral politics, the Free Clothing Program, the Free Food Programs, and those things that went on.

**SCB** *Did you have any internal struggle in your own head when it jumped from each phase? I mean, I know as an artist it was not easy, but at least you had the skills and the artistic ability to produce what each phase needed. But it would seem to me if you have to go from images of armed struggle and resistance to mainstream representation, didn't that take your head somewhere?*

**ED** Well, no because what happened is I understood where Huey and Bobby were always coming from. A lot of people came into the party thinking that the party was just about armed struggle; it was much more than that. They were trying to show that there was a necessity for struggle, but you also had to have a base of support. So, I kind of understood that.

**SCB** *Did you ever think about the relationship of the craft you learned for commercial advertising and the purposes for which you used the crafts in these fields?*

**ED** When I went into advertising it was about employment, job security, all those things that you normally go to school for. But my consciousness began to become broader and more aware of other things you're exposed to in the community.

**SCB** *So, initially you responded to a concept that Huey or Bobby gave you and then you improved on it, right? Did you ever come up with ideas of your own?*

**ED** Well, the truth of the matter is that it never came down to Huey saying that you need to do this or that. The inspiration came from being involved in the politics of the party. Having our political education classes, doing the outreach in the community—all of these things were part of the inspiration for the artwork. Then the key to it was the feedback that you got from the community. And so you'd know you were on the right track with something that had a connection between what you were doing and what you were saying in the community.

**SCB** *It was a collective process?*

**ED** In the early days when we used to do posters for events, we would take the posters and take them and plaster them up on the walls of the community. So, we started getting up early in the morning to sell papers, we would get a bucket of wheat paste, and we'd take a lot of the newsprint posters that we'd done of the artwork and plaster it on the walls of the community. And that's how the community became the gallery for the artwork. So, the inspiration of the community inspired the party members so it was a whole dynamic.

**SCB** *So, do you think that your pictures are a visual history of the Panthers?*

**ED** You could say that. From the inception up until I think about 1977 or '78 was the last piece I did. Yeah, in a sense, it could reflect the Ten-Point Platform of the Black Panther Party in the visual artistic sense.

**SCB** *In your mind, are there certain categories of your work? Are there other blocks of work?*

**ED** There are caricatures that I did. Then I started integrating collage-type photographs into the artwork itself so that it has a broad appeal. And then also being inspired by the work that was being done around the world—the Cuban artists, the artwork in Viet Nam, the art from the Middle East. Being inspired by that art also played a role in the kind of work I wanted to do, showing resistance and armed struggle against oppression.

**SCB** *The work that you did for the party … did you ever do it just as art?*

**ED** No, because we used to always talk—no such thing as art for art's sake. All art was a reflection of a class outlook. Which is true, even today.

**SCB** *Let's say you said to the party, "I need two weeks for myself just to create some art." Did you ever have that impulse?*

**ED** I didn't have any time. Because you're not only doing the art, also designing the flyers, also designing booklets, banners for events. You had all these dynamics you were dealing with. And then also working with other comrades who worked with you, and showing them. Even though I did about 70 to 75 percent of the work, there was still a large volume of work that other party comrades did. And so, you know, they were inspired also. And I would let them shine and do their thing at the same time. You know, each one teach one.

**SCB** *Would you say that you were the center of a new art movement?*

**ED** Ah, no. I knew that it was an inspiration, because of the feedback. So that drove me to continue on, because you know that you were serving a purpose that was bigger than yourself. And the strength came from the fact that I'm able to make this contribution, with my skills, to an organization that's working in the interest of the community.

**SCB** *I always wondered about this: all through the party's life there was a lot of conflict and some factional fights. Did that affect your work?*

**ED** No. Our work was always a reflection of the party even if there were dissenting voices within the party. For some reason the artwork always transcended all of that. Inside and outside the party, people appreciated it.

**SCB** *As an individual, with an opinion, there must have been some times when you said, "Well, I don't know if I agree with this."*

**ED** Oh yeah, there were times when people were expelled; they wanted me to put something on the cover about the expulsion. So, I tried to play it down as much as I could in the design. Those differences were exploited by an external force, you see, COINTELPRO [Counter Intelligence Program] and all those other things.

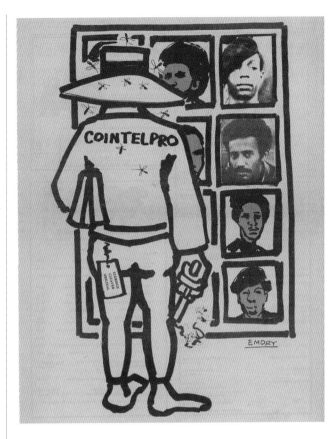

**SCB** *Did you ever read any comments about your artwork by the COINTELPRO people?*

**ED** Yeah. And I've read stuff by the House of Representatives Committee on Internal Security and other material I've gotten through the Freedom of Information Act concerning the Counter Intelligence Program. They were giving descriptions of who I was, what my title was, what I did, and the whole bit.

**SCB** *Did they ever review your work?*

**ED** Some of it. We had a house in East Oakland where my comrades and I lived in a collective. The phone number was unlisted. I got a call there one day. The guy said, "Hello Emory. How are you doing? I'm an art collector and I'm interested in your art." After a while, I asked myself how he got the number since it was unlisted. I started to feel that it was the police. I said, "Well, I'm not interested." He said: "We want to talk to you about your art." Again, I told him I wasn't interested. He said, "OK," and hung up. It just so happened that the guy called back again when I was at central headquarters. I told one of my comrades to get on the other phone to witness it. The so-called art dealer said,

**ABOVE** April 17, 1976: This drawing shows some of the fallen Black Panther Party members who were killed during the government's Counter Intelligence Program (COINTELPRO).

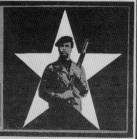

# THE BLACK PANTHER

*Black Community News Service* 25 cents

VOL. IV, NO. 28      SATURDAY, JANUARY 9, 1971

PUBLISHED WEEKLY   **THE BLACK PANTHER PARTY**   MINISTRY OF INFORMATION BOX 2967, CUSTOM HOUSE SAN FRANCISCO, CA 94126

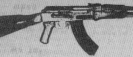

"In the spirit of revolutionary solidarity the Black Panther Party hereby offers to the National Liberation Front and Provisional Revolutionary Government of South Vietnam an undetermined number of troops to assist you in your fight against American Imperialism."

HUEY P. NEWTON,
Supreme Commander,
Minister of Defense, Black Panther Party

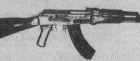

"With profound gratitude, we take notice of your enthusiastic proposal; when necessary, we shall call for your volunteers to assist us."

STORY CENTER PAGE

NGUYEN THI DINH,
Deputy Commander
of the SVN People's Liberation Armed Forces

January 9, 1971

"Emory, I just called back about your art. We'd like to have a meeting with you. We like your art and we're going to make you rich. Why don't you come over and talk with us. We're art dealers, we're over in San Francisco at such and such hotel." I told them I still wasn't interested. They got very agitated with me because I refused the offer.

But we were well aware of how they operated. They would set you up. If I had gone to check it out, to see if it was a real deal, they would have set me up. You had to understand with the NY 21 [the group of twenty-one Black Panthers that was arrested by police in 1969], they threatened to throw one of those sisters out the window. It's the same thing they were doing with politicians. Getting them in those rooms and manipulating them. We were aware of that kind of stuff. It wasn't about the art. It was entrapment. There was all kinds of illegal government stuff going on. They were trying anything they could to discredit us as a legitimate organization.

You see, we were having a major international influence. All the progressive governments around the world had a subscription to the Black Panther Party paper. That meant they were exposed to the artwork. We also had a booth in the First Pan-African Cultural Festival in Algeria. We had tons and tons of materials. We got a lot of exposure there.

**SCB** *You traveled a bit while in the party, right? Did you meet other artists? When you went to different places, did you find that your art was known separately as your art, or was it known as Black Panther art?*

**ED** I don't think it had any significance other than within the circles that bought our paper, you see what I'm saying? We said, well, it's being spread and it was being acknowledged. So that was the key thing. People weren't using it to exploit it for financial gains. It was a spread of ideas. But it's been the young people who show new interest in this work. It's been the young folks.

**SCB** *Do you see examples of your work or references to your work in youth culture or pop culture today?*

**ED** Well, I hear people say that. But I never thought of it. But I hear people say that from time to time. Well, I still have something more to say. I like to do social commentary issues. I feel art should serve a purpose by doing social commentary. I understand not everybody's going to do that, but all of it is social commentary, whether it's positive or negative, mainstream or nonmainstream, it has some social commentary to it.

**SCB** *Who are the people that you liked?*

**ED** Well, I identified with the revolutionary art of the world that was coming in. From Viet Nam, the work out of Cuba, the Middle East, that was the work that I liked during that period.

**SCB** *Do you remember any names?*

**ED** I never got caught up in the name, I got caught up in the quality of the work or if it inspired you. I never got caught up in artists' names per se. I think that maybe one artist I can always tell you about. It was Charles White. When I was a kid, my auntie used to have a calendar that she got from her insurance company, and his artwork was on the calendar every year. And that was the Black art I was exposed to as a youngster coming up.

**SCB** *You said in the beginning you didn't think your artwork was very good.*

**ED** No, because the first drawings that I did, it just didn't come off right for me.

**SCB** *People liked it though.*

**ED** You can like any art if you don't get caught up in the technical aspect of it.

**SCB** *Are you a harsh self-critic? Do you think you're hard on yourself when you look at your work?*

**ED** Not anymore. At one time I was. Now I let it go. If it ain't working, I just let it go until it comes to me. Then I come back to it. I don't pressure myself. I try to work in the moment and not get caught in the possibilities or expectations. I let the results take care of themselves. I don't pressure myself to meet a deadline, you know what I mean?

**SCB** *What would you most like this book to do?*

**ED** Well, to be inspiring. You know, not to duplicate, but to be inspiring to people who want to carry on, to do some social commentary, art wise. I mean the artwork is there, in a format that people can get a sense of what took place. ●

SOUTH AFRICA!

SOUTH AFRICA!!

SOUTH AFRICA!!!

SOUTH AFRICA!!!!

SOUTH AFRICA!!!!!

REPRESSION BREEDS RESISTANCE!!

EMORY

**September 4, 1976:** The images on pages 206–211 expose the brutal practices of the South African government, foreshadowing the national movement to end apartheid that would develop in the next decade.

December 13, 1975

# THE TALKING IS OVER!!!

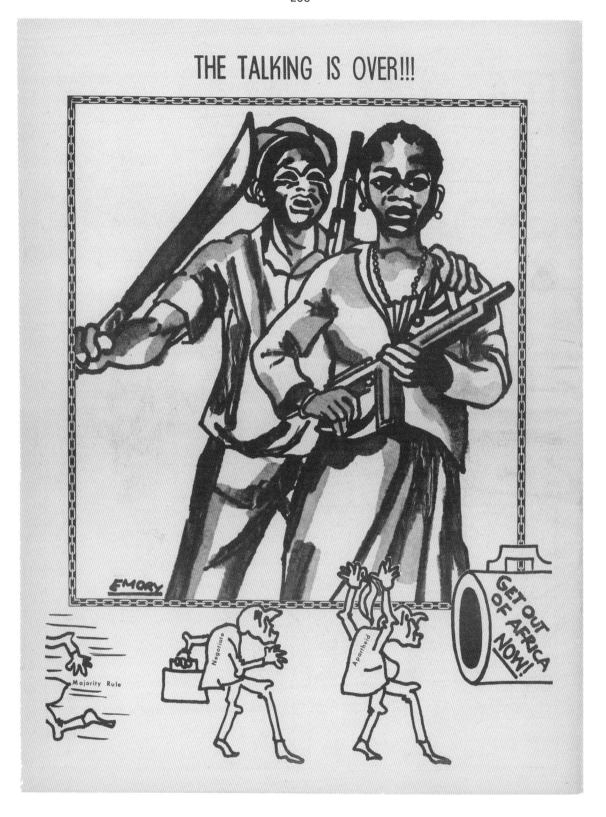

October 9, 1976

209

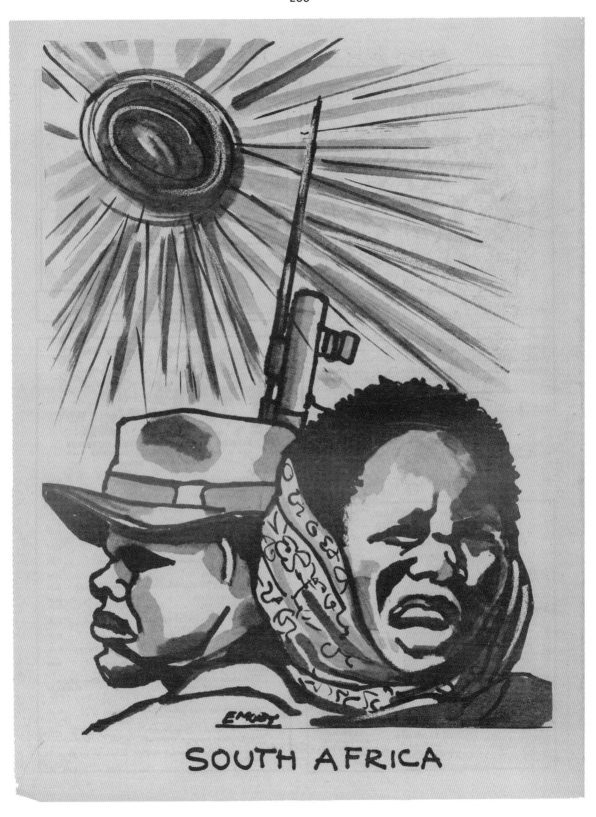

SOUTH AFRICA

September 25, 1976

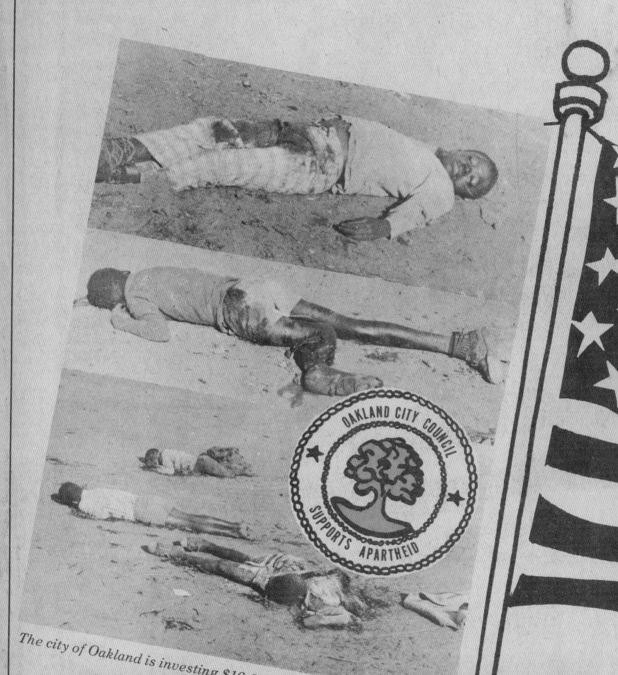

The city of Oakland is investing $16.6 million in racist South Africa.

EMORY

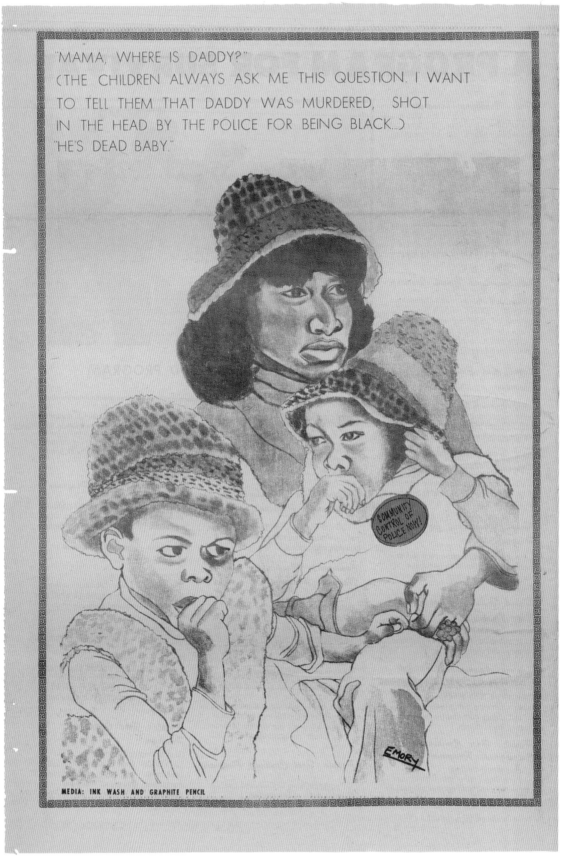

"MAMA, WHERE IS DADDY?"
(THE CHILDREN ALWAYS ASK ME THIS QUESTION. I WANT
TO TELL THEM THAT DADDY WAS MURDERED, SHOT
IN THE HEAD BY THE POLICE FOR BEING BLACK...)
"HE'S DEAD BABY."

MEDIA: INK WASH AND GRAPHITE PENCIL

*Previous pages* **April 22, 1977**

**May 26, 1973**

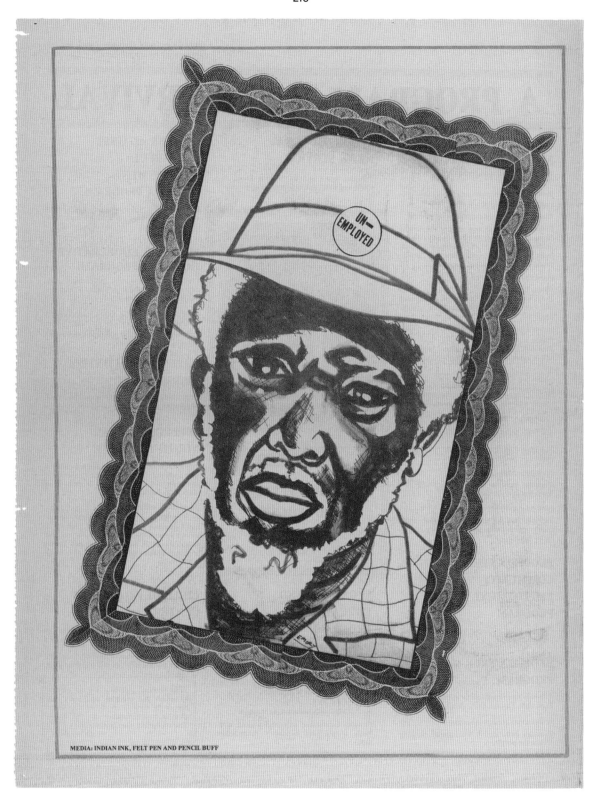

MEDIA: INDIAN INK, FELT PEN AND PENCIL BUFF

**April 6, 1974:** This image illustrates the plight of unemployed seniors.

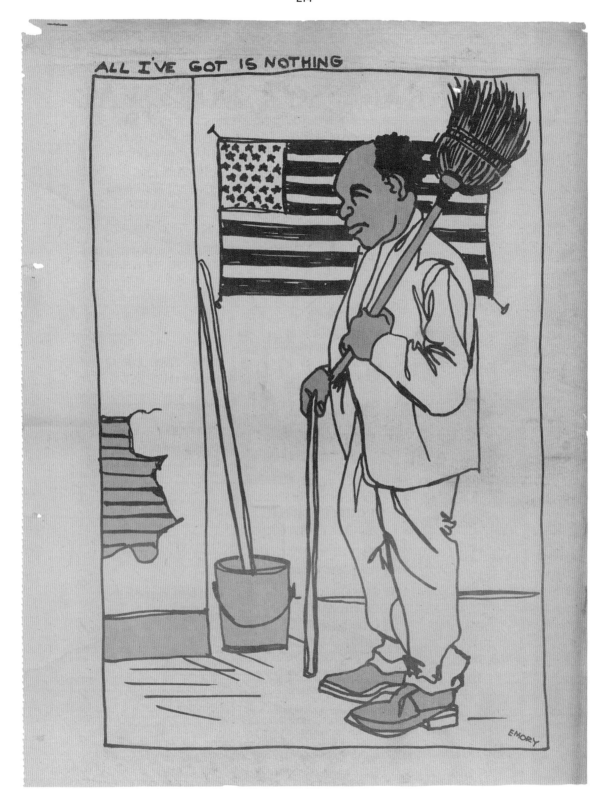

**August 4, 1975:** This image illustrates the plight of unemployed veterans.

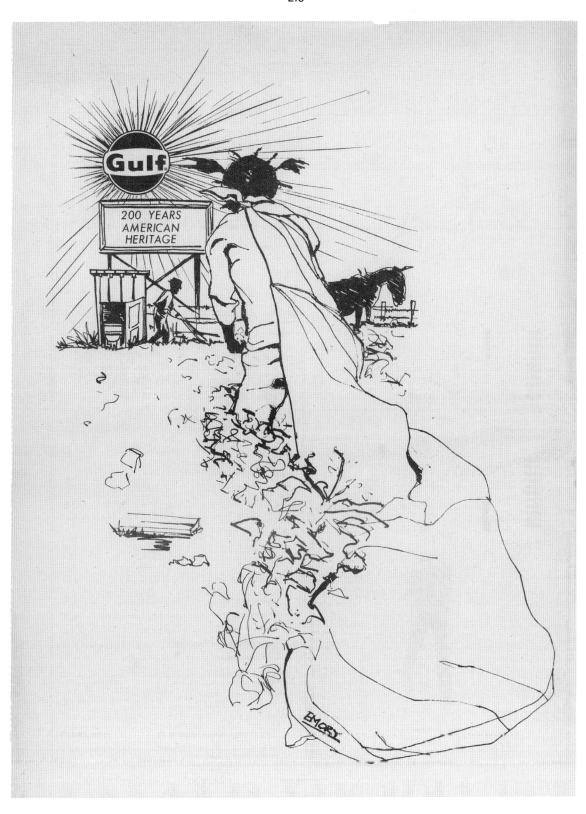

**March 27, 1976:** This drawing was done for the 1976 bicentennial. The figure is carrying
a cotton sack, symbolizing America's heritage of slavery. The Gulf sign in the background underscores
how corporations profit from the labor of poor people.

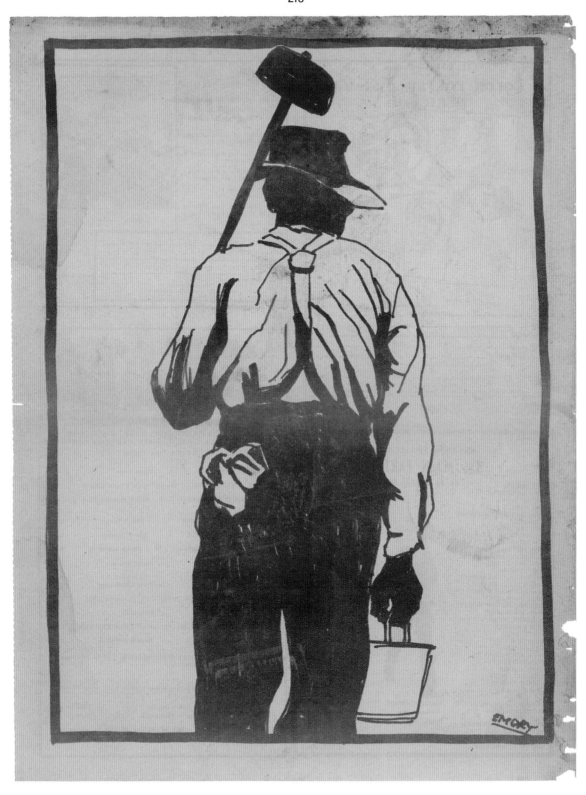

**April 10, 1976:** The source for this drawing is a photograph
of Southern field workers. (see page 156).

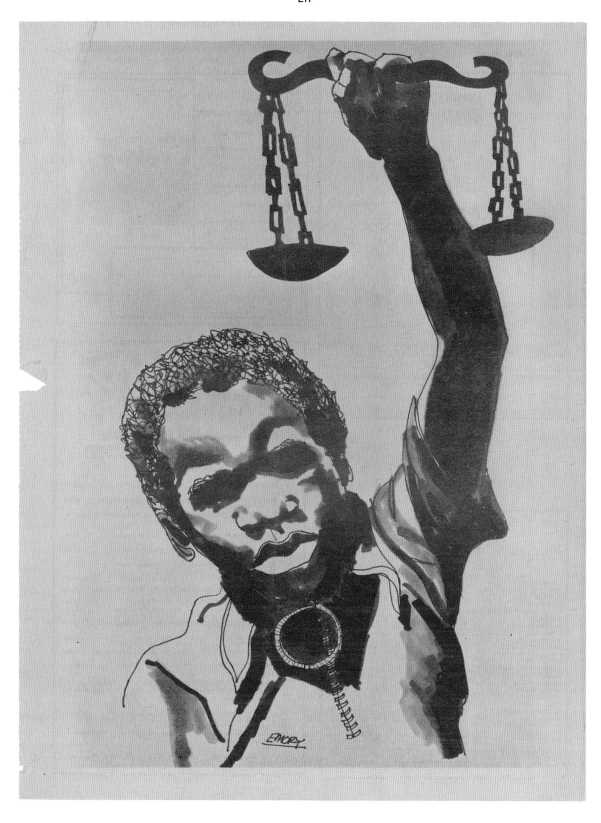

**November 20, 1976:** This image represents the ongoing struggle for social justice.

# BIBLIOGRAPHY

Abu-Jamal, Mumia. *Live from Death Row*. New York: Avon Books, 1996.

———. *We Want Freedom*. Cambridge, MA: South End Press, 2004.

Arend, Orissa. *Showdown in Desire: People, Panthers, Piety, and Police—The Story of the Black Panthers in New Orleans, 1970*. New Orleans: n.p., 2003.

Barron, Stephanie, and Maurice Tuchman, eds. *The Avant-Garde in Russia 1910–1930: New Perspectives*. Cambridge, MA: The MIT Press, 1980.

Baruch, Ruth-Marion, and Pirkle Jones. *Black Panthers 1968*. Los Angeles: Greybull Press, 2002.

———. *The Vanguard: A Photographic Essay on the Black Panthers*. Boston: Beacon Press, 1970.

Benjamin, Walter. *Reflections*. New York: Schocken Books, 1986.

Brown, Elaine. *A Taste of Power: A Black Woman's Story*. New York: Anchor Books, 1992.

Brown, H. Rap. *Die Nigger Die: A Political Autobiography*. New York: The Dial Press, 1969.

Campbell, Mary Schmidt. *Tradition and Conflict: Images of a Turbulent Decade, 1963–1973*. New York: The Studio Museum in Harlem, 1985.

Carmichael, Stokely, and Charles V. Hamilton. *Black Power: The Politics of Liberation in America*. New York: Vintage Books, 1967.

Chapman, Abraham, ed. *New Black Voices: An Anthology of Contemporary Afro-American Literature*. New York: Mentor/Penguin Books, 1972.

Churchill, Ward, and Jim Vander Wall. *Agents of Repression: The FBI's Secret Wars Against the Black Panther Party and the American Indian Movement*. Cambridge, MA: South End Press, 2002.

———. *The CointelPro Papers: Documents from the FBI's Secret Wars Against Dissent in the United States*. Cambridge, MA: South End Press, 2002.

Cleaver, Eldridge. *Soul on Ice*. New York: Dell Publishing Co., 1970.

Cleaver, Kathleen, and George Katsiaficas, eds. *Liberation, Imagination, and the Black Panther Party*. New York: Routledge, 2001.

Cushing, Lincoln. *¡Revolución!: Cuban Poster Art*. San Francisco: Chronicle Books, 2003.

Davis, Angela. *Angela Davis: An Autobiography*. New York: Bantam Books, 1975.

Durham, Michael S. *Powerful Days: The Civil Rights Photography of Charles Moore*. New York: Stewart, Tabori, and Chang, 1991.

Fanon, Frantz. *Black Skin, White Masks*. New York: Grove Press, 1967.

———. *The Wretched of the Earth*. New York: Grove Press, 1963.

Fax, Elton C. *Black Artists of the New Generation*. New York: Dodd, Mead & Co., 1977.

Fenton, David, ed. *Shots: Photographs from the Underground Press*. New York: Douglas Book Co., 1971.

Foner, Philip S., ed. *The Black Panthers Speak*. Cambridge, MA: Da Capo Press, 2002.

Fujino, Diane. *Heartbeat of Struggle: The Revolutionary Life of Yuri Kochiyama*. Minneapolis: University of Minnesota Press, 2005.

Gayle, Addison, Jr., ed. *The Black Aesthetic*. New York: Doubleday, 1971.

Golden, Thelma, et. al. *Freestyle*. New York: The Studio Museum in Harlem, 2001.

Hansberry, Lorraine. *The Movement: Documentary of a Struggle for Equality*. New York: Simon and Schuster, 1964.

Hilliard, David, and Lewis Cole. *This Side of Glory: The Autobiography of David Hilliard and the Story of the Black Panther Party*. Boston: Little, Brown and Co., 1993.

Howard, Elbert Big Man. *Panther on the Prowl*. United States: BCP Digital Printing, 2002.

Jackson, George. *Soledad Brother: The Prison Letters of George Jackson*. New York: Bantam Books, 1970.

Jeffries, Judson L. *Huey P. Newton: The Radical Theorist*. Jackson: University Press of Mississippi, 2002.

Jones, Charles E., ed. *The Black Panther Party Reconsidered*. Baltimore: Black Classic Press, 1998.

Jones, LeRoi. *Home: Social Essays*. New York: Morrow & Co., 1963.

Kern-Foxworth, Marilyn. *Aunt Jemima, Uncle Ben, and Rastus: Blacks in Advertising, Yesterday, Today, Tomorrow*. London: Greenwood Press, 1994.

Lockwood, Lee. *Conversation with Eldridge Cleaver: Algiers*. New York: Dell Publishing, 1970.

Marable, Manning, and Leith Mullings. *Freedom: A Photographic History of the African American Struggle*. New York: Phaidon, 2002.

McQuiston, Liz. *Graphic Agitation: Social and Political Graphics Since the Sixties*. New York: Phaidon, 2004.

Menkart, Deborah, Alana D. Murray, and Jenice L. View, eds. *Putting the Movement Back into Civil Rights Teaching*. United States: McArdle Printing, 2004.

Moore, Joe Louis, and the Dr. Huey P. Newton Foundation. *The Legacy of the Panthers: A Photographic Exhibition*. Berkeley: Inkworks Press, 1995.

Newton, Huey P. *Revolutionary Suicide*. New York: Writers and Readers Publishing, 1995.

——. *To Die for the People*. New York: Writers and Readers Publishing, 1999.

——. *War Against the Panthers: A Study of Repression in America*. New York: Harlem River Press, 1996.

Noriega, Chon A. *Just Another Poster? Chicano Graphic Arts in California*. Seattle: University of Washington Press, 2001.

Philippe, Robert. *Political Graphics: Art as a Weapon*. New York: Abbeville Press, 1982.

Pieterse, Jan Nederveen. *White on Black: Images of Africa and Blacks in Western Popular Culture*. New Haven: Yale University Press, 1992.

Piper, Adrian. *Out of Order, Out of Sight: Volume 2, Selected Writings in Art Criticism 1967–1992*. Cambridge, MA: The MIT Press, 1996.

Powell, Richard J. *The Blues Aesthetic: Black Culture and Modernism*. Washington, D.C.: Washington Project for the Arts, 1989.

Sales, William W., Jr. *From Civil Rights to Black Liberation: Malcolm X and the Organization of Afro American Unity*. Cambridge, MA: South End Press, 1994.

Sanchez, Sonia. *Home Coming*. Detroit: Broadside Press, 1969.

——. *We A BaddDDD People*. Detroit: Broadside Press, 1970.

Seale, Bobby. *Seize the Time: The Story of the Black Panther Party and Huey P. Newton*. Baltimore: Black Classic Press, 1991.

Shakur, Assata. *Assata, An Autobiography*. Chicago: Lawrence Hill Books, 1987.

Smethurst, James E. *The Black Arts Movement: Literary Nationalism in the 1960s and 1970s*. Chapel Hill: University of North Carolina Press, 2005.

Van Peebles, Mario, Ula Y. Taylor, and J. Tarika Lewis. *Panther: A Pictorial History of the Black Panthers and the Story Behind the Film*. New York: New Market Press, 1995.

Williams, Robert F. *Negroes With Guns*. New York: Marzani & Mansell, 1962.

Wood, Paul, et. al. *The Great Utopia: The Russian and Soviet Avant-Garde 1915–1932*. New York: Guggenheim Museum, 1992.

X, Malcolm, and Alex Haley. *The Autobiography of Malcolm X*. New York: Grove Press, 1992.

X, Malcolm. *Malcolm X Speaks: Selected Speeches and Statements*. Edited by George Breitman. New York: Grove Press, 1990.

## NEWSPAPERS AND PERIODICALS

*Basta Ya!* (newspaper). Published by Los Siete de la Raza. San Francisco, 1969–72.

*La Causa* (newspaper). Published by Brown Beret. Los Angeles, 1969–71.

*The Crusader Monthly Newsletter*. Published by Robert F. Williams and Mabel Williams. Havana, Cuba (1962–65) and Peking, China (1966–69).

*Getting Together* (newspaper). Published by I Wor Kuen, New York and San Francisco, 1970–78.

*Jihad News* (newspaper). Published by Afrikan Peoples Party. 1973–80.

*Kalayaan International* (newspaper). Published by Kalayaan Collective. San Francisco, 1970–73.

*The New African* (newspaper). Published by Republic of New Africa, 1968–83.

*Palante—Latin Revolutionary News Service* (newspaper). Published by Young Lords Party. New York, 1969–76.

*Red Guard Community Newspaper*. Published by Red Guard Party. San Francisco, 1969–70.

Suppressed Issue: Guerilla War in the USA." *Scanlan's Monthly* (St. Jean, Quebec) Vol. 1, No. 8 (1971)

*Tricontinental*. Published by Organization of Solidarity of the People of Asia, Africa, and Latin America (OSPAAAL). Havana, Cuba, 1966–present.

# INDEX

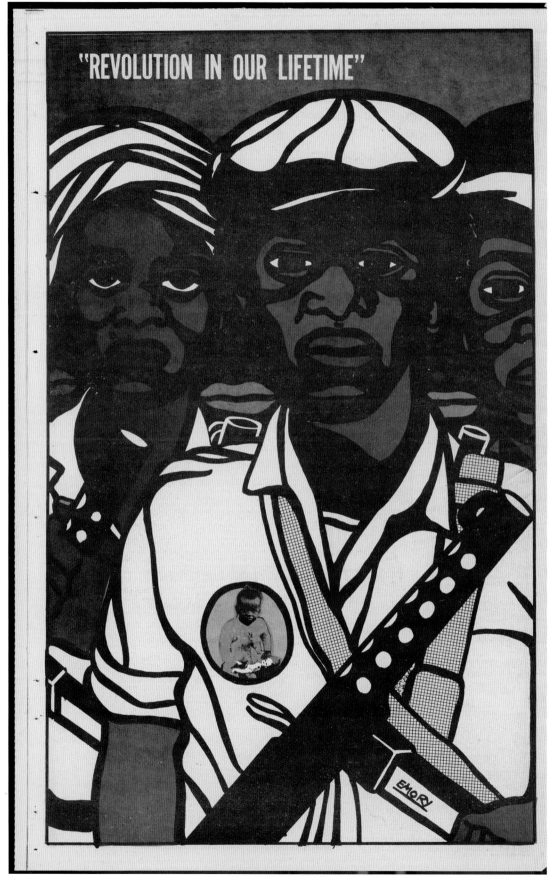

November 8, 1969

## ACKNOWLEDGMENTS

One of the great pleasures in putting this book together has been the opportunity to meet so many remarkable people. I must express special gratitude to Kathleen Cleaver for her exceptional support and guidance. My deep appreciation goes to the contributing authors, who have provided this volume with diverse and extraordinary perspectives on Emory Douglas's work. Special thanks is owed to Cyndi DeVesey Douglas, who worked with her father and St. Clair Bourne to edit and shape the interview. Thanks also to Alden and Mary Kimbrough, Carol Wells of the Center for the Study of Political Graphics, Black Panther Party historian Billy X Jennings, and Sam Brooks for their generosity in loaning the works for reproduction and enthusiastic support of Douglas's work. I am especially grateful to Lorraine Wild and Stuart Smith at Green Dragon. Their elegant, coherent design reveals a deep understanding of Douglas's artwork and design skills. The superb quality of the reproductions is courtesy of Tony Manzella and Rusty Sena at Echelon. Thanks are due to Pirkle Jones and his assistant Jennifer McFarland for generously allowing us to reproduce his photographs, and to Lincoln Cushing and Michael Rossman for loaning us images. I am indebted to Candice Lin, who has helped immeasurably in every aspect of the production. My great appreciation goes to Russell Ferguson for bringing this book to the attention of the publisher. Without his enthusiastic support from the beginning, I'm not sure it would exist. The contributors to this volume continue the struggle and many do so in virtual obscurity. For more information, please contact: Black Panther Party founder Bobby Seale at ReachBS@msn.com and www.BobbySeale.com; Billy X Jennings at www.itsabouttimebpp.com; and Carol Wells at the Center for the Study of Political Graphics at www.politicalgraphics.org.

    SAM DURANT

## PHOTO CREDITS

Digital imaging of Emory Douglas's artwork by Echelon, except: 1, 2, 6, 18, 57, 107, 172, 177, 178 (photographed by Gene Ogami) unless otherwise noted

t= top; b=bottom; l=left; r=right

Courtesy AOUON Archive, Berkeley, California. Digital imaging by Lincoln Cushing: 137

© 1968 Ruth-Marion Baruch: 59

Courtesy of Sam Brooks: 127, 165, 195, 196, 197, 203, 206, 209, 213, 217

Courtesy of Center for the Study of Political Graphics: case (hardcover only), 6, 15, 18, 20, 24, 30, 31, 34 (b), 43, 44, 45 (t), 54, 57, 71, 72 (t), 73 (t), 75, 76, 77, 80, 83, 85, 88, 94, 105, 107, 114, 117, 119, 124, 125, 126, 133, 135, 138, 145, 152, 156, 157, 159, 160, 161, 162, 163, 167, 168, 174, 177, 182–183, 184, 186, 187, 188, 189, 190, 198, 212, 221, 224

© The Crusader newsletter, front page, March 1965, Robert F. Williams, Editor: 131

Docs Populi / Lincoln Cushing Archive, Berkeley, California. Digital imaging by Lincoln Cushing: 99 (l), 100, 101

Courtesy of Emory Douglas: 26, 34 (t), 35 (t and b)

© Colette Gaiter: 93

© Getting Together / graphic: Leland Wong: 134

Home Coming: Poems by Sonia Sanchez, Broadside Press, Detroit, Michigan. 1969. Image © Emory Douglas: 26

Collection International Institute of Social History, Amsterdam: 98

Courtesy of Billy X Jennings: 90–91, 164, 191, 210–211, 214, 216

© 1968 Pirkle Jones: 11, 53, 58

Courtesy of Alden and Mary Kimborough: jacket front and inside (hardcover only), 1, 2, 5, 8–9, 14, 16–17, 23, 28, 29, 32, 33, 36, 37 (t and b), 38, 39 (t and b), 40, 41, 42, 45 (b), 46, 47, 50, 52, 56, 63, 64, 65, 66, 67, 68, 69, 70, 72 (b), 73 (b), 74, 78, 79, 81, 82, 84, 86, 87, 89, 92, 97, 99, 102, 103, 106, 110, 111, 112, 113, 115, 116, 118, 120, 121, 122, 123, 128, 130, 136, 139, 140 (l and r), 141, 142, 143, 144, 146, 147, 148, 149, 150, 151, 153, 154, 155, 158, 166, 170, 172, 173, 175, 178, 179, 181, 185, 192, 193, 194, 201, 204, 207, 208, 215, 222

© Joshua Mays, artist; concept/owner Ashara Ekundayo, BluBlakMedia, LLC: 108

© Malaquias Montoya, artist: 132

Courtesy Sacramento Bee Collection, Black Panthers Sacramento Archives and Museum Collection Center: 48

© Rigo 23, artist: 109

© 2006 Stephen Shames / Polaris Images: 13

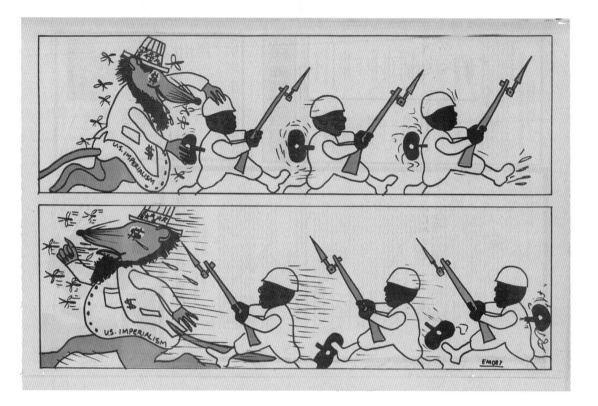

FIRST PUBLISHED IN THE UNITED STATES OF AMERICA
IN 2007
BY RIZZOLI INTERNATIONAL PUBLICATIONS, INC.
300 PARK AVENUE SOUTH
NEW YORK, NY 10010
www.rizzoliusa.com
All art copyright © Emory Douglas, unless otherwise noted

*Emory Douglas: A "Good Brother," a "Bad" Artist*
copyright © 2007 Amiri Baraka

*An Artist for the People: An Interview with Emory Douglas*
copyright © 2007 St. Clair Bourne

*A Picture is Worth a Thousand Words* copyright © 2007 Kathleen Cleaver

Introduction copyright © 2007 Sam Durant

Introduction to revised edition and *What Revolution Looks Like:
The Work of Black Panther Artist Emory Douglas*
copyright © 2013 and 2007 (respectively) Colette Gaiter

Preface copyright © 2007 Danny Glover

*Emory Douglas and the Third World Cultural Revolution*
copyright © 2007 Greg Jung Morozumi

"definition for blk/children" copyright © Sonia Sanchez

Foreword copyright © 2007 Bobby Seale

*The Genius of Emory Douglas* copyright © 2007 John Sinclair

2014 2015 2016 2017 / 10 9 8 7 6 5 4 3 2 1

ISBN:
978-0-8478-4189-9

Library of Congress Control Number:
2013951055

Designed by
Lorraine Wild and Stuart Smith,
Green Dragon Office, Los Angeles

Typeset in
Knockout, Champion, and Ziggurate
designed by Jonathan Hoefler, HTF Foundry

Bell Gothic
designed by Chauncey H. Griffith; and Monotype foundry

Garamond
based on the original design of Claude Garamond

Scanning and separation by
Echelon, Venice, California, unless otherwise noted

Printed in China

*Above* **NOVEMBER 1, 1969**

*Page 1* **1967:** Douglas originally painted this image in gouache in 1966.
At Eldridge Cleaver's suggestion, the painting was reproduced as the first
color poster for the Black Panther Party.

*Page 2* **1967:** This image was drawn in 1966 as Douglas transitioned
from the Black Arts Movement to the Black Panther Party. In 1967, after
Douglas joined the party, he made this image along with several others
into a series of posters.

*Page 6* **CIRCA 1970:** In the original of this offset color poster, Douglas
juxtaposes the faces of the lumpen (the under class) with the lyrics from
an old slave song shown here connecting the history of oppression with the
struggles of contemporary black people.